Si
M
of
W

MW01503991

of Midnight, The Doomsday Conspiracy, The Stars Shine Down, Nothing Lasts Forever and *Morning, Noon & Night*, all Number One international best-sellers. His first book, *The Naked Face*, was acclaimed by the *New York Times* as 'the best first mystery novel of the year'. Mr Sheldon has won a Tony award for Broadway's *Redhead* and an Academy Award for *The Bachelor and the Bobby Soxer*. *Rage of Angels*, *Master of the Game*, *Windmills of the Gods* and *Memories of Midnight* have been made into highly successful television mini-series.

He has written the screenplays for twenty-three motion pictures, including *Easter Parade* (with Judy Garland) and *Annie Get Your Gun*. He also created four long-running television series, including *Hart to Hart* and *I Dream of Jeannie*, which he produced. He was awarded the 1993 Prix Littéraire de Deauville, from the Deauville Film Festival, and is now included in the Guinness Book of Records as 'The Most Translated Author'. Mr Sheldon and his wife live in southern California and London.

For more about Sidney Sheldon, see his website at http://www.sidneysheldon.com

'The reason he is the world's biggest-selling author is his gripping, twisting plots. This story is no exception.' *Sunday Express*

SIDNEY SHELDON

THE
BEST LAID
PLANS

HarperCollins *Publishers* India
a joint venture with

New Delhi

HarperCollins *Publishers* India
a joint venture with
The India Today Group
by arrangement with
HarperCollins *Publishers* Limited

First published in Great Britain by
HarperCollins *Publishers* 1997
Special overseas edition 1997
Paperback edition 1998

Published by HarperCollins *Publishers* India 2003

Sixth impression 2007

ISBN 13: 978-8-17-223492-8
ISBN 10: 8-17-223492-9

HarperCollins *Publishers*
1A Hamilton House, Connaught Place, New Delhi 110 001, India
77-85 Fulham Palace Road, London W6 8JB, United Kingdom
Hazelton Lanes, 55 Avenue Road, Suite 2900, Toronto, Ontario M5R 3L2
and 1995 Markham Road, Scarborough, Ontario M1B 5M8, Canada
25 Ryde Road, Pymble, Sydney, NSW 2073, Australia
31 View Road, Glenfield, Auckland 10, New Zealand
10 East 53rd Street, New York NY 10022, USA

Printed and bound at
Thomson Press (India) Ltd.

This book is dedicated to you
with my appreciation

THE
BEST LAID
PLANS

One

The first entry in Leslie Stewart's diary read:

> *Dear Diary: This morning I met the man I am going to marry.*

It was a simple, optimistic statement, with not the slightest portent of the dramatic chain of events that was about to occur.

It was one of those rare, serendipitous days when nothing could go wrong, when nothing would dare go wrong. Leslie Stewart had no interest in astrology, but that morning, as she was leafing through the *Lexington Herald-Leader*, a horoscope in an astrology column by Zoltaire caught her eye. It read:

> For Leo (July 23rd to August 22nd). The new moon illuminates your love life. You are in your lunar cycle high now, and must pay close attention to an

1

EXCITING NEW EVENT IN YOUR LIFE. YOUR
COMPATIBLE SIGN IS VIRGO. TODAY WILL
BE A RED-LETTER DAY. BE PREPARED TO
ENJOY IT.

Be prepared to enjoy what? Leslie thought wryly. Today was going to be like every other day. Astrology was nonsense, mind candy for fools.

Leslie Stewart was a public relations and advertising executive at the Lexington, Kentucky, firm of Bailey & Tomkins. She had three meetings scheduled for that afternoon, the first with the Kentucky Fertilizer Company, whose executives were excited about the new campaign she was working up for them. They especially liked its beginning: 'If you want to smell the roses ...' The second meeting was with the Breeders Stud Farm, and the third with the Lexington Coal Company. Red-letter day?

In her late twenties, with a slim, provocative figure, Leslie Stewart had an exciting, exotic look; gray, sloe eyes, high cheek-bones, and soft, honey-colored hair, which she wore long and elegantly simple. A friend of Leslie's had once told her, 'If you're beautiful and have a brain and a vagina, you can own the world.'

Leslie Stewart was beautiful and had an IQ of 170, and nature had taken care of the rest. But she found her looks a disadvantage. Men were constantly propositioning her

or proposing, but few of them bothered to try really to get to know her.

Aside from the two secretaries who worked at Bailey & Tomkins, Leslie was the only woman there. There were fifteen male employees. It had taken Leslie less than a week to learn that she was more intelligent than any of them. It was a discovery she decided to keep to herself.

In the beginning, both partners, Jim Bailey, an overweight, soft-spoken man in his forties, and Al Tomkins, anorexic and hyper, ten years younger than Bailey, individually tried to talk Leslie into going to bed with them.

She had stopped them very simply. 'Ask me once more, and I'll quit.'

That had put an end to that. Leslie was too valuable an employee to lose.

Her first week on the job, during a coffee break, Leslie had told her fellow employees a joke.

'Three men came across a female genie who promised to grant each one a wish. The first man said, "I wish I were twenty-five percent smarter." The genie blinked, and the man said, "Hey, I feel smarter already."

'The second man said, "I wish I were fifty percent smarter." The genie blinked, and the man exclaimed, "That's wonderful! I think I know things now that I didn't know before."

'The third man said, "I'd like to be one hundred percent smarter."

'So the genie blinked, and the man changed into a woman.'

Leslie looked expectantly at the men at the table. They were all staring at her, unamused.

Point taken.

The red-letter day that the astrologer had promised began at eleven o'clock that morning. Jim Bailey walked into Leslie's tiny, cramped office.

'We have a new client,' he announced. 'I want you to take charge.'

She was already handling more accounts than anyone else at the firm, but she knew better than to protest.

'Fine,' she said. 'What is it?'

'It's not a what, it's a who. You've heard of Oliver Russell, of course?'

Everyone had heard of Oliver Russell. A local attorney and candidate for governor, he had his face on billboards all over Kentucky. With his brilliant legal record, he was considered, at thirty-five, the most eligible bachelor in the state. He was on all the talk shows on the major television stations in Lexington – WDKY, WTVQ, WKYT – and on the popular local radio stations, WKQQ and WLRO. Strikingly handsome, with black, unruly hair, dark eyes, an athletic build, and a warm smile, he had the reputation of having slept with most of the ladies in Lexington.

'Yes, I've heard of him. What are we going to do for him?'

'We're going to try to help turn him into the governor of Kentucky. He's on his way here now.'

Oliver Russell arrived a few minutes later. He was even more attractive in person than in his photographs.

When he was introduced to Leslie, he smiled warmly. 'I've heard a lot about you. I'm so glad you're going to handle my campaign.'

He was not at all what Leslie had expected. There was a completely disarming sincerity about the man. For a moment, Leslie was at a loss for words.

'I – thank you. Please sit down.'

Oliver Russell took a seat.

'Let's start at the beginning,' Leslie suggested. 'Why are you running for governor?'

'It's very simple. Kentucky's a wonderful state. We know it is, because we live here, and we're able to enjoy its magic – but much of the country thinks of us as a bunch of hillbillies. I want to change that image. Kentucky has more to offer than a dozen other states combined. The history of this country began here. We have one of the oldest capitol buildings in America. Kentucky gave this country two presidents. It's the land of Daniel Boone and Kit Carson and Judge Roy Bean. We have the most beautiful scenery in the world – exciting caves, rivers, bluegrass fields – everything. I want to open all that up to the rest of the world.'

He spoke with a deep conviction, and Leslie found her-

self strongly drawn to him. She thought of the astrology column. *'The new moon illuminates your love life. Today will be a red-letter day. Be prepared to enjoy it.'*

Oliver Russell was saying, 'The campaign won't work unless you believe in this as strongly as I do.'

'I do,' Leslie said quickly. Too quickly? 'I'm really looking forward to this.' She hesitated a moment. 'May I ask you a question?'

'Certainly.'

'What's your birth sign?'

'Virgo.'

After Oliver Russell left, Leslie went into Jim Bailey's office. 'I like him,' she said. 'He's sincere. He really cares. I think he'd make a fine governor.'

Jim looked at her thoughtfully. 'It's not going to be easy.'

She looked at him, puzzled. 'Oh? Why?'

Bailey shrugged. 'I'm not sure. There's something going on that I can't explain. You've seen Russell on all the billboards and on television?'

'Yes.'

'Well, that's stopped.'

'I don't understand. Why?'

'No one knows for certain, but there are a lot of strange rumors. One of the rumors is that someone was backing Russell, putting up all the money for his campaign, and then for some reason suddenly dropped him.'

6

'In the middle of a campaign he was winning? That doesn't make sense, Jim.'

'I know.'

'Why did he come to us?'

'He really wants this. I think he's ambitious. And he feels he can make a difference. He would like us to figure out a campaign that won't cost him a lot of money. He can't afford to buy any more airtime or do much advertising. All we can really do for him is to arrange interviews, plant newspaper articles, that sort of thing.' He shook his head. 'Governor Addison is spending a fortune on his campaign. In the last two weeks, Russell's gone way down in the polls. It's a shame. He's a good lawyer. Does a lot of pro bono work. I think he'd make a good governor, too.'

That night Leslie made her first note in her new diary.

> *Dear Diary: This morning I met the man I am going to marry.*

Leslie Stewart's early childhood was idyllic. She was an extraordinarily intelligent child. Her father was an English professor at Lexington Community College and her mother was a housewife. Leslie's father was a handsome man, patrician and intellectual. He was a caring father, and he saw to it that the family took their vacations together and traveled together. Her father adored her. 'You're Daddy's girl,' he would say. He would tell her how beautiful she looked and compliment

her on her grades, her behavior, her friends. Leslie could do no wrong in his eyes. For her ninth birthday, her father bought her a beautiful brown velvet dress with lace cuffs. He would have her put the dress on, and he would show her off to his friends when they came to dinner. 'Isn't she a beauty?' he would say.

Leslie worshiped him.

One morning, a year later, in a split second, Leslie's wonderful life vanished. Her mother, face stained with tears, sat her down. 'Darling, your father has ... left us.'

Leslie did not understand at first. 'When will he be back?'

'He's not coming back.'

And each word was a sharp knife.

My mother has driven him away, Leslie thought. She felt sorry for her mother because now there would be a divorce and a custody fight. Her father would never let her go. Never. *He'll come for me*, Leslie told herself.

But weeks passed, and her father never called. *They won't let him come and see me*, Leslie decided. *Mother's punishing him.*

It was Leslie's elderly aunt who explained to the child that there would be no custody battle. Leslie's father had fallen in love with a widow who taught at the university and had moved in with her, in her house on Limestone Street.

One day when they were out shopping, Leslie's mother

pointed out the house. 'That's where they live,' she said bitterly.

Leslie resolved to visit her father. *When he sees me*, she thought, *he'll want to come home.*

On a Friday, after school, Leslie went to the house on Limestone Street and rang the doorbell. The door was opened by a girl Leslie's age. She was wearing a brown velvet dress with lace cuffs. Leslie stared at her, in shock.

The little girl was looking at her curiously. 'Who are you?'

Leslie fled.

Over the next year, Leslie watched her mother retire into herself. She had lost all interest in life. Leslie had believed that 'dying of a broken heart' was an empty phrase, but Leslie helplessly watched her mother fade away and die, and when people asked her what her mother had died of, Leslie answered, 'She died of a broken heart.'

And Leslie resolved that no man would ever do that to her.

After her mother's death, Leslie moved in with her aunt. Leslie attended Bryan Station High School and was graduated from the University of Kentucky summa cum laude. In her final year in college, she was voted beauty queen, and turned down numerous offers from modeling agencies.

Leslie had two brief affairs, one with a college football hero, and the other with her economics professor. They quickly bored her. The fact was that she was brighter than both of them.

Just before Leslie was graduated, her aunt died. Leslie finished school and applied for a job at the advertising and public relations agency of Bailey & Tomkins. Its offices were on Vine Street in a U-shaped brick building with a copper roof and a fountain in the courtyard.

Jim Bailey, the senior partner, had examined Leslie's résumé, and nodded. 'Very impressive. You're in luck. We need a secretary.'

'A secretary? I hoped –'

'Yes?'

'Nothing.'

Leslie started as a secretary, taking notes at all the meetings, her mind all the while judging and thinking of ways to improve the advertising campaigns that were being suggested. One morning, an account executive was saying, 'I've thought of the perfect logo for the Rancho Beef Chili account. On the label of the can, we show a picture of a cowboy roping a cow. It suggests that the beef is fresh, and –'

That's a terrible idea, Leslie thought. They were all staring at her, and to her horror, Leslie realized she had spoken aloud.

'Would you mind explaining that, young lady?'

'I . . .' She wished she were somewhere else. Anywhere. They were all waiting. Leslie took a deep breath. 'When people eat meat, they don't want to be reminded that they're eating a dead animal.'

There was a heavy silence. Jim Bailey cleared his throat. 'Maybe we should give this a little more thought.'

The following week, during a meeting on how to publicize a new beauty soap account, one of the executives said, 'We'll use beauty contest winners.'

'Excuse me,' Leslie said diffidently. 'I believe that's been done. Why couldn't we use lovely flight attendants from around the world to show that our beauty soap is universal?'

In the meetings after that, the men found themselves turning to Leslie for her opinion.

A year later, she was a junior copywriter, and two years after that, she became an account executive, handling both advertising and publicity.

Oliver Russell was the first real challenge that Leslie had had at the agency. Two weeks after Oliver Russell came to them, Bailey suggested to Leslie that it might be better to drop him, because he could not afford to pay their usual agency fee, but Leslie persuaded him to keep the account.

'Call it pro bono,' she said.

Bailey studied her a moment. 'Right.'

Leslie and Oliver Russell were seated on a bench in Triangle Park. It was a cool fall day, with a soft breeze coming from the lake. 'I hate politics,' Oliver Russell said.

Leslie looked at him in surprise. 'Then why in the world are you –?'

'Because I want to change the system, Leslie. It's been taken over by lobbyists and corporations that help put the wrong people in power and then control them. There are a lot of things I want to do.' His voice was filled with passion. 'The people who are running the country have turned it into an old boys' club. They care more about themselves than they do about the people. It's not right, and I'm going to try to correct that.'

Leslie listened as Oliver went on, and she was thinking, *He could do it.* There was such a compelling excitement about him. The truth was that she found everything about him exciting. She had never felt this way about a man before, and it was an exhilarating experience. She had no way of knowing how he felt about her. *He is always the perfect gentleman, damn him.* It seemed to Leslie that every few minutes people were coming up to the park bench to shake Oliver's hand and to wish him well. The women were visually throwing daggers at Leslie. *They've probably all been out with him,* Leslie

thought. *They've probably all been to bed with him. Well, that's none of my business.*

She had heard that until recently he had been dating the daughter of a senator. She wondered what had happened. *That's none of my business, either.*

There was no way to avoid the fact that Oliver's campaign was going badly. Without money to pay his staff, and no television, radio, or newspaper ads, it was impossible to compete with Governor Cary Addison, whose image seemed to be everywhere. Leslie arranged for Oliver to appear at company picnics, at factories, and at dozens of social events, but she knew these appearances were all minor-league, and it frustrated her.

'Have you seen the latest polls?' Jim Bailey asked Leslie. 'Your boy is going down the tubes.'

Not if I can help it, Leslie thought.

Leslie and Oliver were having dinner at Cheznous. 'It's not working, is it?' Oliver asked quietly.

'There's still plenty of time,' Leslie said reassuringly. 'When the voters get to know you –'

Oliver shook his head. 'I read the polls, too. I want you to know I appreciate everything you've tried to do for me, Leslie. You've been great.'

She sat there looking at him across the table, thinking, *He's the most wonderful man I've ever met, and I can't help*

him. She wanted to take him in her arms and hold him and console him. *Console him? Who am I kidding?*

As they got up to leave, a man, a woman, and two small girls approached the table.

'Oliver! How are you?' The speaker was in his forties, an attractive-looking man with a black eye patch that gave him the raffish look of an amiable pirate.

Oliver rose and held out his hand. 'Hello, Peter. I'd like you to meet Leslie Stewart. Peter Tager.'

'Hello, Leslie.' Tager nodded toward his family. 'This is my wife, Betsy, and this is Elizabeth and this is Rebecca.' There was enormous pride in his voice.

Peter Tager turned to Oliver. 'I'm awfully sorry about what happened. It's a damned shame. I hated to do it, but I had no choice.'

'I understand, Peter.'

'If there was anything I could have done –'

'It doesn't matter. I'm fine.'

'You know I wish you only the best of luck.'

On the way home, Leslie asked, 'What was that all about?'

Oliver started to say something, then stopped. 'It's not important.'

Leslie lived in a neat one-bedroom apartment in the Brandywine section of Lexington. As they approached the building, Oliver said hesitantly, 'Leslie, I know that your agency is handling me for almost nothing, but

frankly, I think you're wasting your time. It might be better if I just quit now.'

'No,' she said, and the intensity of her voice surprised her. 'You can't quit. We'll find a way to make it work.'

Oliver turned to look at her. 'You really care, don't you?'

Am I reading too much into that question? 'Yes,' she said quietly. 'I really care.'

When they arrived at her apartment, Leslie took a deep breath. 'Would you like to come in?'

He looked at her a long time. 'Yes.'

Afterward, she never knew who made the first move. All she remembered was that they were undressing each other and she was in his arms and there was a wild, feral haste in their lovemaking, and after that, a slow and easy melting, in a rhythm that was timeless and ecstatic. It was the most wonderful feeling Leslie had ever experienced.

They were together the whole night, and it was magical. Oliver was insatiable, giving and demanding at the same time, and he went on forever. He was an animal. And Leslie thought, *Oh, my God, I'm one, too.*

In the morning, over a breakfast of orange juice, scrambled eggs, toast, and bacon, Leslie said, 'There's going to be a picnic at Green River Lake on Friday, Oliver. There will be a lot of people there. I'll arrange for you to make a

speech. We'll buy radio time to let everyone know you're going to be there. Then we'll –'

'Leslie,' he protested, 'I haven't the money to do that.'

'Oh, don't worry about that,' she said airily. 'The agency will pay for it.'

She knew that there was not the remotest chance that the agency would pay for it. She intended to do that herself. She would tell Jim Bailey that the money had been donated by a Russell supporter. And it would be the truth. *I'll do anything in the world to help him*, she thought.

There were two hundred people at the picnic at Green River Lake, and when Oliver addressed the crowd, he was brilliant.

'Half the people in this country don't vote,' he told them. 'We have the lowest voting record of any industrial country in the world – less than fifty percent. If you want things to change, it's your responsibility to make sure they do change. It's more than a responsibility, it's a privilege. There's an election coming up soon. Whether you vote for me or my opponent, vote. Be there.'

They cheered him.

Leslie arranged for Oliver to appear at as many functions as possible. He presided at the opening of a children's

clinic, dedicated a bridge, talked to women's groups, labor groups, at charity events, and retirement homes. Still, he kept slipping in the polls. Whenever Oliver was not campaigning, he and Leslie found some time to be together. They went riding in a horse-drawn carriage through Triangle Park, spent a Saturday afternoon at the Antique Market, and had dinner at À la Lucie. Oliver gave Leslie flowers for Groundhog Day and on the anniversary of the Battle of Bull Run, and left loving messages on her answering machine: 'Darling – where are you? I miss you, miss you, miss you.'

'I'm madly in love with your answering machine. Do you have any idea how sexy it sounds?'

'I think it must be illegal to be this happy. I love you.'

It didn't matter to Leslie where she and Oliver went: She just wanted to be with him.

One of the most exciting things they did was to go whitewater rafting on the Russell Fork River one Sunday. The trip started innocently, gently, until the river began to pound its way around the base of the mountains in a giant loop that began a series of deafening, breathtaking vertical drops in the rapids: five feet . . . eight feet . . . nine feet . . . only a terrifying raft length apart. The trip took three and a half hours, and when Leslie and Oliver got off the raft, they were soaking wet and glad to be alive. They could not keep their hands off each other. They

made love in their cabin, in the back of his automobile, in the woods.

One early fall evening, Oliver prepared dinner at his home, a charming house in Versailles, a small town near Lexington. There were grilled flank steaks marinated in soy sauce, garlic, and herbs, served with baked potato, salad, and a perfect red wine.

'You're a wonderful cook,' Leslie told him. She snuggled up to him. 'In fact, you're a wonderful everything, sweetheart.'

'Thank you, my love.' He remembered something. 'I have a little surprise for you that I want you to try.' He disappeared into the bedroom for a moment and came out carrying a small bottle with a clear liquid inside.

'Here it is,' he said.

'What is it?'

'Have you heard of Ecstasy?'

'Heard of it? I'm in it.'

'I mean the drug Ecstasy. This is liquid Ecstasy. It's supposed to be a great aphrodisiac.'

Leslie frowned. 'Darling – you don't need that. We don't need it. It could be dangerous.' She hesitated. 'Do you use it often?'

Oliver laughed. 'As a matter of fact, I don't. Take that look off your face. A friend of mine gave me this and told me to try it. This would have been the first time.'

'Let's not have a first time,' Leslie said. 'Will you throw it away?'

'You're right. Of course I will.' He went into the bathroom, and a moment later Leslie heard the toilet flush. Oliver reappeared.

'All gone.' He grinned. 'Who needs Ecstasy in a bottle? I have it in a better package.'

And he took her in his arms.

Leslie had read the love stories and had heard the love songs, but nothing had prepared her for the incredible reality. She had always thought that romantic lyrics were sentimental nonsense, wishful dreaming. She knew better now. The world suddenly seemed brighter, more beautiful. Everything was touched with magic, and the magic was Oliver Russell.

One Saturday morning, Oliver and Leslie were hiking in the Breaks Interstate Park, enjoying the spectacular scenery that surrounded them.

'I've never been on this trail before,' Leslie said.

'I think you're going to enjoy it.'

They were approaching a sharp curve in the path. As they rounded it, Leslie stopped, stunned. In the middle of the path was a hand-painted wooden sign: LESLIE, WILL YOU MARRY ME?

Leslie's heart began to beat faster. She turned to Oliver, speechless.

He took her in his arms. 'Will you?'

How did I get so lucky? Leslie wondered. She hugged him tightly and whispered, 'Yes, darling. Of course I will.'

'I'm afraid I can't promise you that you're going to marry a governor, but I'm a pretty good attorney.'

She snuggled up to him and whispered, 'That will do nicely.'

A few nights later, Leslie was getting dressed to meet Oliver for dinner when he telephoned.

'Darling, I'm terribly sorry, but I've bad news. I have to go to a meeting tonight, and I'll have to cancel our dinner. Will you forgive me?'

Leslie smiled and said softly, 'You're forgiven.'

The following day, Leslie picked up a copy of the *State Journal*. The headline read: WOMAN'S BODY FOUND IN KENTUCKY RIVER. The story went on: 'Early this morning, the body of a nude woman who appeared to be in her early twenties was found by police in the Kentucky River ten miles east of Lexington. An autopsy is being performed to determine the cause of death . . .'

Leslie shuddered as she read the story. *To die so young. Did she have a lover? A husband? How thankful I am to be alive and so happy and so loved.*

* * *

It seemed that all of Lexington was talking about the forthcoming wedding. Lexington was a small town, and Oliver Russell was a popular figure. They were a spectacular-looking couple, Oliver dark and handsome, and Leslie with her lovely face and figure and honey-blond hair. The news had spread like wildfire.

'I hope he knows how lucky he is,' Jim Bailey said.

Leslie smiled. 'We're both lucky.'

'Are you going to elope?'

'No. Oliver wants to have a formal wedding. We're getting married at the Calvary Chapel church.'

'When does the happy event take place?'

'In six weeks.'

A few days later, a story on the front page of the *State Journal* read: 'An autopsy has revealed that the woman found in the Kentucky River, identified as Lisa Burnette, a legal secretary, died of an overdose of a dangerous illegal drug known on the streets as liquid Ecstasy . . .'

Liquid Ecstasy. Leslie recalled the evening with Oliver. And she thought, *How lucky it was that he threw that bottle away.*

The next few weeks were filled with frantic preparations for the wedding. There was so much to do. Invitations

went out to two hundred people. Leslie chose a maid of honor and selected her outfit, a ballerina-length dress with matching shoes and gloves to complement the length of the sleeves. For herself, Leslie shopped at Fayette Mall on Nicholasville Road and selected a floor-length gown with a full skirt and a sweep train, shoes to match the gown, and long gloves.

Oliver ordered a black cutaway coat with striped trousers, gray waistcoat, a wing-collared white shirt, and a striped ascot. His best man was a lawyer in his firm.

'Everything is set,' Oliver told Leslie. 'I've made all the arrangements for the reception afterward. Almost everyone has accepted.'

Leslie felt a small shiver go through her. 'I can't wait, my darling.'

On a Thursday night one week before the wedding, Oliver came to Leslie's apartment.

'I'm afraid something has come up, Leslie. A client of mine is in trouble. I'm going to have to fly to Paris to straighten things out.'

'Paris? How long will you be gone?'

'It shouldn't take more than two or three days, four days at the most. I'll be back in plenty of time.'

'Tell the pilot to fly safely.'

'I promise.'

When Oliver left, Leslie picked up the newspaper

on the table. Idly, she turned to the horoscope by Zoltaire. It read:

FOR LEO (JULY 23RD TO AUGUST 22ND). THIS IS NOT A GOOD DAY TO CHANGE PLANS. TAKING RISKS CAN LEAD TO SERIOUS PROBLEMS.

Leslie read the horoscope again, disturbed. She was almost tempted to telephone Oliver and tell him not to leave. *But that's ridiculous*, she thought. *It's just a stupid horoscope.*

By Monday, Leslie had not heard from Oliver. She telephoned his office, but the staff had no information. There was no word from him Tuesday. Leslie was beginning to panic. At four o'clock on Wednesday morning, she was awakened by the insistent ringing of the telephone. She sat up in bed and thought: *It's Oliver! Thank God.* She knew that she should be angry with him for not calling her sooner, but that was unimportant now.

She picked up the receiver. 'Oliver . . .'

A male voice said, 'Is this Leslie Stewart?'

She felt a sudden cold chill. 'Who – who is this?'

'Al Towers, Associated Press. We have a story going out on our wires, Miss Stewart, and we wanted to get your reaction.'

Something terrible had happened. Oliver was dead.

'Miss Stewart?'

23

'Yes.' Her voice was a strangled whisper.

'Could we get a quote from you?'

'A quote?'

'About Oliver Russell marrying Senator Todd Davis's daughter in Paris.'

For an instant the room seemed to spin.

'You and Mr Russell were engaged, weren't you? If we could get a quote . . .'

She sat there, frozen.

'Miss Stewart.'

She found her voice. 'Yes. I – I wish them both well.' She replaced the receiver, numb. It was a nightmare. She would awaken in a few minutes and find that she had been dreaming.

But this was no dream. She had been abandoned again. *Your father's not coming back.* She walked into the bathroom and stared at her pale image in the mirror. *'We have a story going out on our wires.'* Oliver had married someone else. *Why? What have I done wrong? How have I failed him?* But deep down she knew that it was Oliver who had failed her. He was gone. How could she face the future?

When Leslie walked into the agency that morning, everyone was trying hard not to stare at her. She went into Jim Bailey's office.

He took one look at her pale face and said, 'You shouldn't have come in today, Leslie. Why don't you go home and –'

She took a deep breath. 'No, thank you. I'll be fine.'

The radio and television newscasts and afternoon news-papers were filled with details of the Paris wedding. Senator Todd Davis was without doubt Kentucky's most influential citizen, and the story of his daughter's marriage and of the groom's jilting Leslie was big news.

The phones in Leslie's office never stopped ringing.

'This is the *Courier-Journal*, Miss Stewart. Could you give us a statement about the wedding?'

'Yes. The only thing I care about is Oliver Russell's happiness.'

'But you and he were going to be –'

'It would have been a mistake for us to marry. Senator Davis's daughter was in his life first. Obviously, he never got over her. I wish them both well.'

'This is the *State Journal* in Frankfort . . .'

And so it went.

It seemed to Leslie that half of Lexington pitied her, and the other half rejoiced at what had happened to her. Wherever Leslie went, there were whispers and hastily broken-off conversations. She was fiercely determined not to show her feelings.

'How could you let him do this to –?'

'When you truly love someone,' Leslie said firmly, 'you want him to be happy. Oliver Russell is the finest human being I've ever known. I wish them both every happiness.'

She sent notes of apology to all those who had been invited to the wedding and returned their gifts.

Leslie had been half hoping for and half dreading the call from Oliver. Still, when it came, she was unprepared. She was shaken by the familiar sound of his voice.

'Leslie . . . I don't know what to say.'

'It's true, isn't it?'

'Yes.'

'Then there isn't anything to say.'

'I just wanted to explain to you how it happened. Before I met you, Jan and I were almost engaged. And when I saw her again – I – I knew that I still loved her.'

'I understand, Oliver. Goodbye.'

Five minutes later, Leslie's secretary buzzed her. 'There's a telephone call for you on line one, Miss Stewart.'

'I don't want to talk to –'

'It's Senator Davis.'

The father of the bride. *What does he want with me?* Leslie wondered. She picked up the telephone.

A deep southern voice said, 'Miss Stewart?'

'Yes.'

'This is Todd Davis. I think you and I should have a little talk.'

She hesitated. 'Senator, I don't know what we –'

'I'll pick you up in one hour.' The line went dead.

* * *

26

Exactly one hour later, a limousine pulled up in front of the office building where Leslie worked. A chauffeur opened the car door for Leslie. Senator Davis was in the backseat. He was a distinguished-looking man with flowing white hair and a small, neat mustache. He had the face of a patriarch. Even in the fall he was dressed in his trademark white suit and white broad-brimmed leghorn hat. He was a classic figure from an earlier century, an old-fashioned southern gentleman.

As Leslie got into the car, Senator Davis said, 'You're a beautiful young woman.'

'Thank you,' she said stiffly.

The limousine started off.

'I didn't mean just physically, Miss Stewart. I've been hearing about the manner in which you've been hand-ling this whole sordid matter. It must be very dis-tressing for you. I couldn't believe the news when I heard it.' His voice filled with anger. 'Whatever hap-pened to good old-fashioned morality? To tell you the truth, I'm disgusted with Oliver for treating you so shabbily. And I'm furious with Jan for marrying him. In a way, I feel guilty, because she's my daughter. They deserve each other.' His voice was choked with emotion.

They rode in silence for a while. When Leslie finally spoke, she said, 'I know Oliver. I'm sure he didn't mean to hurt me. What happened . . . just happened. I want only the best for him. He deserves that, and I wouldn't do anything to stand in his way.'

'That's very gracious of you.' He studied her a moment. 'You really are a remarkable young lady.'

The limousine had come to a stop. Leslie looked out the window. They had reached Paris Pike, at the Kentucky Horse Center. There were more than a hundred horse farms in and around Lexington, and the largest of them was owned by Senator Davis. As far as the eye could see were white plank fences, white paddocks with red trim, and rolling Kentucky bluegrass.

Leslie and Senator Davis stepped out of the car and walked over to the fence surrounding the racetrack. They stood there a few moments, watching the beautiful animals working out.

Senator Davis turned to Leslie. 'I'm a simple man,' he said quietly. 'Oh, I know how that must sound to you, but it's the truth. I was born here, and I could spend the rest of my life here. There's no place in the world like it. Just look around you, Miss Stewart. This is as close as we may ever come to heaven. Can you blame me for not wanting to leave all this? Mark Twain said that when the world came to an end, he wanted to be in Kentucky, because it's always a good twenty years behind. I have to spend half my life in Washington, and I loathe it.'

'Then why do you do it?'

'Because I have a sense of obligation. Our people voted me into the Senate, and until they vote me out, I'll be there trying to do the best job I can.' He abruptly changed the subject. 'I want you to know how much I admire your sentiments and the way you've behaved. If

you had been nasty about this, I suppose it could have created quite a scandal. As it is, well – I'd like to show my appreciation.'

Leslie looked at him.

'I thought that perhaps you would like to get away for a while, take a little trip abroad, spend some time traveling. Naturally, I'd pick up all the –'

'Please don't do this.'

'I was only –'

'I know. I haven't met your daughter, Senator Davis, but if Oliver loves her, she must be very special. I hope they'll be happy.'

He said awkwardly, 'I think you should know they're coming back here to get married again. In Paris, it was a civil ceremony, but Jan wants a church wedding here.'

It was a stab in the heart. 'I see. All right. They have nothing to worry about.'

'Thank you.'

The wedding took place two weeks later, in the Calvary Chapel church where Leslie and Oliver were to have been married. The church was packed.

Oliver Russell, Jan and Senator Todd Davis were standing before the minister at the altar. Jan Davis was an attractive brunette, with an imposing figure and an aristocratic air.

The minister was nearing the end of the ceremony. 'God meant for man and woman to be united in holy

matrimony, and as you go through life together . . .'

The church door opened, and Leslie Stewart walked in. She stood at the back for a moment, listening, then moved to the last pew, where she remained standing.

The minister was saying, '. . . so if anyone knows why this couple should not be united in holy matrimony, let him speak now or forever hold his . . .' He glanced up and saw Leslie. '. . . hold his peace.'

Almost involuntarily, heads began to turn in Leslie's direction. Whispers began to sweep through the crowd. People sensed that they were about to witness a dramatic scene, and the church filled with sudden tension.

The minister waited a moment, then nervously cleared his throat. 'Then, by the power vested in me, I now pronounce you man and wife.' There was a note of deep relief in his voice. 'You may kiss the bride.'

When the minister looked up again, Leslie was gone.

The final note in Leslie Stewart's diary read:

> *Dear Diary: It was a beautiful wedding. Oliver's bride is very pretty. She wore a lovely white lace-and-satin wedding gown with a halter top and a bolero jacket. Oliver looked more handsome than ever. He seemed very happy. I'm pleased.*
>
> *Because before I'm finished with him, I'm going to make him wish he had never been born.*

Two

It was Senator Todd Davis who had arranged the reconciliation of Oliver Russell and his daughter.

Todd Davis was a widower. A multibillionaire, the senator owned tobacco plantations, coal mines, oil fields in Oklahoma and Alaska, and a world-class racing stable. As Senate majority leader, he was one of the most powerful men in Washington, and was serving his fifth term. He was a man with a simple philosophy: Never forget a favor, never forgive a slight. He prided himself on picking winners, both at the track and in politics, and early on he had spotted Oliver Russell as a comer. The fact that Oliver might marry his daughter was an unexpected plus, until, of course, Jan foolishly called it off. When the senator heard the news of the impending wedding between Oliver Russell and Leslie Stewart, he found it disturbing. Very disturbing.

Senator Davis had first met Oliver Russell when Oliver handled a legal matter for him. Senator Davis was

31

impressed. Oliver was intelligent, handsome, and articulate, with a boyish charm that drew people to him. The senator arranged to have lunch with Oliver on a regular basis, and Oliver had no idea how carefully he was being assessed.

A month after meeting Oliver, Senator Davis sent for Peter Tager. 'I think we've found our next governor.'

Tager was an earnest man who had grown up in a religious family. His father was a history teacher and his mother was a housewife, and they were devout churchgoers. When Peter Tager was eleven, he had been traveling in a car with his parents and younger brother when the brakes of the car failed. There had been a deadly accident. The only one who survived was Peter, who lost an eye.

Peter believed that God had spared him so that he could spread His word.

Peter Tager understood the dynamics of politics better than anyone Senator Davis had ever met. Tager knew where the votes were and how to get them. He had an uncanny sense of what the public wanted to hear and what it had gotten tired of hearing. But even more important to Senator Davis was the fact that Peter Tager was a man he could trust, a man of integrity. People liked him. The black eye patch he wore gave him a dashing look. What mattered to Tager more than anything in the world was his family. The senator had never met a man so deeply proud of his wife and children.

When Senator Davis first met him, Peter Tager had been contemplating going into the ministry.

'So many people need help, Senator. I want to do what I can.'

But Senator Davis had talked him out of the idea. 'Think of how many more people you can help by working for me in the Senate of the United States.' It had been a felicitous choice. Tager knew how to get things done.

'The man I have in mind to run for governor is Oliver Russell.'

'The attorney?'

'Yes. He's a natural. I have a hunch if we get behind him, he can't miss.'

'Sounds interesting, Senator.'

The two of them began to discuss it.

Senator Davis spoke to Jan about Oliver Russell. 'The boy has a hot future, honey.'

'He has a hot past, too, Father. He's the biggest wolf in town.'

'Now, darling, you mustn't listen to gossip. I've invited Oliver to dinner here Friday.'

The dinner Friday evening went well. Oliver was charming, and in spite of herself, Jan found herself warming to him. The senator sat at his place watching them, asking

questions that brought out the best in Oliver.

At the end of the evening, Jan invited Oliver to a dinner party the following Saturday. 'I'd be delighted.'

From that night on, they started seeing only each other.

'They'll be getting married soon,' the senator predicted to Peter Tager. 'It's time we got Oliver's campaign rolling.'

Oliver was summoned to a meeting at Senator Davis's office.

'I want to ask you a question,' the senator said. 'How would you like to be the governor of Kentucky?'

Oliver looked at him in surprise. 'I – I haven't thought about it.'

'Well, Peter Tager and I have. There's an election coming up next year. That gives us more than enough time to build you up, let people know who you are. With us behind you, you can't lose.'

And Oliver knew it was true. Senator Davis was a powerful man, in control of a well-oiled political machine, a machine that could create myths or destroy anyone who got in its way.

'You'd have to be totally committed,' the senator warned.

'I would be.'

'I have some even better news for you, son. As far as I'm concerned, this is only the first step. You serve a term or two as governor, and I promise you we'll move you into the White House.'

Oliver swallowed. 'Are – are you serious?'

'I don't joke about things like this. I don't have to tell you that this is the age of television. You have something that money can't buy – charisma. People are drawn to you. You genuinely like people, and it shows. It's the same quality Jack Kennedy had.'

'I – I don't know what to say, Todd.'

'You don't have to say anything. I have to return to Washington tomorrow, but when I get back, we'll go to work.'

A few weeks later, the campaign for the office of governor began. Billboards with Oliver's picture flooded the state. He appeared on television and at rallies and political seminars. Peter Tager had his own private polls that showed Oliver's popularity increasing each week.

'He's up another five points,' he told the senator. 'He's only ten points behind the governor, and we've still got plenty of time left. In another few weeks, they should be neck and neck.'

Senator Davis nodded. 'Oliver's going to win. No question about it.'

* * *

Todd Davis and Jan were having breakfast. 'Has our boy proposed to you yet?'

Jan smiled. 'He hasn't come right out and asked me, but he's been hinting around.'

'Well, don't let him hint too long. I want you to be married before he becomes governor. It will play better if the governor has a wife.'

Jan put her arms around her father. 'I'm so glad you brought him into my life. I'm mad about him.'

The senator beamed. 'As long as he makes you happy, I'm happy.'

Everything was going perfectly.

The following evening, when Senator Davis came home, Jan was in her room, packing, her face stained with tears.

He looked at her, concerned. 'What's going on, baby?'

'I'm getting out of here. I never want to see Oliver again as long as I live!'

'Whoa! Hold on there. What are you talking about?'

She turned to him. 'I'm talking about Oliver.' Her tone was bitter. 'He spent last night in a motel with my best friend. She couldn't wait to call and tell me what a wonderful lover he was.'

The senator stood there in shock. 'Couldn't she have been just –?'

'No. I called Oliver. He – he couldn't deny it. I've decided to leave. I'm going to Paris.'

'Are you sure you're doing –?'

'I'm positive.'

And the next morning Jan was gone.

The senator sent for Oliver. 'I'm disappointed in you, son.'

Oliver took a deep breath. 'I'm sorry about what happened, Todd. It was – it was just one of those things. I had a few drinks and this woman came on to me and – well, it was hard to say no.'

'I can understand that,' the senator said sympathetically. 'After all, you're a man, right?'

Oliver smiled in relief. 'Right. It won't happen again, I can assure –'

'It's too bad, though. You would have made a fine governor.'

The blood drained from Oliver's face. 'What – what are you saying, Todd?'

'Well, Oliver, it wouldn't look right if I supported you now, would it? I mean, when you think about Jan's feelings –'

'What does the governorship have to do with Jan?'

'I've been telling everybody that there was a good chance that the next governor was going to be my son-in-law. But since you're not going to be my son-in-law, well, I'll just have to make new plans, won't I?'

'Be reasonable, Todd. You can't –'

Senator Davis's smile faded. 'Never tell me what I can

or can't do, Oliver. I can make you and I can break you!'
He smiled again. 'But don't misunderstand me. No hard
feelings. I wish you only the best.'

Oliver sat there, silent for a moment. 'I see.' He rose
to his feet. 'I – I'm sorry about all this.'

'I am, too, Oliver. I really am.'

When Oliver left, the senator called in Peter Tager. 'We're
dropping the campaign.'

'Dropping it? Why? It's in the bag. The latest polls –'

'Just do as I tell you. Cancel all of Oliver's appearances.
As far as we're concerned, he's out of the race.'

Two weeks later, the polls began to show a drop in Oliver
Russell's ratings. The billboards started to disappear, and
the radio and television ads had been canceled.

'Governor Addison is beginning to pick up ratings in
the polls. If we're going to find a new candidate, we'd
better hurry,' Peter Tager said.

The senator was thoughtful. 'We have plenty of time.
Let's play this out.'

It was a few days later that Oliver Russell went to the
Bailey & Tomkins agency to ask them to handle his
campaign. Jim Bailey introduced him to Leslie, and
Oliver was immediately taken with her. She was not

only beautiful, she was intelligent and sympathetic and believed in him. He had sometimes felt a certain aloofness in Jan, but he had overlooked it. With Leslie, it was completely different. She was warm and sensitive, and it had been natural to fall in love with her. From time to time, Oliver thought about what he had lost. '. . . *this is only the first step. You serve a term or two as governor, and I promise you we'll move you into the White House.*'

The hell with it. I can be happy without any of that, Oliver persuaded himself. But occasionally, he could not help thinking about the good things he might have accomplished.

With Oliver's wedding imminent, Senator Davis had sent for Tager.

'Peter, we have a problem. We can't let Oliver Russell throw away his career by marrying a nobody.'

Peter Tager frowned. 'I don't know what you can do about it now, Senator. The wedding is all set.'

Senator Davis was thoughtful for a moment. 'The race hasn't been run yet, has it?'

He telephoned his daughter in Paris. 'Jan, I have some terrible news for you. Oliver is getting married.'

There was a long silence. 'I – I heard.'

'The sad part is that he doesn't love this woman. He told me he's marrying her on the rebound because you left him. He's still in love with you.'

'Did Oliver say that?'

'Absolutely. It's a terrible thing he's doing to himself. And, in a way, you're forcing him to do it, baby. When you ran out on him, he just fell apart.'

'Father, I – I had no idea.'

'I've never seen a more unhappy man.'

'I don't know what to say.'

'Do you still love him?'

'I'll always love him. I made a terrible mistake.'

'Well, then, maybe it's not too late.'

'But he's getting married.'

'Honey, why don't we just wait and see what happens? Maybe he'll come to his senses.'

When Senator Davis hung up, Peter Tager said, 'What are you up to, Senator?'

'Me?' Senator Davis said innocently. 'Nothing. Just putting a few pieces back together, where they belong. I think I'll have a little talk with Oliver.'

That afternoon, Oliver Russell was in Senator Davis's office.

'It's good to see you, Oliver. Thank you for dropping by. You're looking very well.'

'Thank you, Todd. So are you.'

'Well, I'm getting on, but I do the best I can.'

'You asked to see me, Todd?'

'Yes, Oliver. Sit down.'

Oliver took a chair.

'I want you to help me out with a legal problem I'm

having in Paris. One of my companies over there is in trouble. There's a stockholders' meeting coming up. I'd like you to be there for it.'

'I'll be glad to. When is the meeting? I'll check my calendar and –'

'I'm afraid you'd have to leave this afternoon.'

Oliver stared at him. 'This afternoon?'

'I hate to give you such short notice, but I just heard about it. My plane's waiting at the airport. Can you manage it? It's important to me.'

Oliver was thoughtful. 'I'll try to work it out, somehow.'

'I appreciate that, Oliver. I knew I could count on you.' He leaned forward. 'I'm real unhappy about what's been happening to you. Have you seen the latest polls?' He sighed. 'I'm afraid you're way down.'

'I know.'

'I wouldn't mind so much, but . . .' He stopped.

'But –?'

'You'd have made a fine governor. In fact, your future couldn't have been brighter. You would have had money . . . power. Let me tell you something about money and power, Oliver. Money doesn't care who owns it. A bum can win it in a lottery, or a dunce can inherit it, or someone can get it by holding up a bank. But power – that's something different. To have power is to own the world. If you were governor of this state, you could affect the lives of everybody living here. You could get bills passed that would help the people, and you'd have

41

the power to veto bills that could harm them. I once promised you that someday you could be President of the United States. Well, I meant it, and you could have been. And think about that power, Oliver, to be the most important man in the world, running the most powerful country in the world. That's something worth dreaming about, isn't it? Just think about it.' He repeated slowly, 'The most powerful man in the world.'

Oliver was listening, wondering where the conversation was leading.

As though in answer to Oliver's unspoken question, the senator said, 'And you let all that get away, for a piece of pussy. I thought you were smarter than that, son.'

Oliver waited.

Senator Davis said casually, 'I talked to Jan this morning. She's in Paris, at the Ritz. When I told her you were getting married – well, she just broke down and sobbed.'

'I – I'm sorry, Todd. I really am.'

The senator sighed. 'It's just a shame that you two couldn't get together again.'

'Todd, I'm getting married next week.'

'I know. And I wouldn't interfere with that for anything in the world. I suppose I'm just an old sentimentalist, but to me marriage is the most sacred thing on earth. You have my blessing, Oliver.'

'I appreciate that.'

'I know you do.' The senator looked at his watch. 'Well, you'll want to go home and pack. The background

and details of the meeting will be faxed to you in Paris.'

Oliver rose. 'Right. And don't worry. I'll take care of things over there.'

'I'm sure you will. By the way, I've booked you in at the Ritz.'

On Senator Davis's luxurious Challenger, flying to Paris, Oliver thought about his conversation with the senator. *'You'd have made a fine governor. In fact, your future couldn't have been brighter . . . Let me tell you something about money and power, Oliver . . . To have power is to own the world. If you were governor of this state, you could affect the lives of everybody living here. You could get bills passed that would help the people, and you could veto bills that might harm them.'*

But I don't need that power, Oliver reassured himself. *No. I'm getting married to a wonderful woman. We'll make each other happy. Very happy.*

When Oliver arrived at the TransAir ExecuJet base at Le Bourget Airport in Paris, there was a limousine waiting for him.

'Where to, Mr Russell?' the chauffeur asked.

'By the way, I've booked you in at the Ritz.' Jan was at the Ritz.

It would be smarter, Oliver thought, *if I stayed at a different hotel – the Plaza-Athénée or the Meurice.*

43

The chauffeur was looking at him expectantly.

'The Ritz,' Oliver said. The least he could do was to apologize to Jan.

He telephoned her from the lobby. 'It's Oliver. I'm in Paris.'

'I know,' Jan said. 'Father called me.'

'I'm downstairs. I'd like to say hello if you –'

'Come up.'

When Oliver walked into Jan's suite, he was still not sure what he was going to say.

Jan was waiting for him at the door. She stood there a moment, smiling, then threw her arms around him and held him close. 'Father told me you were coming here. I'm so glad!'

Oliver stood there, at a loss. He was going to have to tell her about Leslie, but he had to find the right words. *I'm sorry about what happened with us . . . I never meant to hurt you . . . I've fallen in love with someone else . . . but I'll always . . .*

'I – I have to tell you something,' he said awkwardly. 'The fact is . . .' And as he looked at Jan, he thought of her father's words. *'I once promised you that some day you could be President of the United States. Well, I meant it . . . And think about that power, Oliver, to be the most important man in the world, running the most powerful country in the world. That's something worth dreaming about, isn't it?'*

'Yes, darling?'

And the words poured out as though they had a life of their own. 'I made a terrible mistake, Jan. I was a bloody fool. I love you. I want to marry you.'

'Oliver!'

'Will you marry me?'

There was no hesitation. 'Yes. Oh, yes, my love!'

He picked her up and carried her into the bedroom, and moments later they were in bed, naked, and Jan was saying, 'You don't know how much I've missed you, darling.'

'I must have been out of my mind . . .'

Jan pressed close to his naked body and moaned. 'Oh! This feels so wonderful.'

'It's because we belong together.' Oliver sat up. 'Let's tell your father the news.'

She looked at him, surprised. 'Now?'

'Yes.'

And I'm going to have to tell Leslie.

Fifteen minutes later Jan was speaking to her father. 'Oliver and I are going to be married.'

'That's wonderful news, Jan. I couldn't be more surprised or delighted. By the way, the mayor of Paris is an old friend of mine. He's expecting your call. He'll marry you there. I'll make sure everything's arranged.'

'But –'

'Put Oliver on.'

45

'Just a minute, Father.' Jan held out the phone to Oliver. 'He wants to talk to you.'

Oliver picked up the phone. 'Todd?'

'Well, my boy, you've made me very happy. You've done the right thing.'

'Thank you. I feel the same way.'

'I'm arranging for you and Jan to be married in Paris. And when you come home, you'll have a big church wedding here. At the Calvary Chapel.'

Oliver frowned. 'The Calvary Chapel? I – I don't think that's a good idea, Todd. That's where Leslie and I . . . Why don't we –?'

Senator Davis's voice was cold. 'You embarrassed my daughter, Oliver, and I'm sure you want to make up for that. Am I right?'

There was a long pause. 'Yes, Todd. Of course.'

'Thank you, Oliver. I look forward to seeing you in a few days. We have a lot to talk about . . . governor . . .'

The Paris wedding was a brief civil ceremony in the mayor's office. When it was over, Jan looked at Oliver and said, 'Father wants to give us a church wedding at the Calvary Chapel.'

Oliver hesitated, thinking about Leslie and what it would do to her. But he had come too far to back down now. 'Whatever he wants.'

Oliver could not get Leslie out of his mind. She had done nothing to deserve what he had done to her. *I'll call her*

and explain. But each time he picked up the telephone, he thought: *How can I explain? What can I tell her?* And he had no answer. He had finally gotten up the nerve to call her, but the press had gotten to her first, and he had felt worse afterward.

The day after Oliver and Jan returned to Lexington, Oliver's election campaign went back into high gear. Peter Tager had set all the wheels in motion, and Oliver became ubiquitous again on television and radio and in the newspapers. He spoke to a large crowd at the Kentucky Kingdom Thrill Park and headed a rally at the Toyota Motor Plant in Georgetown. He spoke at the twenty-thousand-square-foot mall in Lancaster. And that was only the beginning.

Peter Tager arranged for a campaign bus to take Oliver around the state. The bus toured from Georgetown down to Stanford and stopped at Frankfort . . . Versailles . . . Winchester . . . Louisville. Oliver spoke at the Kentucky Fairground and at the Exposition Center. In Oliver's honor, they served burgoo, the traditional Kentucky stew made of chicken, veal, beef, lamb, pork, and a variety of fresh vegetables cooked in a big kettle over an open fire.

Oliver's ratings kept going up. The only interruption in the campaign had been Oliver's wedding. He had seen

Leslie at the back of the church, and he had had an uneasy feeling. He talked about it with Peter Tager.

'You don't think Leslie would try to do anything to hurt me, do you?'

'Of course not. And even if she wanted to, what could she do? Forget her.'

Oliver knew that Tager was right. Things were moving along beautifully. There was no reason to worry. Nothing could stop him now. Nothing.

On election night, Leslie Stewart sat alone in her apartment in front of her television set, watching the returns. Precinct by precinct, Oliver's lead kept mounting. Finally, at five minutes before midnight, Governor Addison appeared on television to make his concession speech. Leslie turned off the set. She stood up and took a deep breath.

> *Weep no more, my lady,*
> *Oh, weep no more today!*
> *We will sing one song for the old Kentucky home,*
> *For the old Kentucky home far away.*

It was time.

Three

Senator Todd Davis was having a busy morning. He had flown into Louisville from the capital for the day, to attend a sale of Thoroughbreds.

'You have to keep up the bloodlines,' he told Peter Tager, as they sat watching the splendid-looking horses being led in and out of the large arena. 'That's what counts, Peter.'

A beautiful mare was being led into the center of the ring. 'That's Sail Away,' Senator Davis said. 'I want her.'

The bidding was spirited, but ten minutes later, when it was over, Sail Away belonged to Senator Davis.

The cellular phone rang. Peter Tager answered it. 'Yes?' He listened a moment, then turned to the senator. 'Do you want to talk to Leslie Stewart?'

Senator Davis frowned. He hesitated a moment, then took the phone from Tager.

'Miss Stewart?'

'I'm sorry to bother you, Senator Davis, but I wonder if I could see you? I need a favor.'

'Well, I'm flying back to Washington tonight, so –'

'I could come and meet you. It's really important.'

Senator Davis hesitated a moment. 'Well, if it's that important, I can certainly accommodate you, young lady. I'll be leaving for my farm in a few minutes. Do you want to meet me there?'

'That will be fine.'

'I'll see you in an hour.'

'Thank you.'

Davis pressed the END button and turned to Tager. 'I was wrong about her. I thought she was smarter than that. She should have asked me for money *before* Jan and Oliver got married.' He was thoughtful for a moment, then his face broke into a slow grin. 'I'll be a son of a bitch.'

'What is it, Senator?'

'I just figured out what this urgency is all about. Miss Stewart has discovered that she's pregnant with Oliver's baby and she's going to need a little financial help. It's the oldest con game in the world.'

One hour later, Leslie was driving onto the grounds of Dutch Hill, the senator's farm. A guard was waiting outside the main house. 'Miss Stewart?'

'Yes.'

'Senator Davis is expecting you. This way, please.'

He showed Leslie inside, along a wide corridor that led to a large paneled library crammed with books. Senator

Davis was at his desk, thumbing through a volume. He looked up and rose as Leslie entered.

'It's good to see you, my dear. Sit down, please.'

Leslie took a seat.

The senator held up his book. 'This is fascinating. It lists the name of every Kentucky Derby winner from the first derby to the latest. Do you know who the first Kentucky Derby winner was?'

'No.'

'Aristides, in 1875. But I'm sure you didn't come here to discuss horses.' He put the book down. 'You said you wanted a favor.'

He wondered how she was going to phrase it. *I just found out I'm going to have Oliver's baby, and I don't know what to do . . . I don't want to cause a scandal, but . . . I'm willing to raise the baby, but I don't have enough money . . .*

'Do you know Henry Chambers?' Leslie asked.

Senator Davis blinked, caught completely off guard. 'Do I – Henry? Yes, I do. Why?'

'I would appreciate it very much if you would give me an introduction to him.'

Senator Davis looked at her, hastily reorganizing his thoughts. 'Is that the favor? You want to meet Henry Chambers?'

'Yes.'

'I'm afraid he's not here anymore, Miss Stewart. He's living in Phoenix, Arizona.'

'I know. I'm leaving for Phoenix in the morning. I thought it would be nice if I knew someone there.'

Senator Davis studied her a moment. His instinct told him that there was something going on that he did not understand.

He phrased his next question cautiously. 'Do you know anything about Henry Chambers?'

'No. Only that he comes from Kentucky.'

He sat there, making up his mind. *She's a beautiful lady*, he thought. *Henry will owe me a favor*. 'I'll make a call.'

Five minutes later, he was speaking to Henry Chambers.

'Henry, it's Todd. You'll be sorry to know that I bought Sail Away this morning. I know you had your eye on her.' He listened a moment, then laughed. 'I'll bet you did. I hear you just got another divorce. Too bad. I liked Jessica.'

Leslie listened as the conversation went on for a few more minutes. Then Senator Davis said, 'Henry, I'm going to do you a good turn. A friend of mine is arriving in Phoenix tomorrow, and she doesn't know a soul there. I would appreciate it if you would keep an eye on her . . . What does she look like?' He looked over at Leslie and smiled. 'She's not too bad-looking. Just don't get any ideas.'

He listened a moment, then turned back to Leslie. 'What time does your plane get in?'

'At two-fifty. Delta flight 159.'

The senator repeated the information into the phone. 'Her name is Leslie Stewart. You'll thank me for this. You take care now, Henry. I'll be in touch.' He replaced the receiver.

'Thank you,' Leslie said.

'Is there anything else I can do for you?'

'No. That's all I need.'

Why? What the hell does Leslie Stewart want with Henry Chambers?

The public fiasco with Oliver Russell had been a hundred times worse than anything Leslie could have imagined. It was a never-ending nightmare. Everywhere Leslie went there were the whispers:

'She's the one. He practically jilted her at the altar . . .'

'I'm saving my wedding invitation as a souvenir . . .'

'I wonder what she's going to do with her wedding gown? . . .'

The public gossip fueled Leslie's pain, and the humiliation was unbearable. She would never trust a man again. Never. Her only consolation was that somehow, someday, she was going to make Oliver Russell pay for the unforgivable thing he had done to her. She had no idea how. With Senator Davis behind him, Oliver would have money and power. *Then I have to find a way to have more money and more power*, Leslie thought. *But how? How?*

The inauguration took place in the garden of the state capitol in Frankfort, near the exquisite thirty-four-foot floral clock.

Jan stood at Oliver's side, proudly watching her handsome husband being sworn in as governor of Kentucky.

If Oliver behaved himself, the next stop was the White House, her father had assured her. And Jan intended to do everything in her power to see that nothing went wrong. Nothing.

After the ceremony, Oliver and his father-in-law were seated in the palatial library of the Executive Mansion, a beautiful building modeled after the Petit Trianon, Marie Antoinette's villa near the palace of Versailles.

Senator Todd Davis looked around the luxurious room and nodded in satisfaction. 'You're going to do fine here, son. Just fine.'

'I owe it all to you,' Oliver said warmly. 'I won't forget that.'

Senator Davis waved a hand in dismissal. 'Don't give it a thought, Oliver. You're here because you deserve to be. Oh, maybe I helped push things along a wee bit. But this is just the beginning. I've been in politics a long time, son, and there are a few things I've learned.'

He looked over at Oliver, waiting, and Oliver said dutifully, 'I'd love to hear them, Todd.'

'You see, people have got it wrong. It's not who you know,' Senator Davis explained, 'it's what you know about who you know. Everybody's got a little skeleton buried somewhere. All you have to do is dig it up, and you'll be surprised how glad they'll be to help you with

whatever you need. I happen to know that there's a congressman in Washington who once spent a year in a mental institution. A representative from up North served time in a reform school for stealing. Well, you can see what it would do to their careers if word ever got out. But it's grist for our mills.'

The senator opened an expensive leather briefcase and took out a sheaf of papers and handed them to Oliver. 'These are the people you'll be dealing with here in Kentucky. They're powerful men and women, but they all have Achilles' heels.' He grinned. 'The mayor has an Achilles' high heel. He's a transvestite.'

Oliver was scanning the papers, wide-eyed.

'You keep those locked up, you hear? That's pure gold.'

'Don't worry, Todd. I'll be careful.'

'And, son – don't put too much pressure on those people when you need something from them. Don't break them – just bend them a little.' He studied Oliver a moment. 'How are you and Jan getting along?'

'Great,' Oliver said quickly. It was true, in a sense. As far as Oliver was concerned, it was a marriage of convenience, and he was careful to see that he did nothing to disrupt it. He would never forget what his earlier indiscretion had almost cost him.

'That's fine. Jan's happiness is very important to me.' It was a warning.

'For me, as well,' Oliver said.

'By the way, how do you like Peter Tager?'

55

Oliver said enthusiastically, 'I like him a lot. He's been a tremendous help to me.'

Senator Davis nodded. 'I'm glad to hear that. You won't find anyone better. I'm going to lend him to you, Oliver. He can smooth a lot of paths for you.'

Oliver grinned. 'Great. I really appreciate that.'

Senator Davis rose. 'Well, I have to get back to Washington. You let me know if you need anything.'

'Thanks, Todd. I will.'

On the Sunday after his meeting with Senator Davis, Oliver tried to find Peter Tager.

'He's in church, Governor.'

'Right. I forgot. I'll see him tomorrow.'

Peter Tager went to church every Sunday with his family, and attended a two-hour prayer meeting three times a week. In a way, Oliver envied him. *He's probably the only truly happy man I've ever known*, he thought.

On Monday morning, Tager came into Oliver's office. 'You wanted to see me, Oliver?'

'I need a favor. It's personal.'

Peter nodded. 'Anything I can do.'

'I need an apartment.'

Tager glanced around the large room in mock disbelief. 'This place is too small for you, Governor?'

'No.' Oliver looked into Tager's one good eye. 'Sometimes I have private meetings at night. They have to be discreet. You know what I mean?'

There was an uncomfortable pause. 'Yes.'

'I want someplace away from the center of town. Can you handle that for me?'

'I guess so.'

'This is just between us, of course.'

Peter Tager nodded, unhappily.

One hour later, Tager telephoned Senator Davis in Washington.

'Oliver asked me to rent an apartment for him, Senator. Something discreet.'

'Did he now? Well, he's learning, Peter. He's learning. Do it. Just make damned sure Jan never hears about it.' The senator was thoughtful for a moment. 'Find him a place out in Indian Hills. Someplace with a private entrance.'

'But it's not right for him to –'

'Peter – just do it.'

Four

The solution to Leslie's problem had come in two disparate items in the *Lexington Herald-Leader*. The first was a long, flattering editorial praising Governor Oliver Russell. The last line read, 'None of us here in Kentucky who knows him will be surprised when one day Oliver Russell becomes President of the United States.'

The item on the next page read: 'Henry Chambers, a former Lexington resident, whose horse Lightning won the Kentucky Derby five years ago, and Jessica, his third wife, have divorced. Chambers, who now lives in Phoenix, is the owner and publisher of the *Phoenix Star*.'

The power of the press. That was real power. Katharine Graham and her *Washington Post* had destroyed a president.

And that was when the idea jelled.

Leslie had spent the next two days doing research on Henry Chambers. The Internet had some interesting

information on him. Chambers was a fifty-five-year-old philanthropist who had inherited a tobacco fortune and had devoted most of his life to giving it away. But it was not his money that interested Leslie.

It was the fact that he owned a newspaper and that he had just gotten a divorce.

Half an hour after her meeting with Senator Davis, Leslie walked into Jim Bailey's office. 'I'm leaving, Jim.'

He looked at her sympathetically. 'Of course. You need a vacation. When you come back, we can –'

'I'm not coming back.'

'What? I – I don't want you to go, Leslie. Running away won't solve –'

'I'm not running away.'

'You've made up your mind?'

'Yes.'

'We're going to hate to lose you. When do you want to leave?'

'I've already left.'

Leslie Stewart had given a lot of thought to the various ways in which she could meet Henry Chambers. There were endless possibilities, but she discarded them one by one. What she had in mind had to be planned very carefully. And then she had thought of Senator Davis. Davis and Chambers had the same background, traveled

in the same circles. The two men would certainly know each other. That was when Leslie had decided to call the senator.

When Leslie arrived at Sky Harbor Airport in Phoenix, on an impulse, she walked over to the newsstand in the terminal. She bought a copy of the *Phoenix Star* and scanned it. No luck. She bought the *Arizona Republic*, and then the *Phoenix Gazette*, and there it was, the astrological column by Zoltaire. *Not that I believe in astrology. I'm much too intelligent for that nonsense. But . . .*

> FOR LEO (JULY 23rd TO AUGUST 22nd).
> JUPITER IS JOINING YOUR SUN. ROMANTIC PLANS MADE NOW WILL BE FULFILLED.
> EXCELLENT PROSPECTS FOR THE FUTURE.
> PROCEED CAUTIOUSLY.

There was a chauffeur and limousine waiting for her at the curb. 'Miss Stewart?'

'Yes.'

'Mr Chambers sends his regards and asked me to take you to your hotel.'

'That's very kind of him.' Leslie was disappointed. She had hoped that he would come to meet her himself.

'Mr Chambers would like to know whether you are free to join him for dinner this evening.'

60

Better. Much better.

'Please tell him I would be delighted.'

At eight o'clock that evening, Leslie was dining with Henry Chambers. Chambers was a pleasant-looking man, with an aristocratic face, graying brown hair, and an endearing enthusiasm.

He was studying Leslie admiringly. 'Todd really meant it when he said he was doing me a favor.'

Leslie smiled. 'Thank you.'

'What made you decide to come to Phoenix, Leslie?'

You don't really want to know. 'I've heard so much about it, I thought I might enjoy living here.'

'It's a great place. You'll love it. Arizona has everything – the Grand Canyon, desert, mountains. You can find anything you want here.'

And I have, Leslie thought.

'You'll need a place to live. I'm sure I can help you locate something.'

Leslie knew the money she had would last for no more than three months. As it turned out, her plan took no more than two months.

Bookstores were filled with how-to books for women on how to get a man. The various pop psychologies ranged from 'Play hard to get' to 'Get them hooked in bed.' Leslie followed none of that advice. She had her own

method: She teased Henry Chambers. Not physically, but mentally. Henry had never met anyone like her. He was of the old school that believed if a blonde was beautiful, she must be dumb. It never occurred to him that he had always been attracted to women who were beautiful and not overly bright. Leslie was a revelation to him. She was intelligent and articulate and knowledgeable about an amazing range of subjects.

They talked about philosophy and religion and history, and Henry confided to a friend, 'I think she's reading up on a lot of things so she can keep up with me.'

Henry Chambers enjoyed Leslie's company tremendously. He showed her off to his friends and wore her on his arm like a trophy. He took her to the Carefree Wine and Fine Art Festival and to the Actors Theater. They watched the Phoenix Suns play at the America West Arena. They visited the Lyon Gallery in Scottsdale, the Symphony Hall, and the little town of Chandler to see the Doo-dah Parade. One evening, they went to see the Phoenix Roadrunners play hockey.

After the hockey game, Henry said, 'I really like you a lot, Leslie. I think we'd be great together. I'd like to make love with you.'

She took his hand in hers and said softly, 'I like you, too, Henry, but the answer is no.'

* * *

The following day they had a luncheon date. Henry telephoned Leslie. 'Why don't you pick me up at the *Star*? I want you to see the place.'

'I'd love to,' Leslie said. That was what she had been waiting for. There were two other newspapers in Phoenix, the *Arizona Republic* and the *Phoenix Gazette*. Henry's paper, the *Star*, was the only one losing money.

The offices and production plant of the *Phoenix Star* were smaller than Leslie had anticipated. Henry took her on a tour, and as Leslie looked around, she thought, *This isn't going to bring down a governor or a president.* But it was a stepping-stone. She had plans for it.

Leslie was interested in everything she saw. She kept asking Henry questions, and he kept referring them to Lyle Bannister, the managing editor. Leslie was amazed at how little Henry seemed to know about the newspaper business and how little he cared. It made her all the more determined to learn everything she could.

It happened at the Borgata, a restaurant in a castlelike old Italian village setting. The dinner was superb. They had enjoyed a lobster bisque, medallions of veal with a sauce béarnaise, white asparagus vinaigrette, and a Grand Marnier soufflé. Henry Chambers was charming and easy to be with, and it had been a beautiful evening.

'I love Phoenix,' Henry was saying. 'It's hard to believe

that only fifty years ago the population here was just sixty-five thousand. Now it's over a million.'

Leslie was curious about something. 'What made you decide to leave Kentucky and move here, Henry?'

He shrugged. 'It wasn't my decision, really. It was my damned lungs. The doctors didn't know how long I had to live. They told me Arizona would be the best climate for me. So I decided to spend the rest of my life – whatever that means – living it up.' He smiled at her. 'And here we are.' He took her hand in his. 'When they told me how good it would be for me, they had no idea. You don't think I'm too old for you, do you?' he asked anxiously.

Leslie smiled. 'Too young. Much too young.'

Henry looked at her for a long moment. 'I'm serious. Will you marry me?'

Leslie closed her eyes for a moment. She could see the hand-painted wooden sign on the Breaks Interstate Park trail: LESLIE, WILL YOU MARRY ME? . . . *'I'm afraid I can't promise you that you're going to marry a governor, but I'm a pretty good attorney.'*

Leslie opened her eyes and looked up at Henry. 'Yes, I want to marry you.' *More than anything in the world.*

They were married two weeks later.

When the wedding announcement appeared in the *Lexington Herald-Leader*, Senator Todd Davis studied it for a long time. *'I'm sorry to bother you, Senator,*

but I wonder if I could see you? I need a favor ... Do you know Henry Chambers? ... I'd appreciate it if you'd introduce me to him.'

If that's all she was up to, there would be no problem. If that's all she was up to.

Leslie and Henry honeymooned in Paris, and wherever they went, Leslie wondered whether Oliver and Jan had visited those same places, walked those streets, dined there, shopped there. She pictured the two of them together, making love, Oliver whispering the same lies into Jan's ears that he had whispered into hers. Lies that he was going to pay dearly for.

Henry sincerely loved her and went out of his way to make her happy. Under other circumstances, Leslie might have fallen in love with him, but something deep within her had died. *I can never trust any man again.*

A few days after they returned to Phoenix, Leslie surprised Henry by saying, 'Henry, I'd like to work at the paper.'

He laughed. 'Why?'

'I think it would be interesting. I was an executive at an advertising agency. I could probably help with that part.'

He protested, but in the end, he gave in.

* * *

Henry noticed that Leslie read the *Lexington Herald-Leader* every day.

'Keeping up with the hometown folks?' he teased her.

'In a way,' Leslie smiled. She avidly read every word that was written about Oliver. She wanted him to be happy and successful. *The bigger they are . . .*

When Leslie pointed out to Henry that the *Star* was losing money, he laughed. 'Honey, it's a drop in the bucket. I've got money coming in from places you never even heard of. It doesn't matter.'

But it mattered to Leslie. It mattered a great deal. As she began to get more and more involved in the running of the newspaper, it seemed to her that the biggest reason it was losing money was the unions. The *Phoenix Star*'s presses were outdated, but the unions refused to let the newspaper put in new equipment, because they said it would cost union members their jobs. They were currently negotiating a new contract with the *Star*.

When Leslie discussed the situation with Henry, he said, 'Why do you want to bother with stuff like that? Let's just have fun.'

'I'm having fun,' Leslie assured him.

Leslie had a meeting with Craig McAllister, the *Star*'s attorney.

'How are the negotiations going?'

'I wish I had better news, Mrs Chambers, but I'm afraid the situation doesn't look good.'

'We're still in negotiation, aren't we?'

'Ostensibly. But Joe Riley, the head of the printers' union, is a stubborn son of a – a stubborn man. He won't give an inch. The pressmen's contract is up in ten days, and Riley says if the union doesn't have a new contract by then, they're going to walk.'

'Do you believe him?'

'Yes. I don't like to give in to the unions, but the reality is that without them, we have no newspaper. They can shut us down. More than one publication has collapsed because it tried to buck the unions.'

'What are they asking?'

'The usual. Shorter hours, raises, protection against future automation . . .'

'They're squeezing us, Craig. I don't like it.'

'This is not an emotional issue, Mrs Chambers. This is a practical issue.'

'So your advice is to give in?'

'I don't think we have a choice.'

'Why don't I have a talk with Joe Riley?'

The meeting was set for two o'clock, and Leslie was late coming back from lunch. When she walked into the reception office, Riley was waiting, chatting with Leslie's secretary, Amy, a pretty, dark-haired young woman.

Joe Riley was a rugged-looking Irishman in his middle forties. He had been a pressman for more than fifteen years. Three years earlier he had been appointed head of his union and had earned the reputation of being the toughest negotiator in the business. Leslie stood there for a moment, watching him flirting with Amy.

Riley was saying, '. . . and then the man turned to her and said, "That's easy for you to say, but how will I get back?"'

Amy laughed. 'Where do you hear those, Joe?'

'I get around, darlin'. How about dinner tonight?'

'I'd love it.'

Riley looked up and saw Leslie. 'Afternoon, Mrs Chambers.'

'Good afternoon, Mr Riley. Come in, won't you?'

Riley and Leslie were seated in the newspaper's conference room. 'Would you like some coffee?' Leslie offered.

'No, thanks.'

'Anything stronger?'

He grinned. 'You know it's against the rules to drink during company hours, Mrs Chambers.'

Leslie took a deep breath. 'I wanted the two of us to have a talk because I've heard that you're a very fair man.'

'I try to be,' Riley said.

'I want you to know that I'm sympathetic to the union. I think your men are entitled to something, but what

68

you're asking for is unreasonable. Some of their habits are costing us millions of dollars a year.'

'Could you be more specific?'

'I'll be glad to. They're working fewer hours of straight time and finding ways to get on the shifts that pay overtime. Some of them put in three shifts back to back, working the whole weekend. I believe they call it "going to the whips." We can't afford that anymore. We're losing money because our equipment is outdated. If we could put in new cold-type production –'

'Absolutely not! The new equipment you want to put in would put my men out of work, and I have no intention of letting machinery throw my men out into the street. Your goddam machines don't have to eat, my men do.' Riley rose to his feet. 'Our contract is up next week. We either get what we want, or we walk.'

When Leslie mentioned the meeting to Henry that evening, he said, 'Why do you want to get involved in all that? The unions are something we all have to live with. Let me give you a piece of advice, sweetheart. You're new to all this, and you're a woman. Let the men handle it. Let's not –' He stopped, out of breath.

'Are you all right?'

He nodded. 'I saw my stupid doctor today, and he thinks I should get an oxygen tank.'

'I'll arrange it,' Leslie said. 'And I'm going to get you a nurse so that when I'm not here –'

'No! I don't need a nurse. I'm – I'm just a little tired.'

'Come on, Henry. Let's get you into bed.'

Three days later, when Leslie called an emergency board meeting, Henry said, 'You go, baby. I'll just stay here and take it easy.' The oxygen tank had helped, but he was feeling weak and depressed.

Leslie telephoned Henry's doctor. 'He's losing too much weight and he's in pain. There must be something you can do.'

'Mrs Chambers, we're doing everything we can. Just see that he gets plenty of rest and stays on the medication.'

Leslie sat there, watching Henry lying in bed, coughing.

'Sorry about the meeting,' Henry said. 'You handle the board. There's nothing anyone can do, anyway.'

She only smiled.

Five

The members of the board were gathered around the table in the conference room, sipping coffee and helping themselves to bagels and cream cheese, waiting for Leslie.

When she arrived, she said, 'Sorry to keep you waiting, ladies and gentlemen. Henry sends his regards.'

Things had changed since the first board meeting Leslie had attended. The board had snubbed her then, and treated her as an interloper. But gradually, as Leslie had learned enough about the business to make valuable suggestions, she had won their respect. Now, as the meeting was about to begin, Leslie turned to Amy, who was serving coffee. 'Amy, I would like you to stay for the meeting.'

Amy looked at her in surprise. 'I'm afraid my shorthand isn't very good, Mrs Chambers. Cynthia can do a better job of –'

'I don't want you to take minutes of the meeting. Just make a note of whatever resolutions we pass at the end.'

'Yes, ma'am.' Amy picked up a notebook and pen and

sat in a chair against the wall.

Leslie turned to face the board. 'We have a problem. Our contract with the pressmen's union is almost up. We've been negotiating for three months now, and we haven't been able to reach an agreement. We have to make a decision, and we have to make it fast. You've all seen the reports I sent you. I'd like to have your opinions.'

She looked at Gene Osborne, a partner in a local law firm.

'If you ask me, Leslie, I think they're getting too damn much already. Give them what they want now, and tomorrow they'll want more.'

Leslie nodded and looked at Aaron Drexel, the owner of a local department store. 'Aaron?'

'I have to agree. There's a hell of a lot of featherbedding going on. If we give them something, we should get something in return. In my opinion, we can afford a strike, and they can't.'

The comments from the others were similar.

Leslie said, 'I have to disagree with all of you.' They looked at her in surprise. 'I think we should let them have what they want.'

'That's crazy.'

'They'll wind up owning the newspaper.'

'There won't be any stopping them.'

'You can't give in to them.'

Leslie let them speak. When they had finished, she said, 'Joe Riley is a fair man. He believes in what he's asking for.'

Seated against the wall, Amy was following the discussion, astonished.

One of the women spoke up. 'I'm surprised you're taking his side, Leslie.'

'I'm not taking anyone's side. I just think we have to be reasonable about this. Anyway, it's not my decision. Let's take a vote.' She turned to look at Amy. 'This is what I want you to put in the record.'

'Yes, ma'am.'

Leslie turned back to the group. 'All those opposed to the union demands, raise your hands.' Eleven hands went into the air. 'Let the record show that I voted yes and that the rest of the committee has voted not to accept the union demands.'

Amy was writing in her notebook, a thoughtful expression on her face.

Leslie said, 'Well, that's it then.' She rose. 'If there's no further business . . .'

The others got to their feet.

'Thank you all for coming.' She watched them leave, then turned to Amy. 'Would you type that up, please?'

'Right away, Mrs Chambers.'

Leslie headed for her office.

The telephone call came a short time later.

'Mr Riley is on line one,' Amy said.

Leslie picked up the telephone. 'Hello.'

'Joe Riley. I just wanted to thank you for what you

tried to do.'

Leslie said, 'I don't understand . . .'

'The board meeting. I heard what happened.'

Leslie said, 'I'm surprised, Mr Riley. That was a private meeting.'

Joe Riley chuckled. 'Let's just say I have friends in low places. Anyway, I thought what you tried to do was great. Too bad it didn't work.'

There was a brief silence, then Leslie said slowly, 'Mr Riley . . . what if I could make it work?'

'What do you mean?'

'I have an idea. I'd rather not discuss it on the phone. Could we meet somewhere . . . discreetly?'

There was a pause. 'Sure. Where did you have in mind?'

'Someplace where neither of us will be recognized.'

'What about meeting at the Golden Cup?'

'Right. I'll be there in an hour.'

'I'll see you.'

The Golden Cup was an infamous café in the seedier section of Phoenix, near the railroad tracks, an area police warned tourists to stay away from. Joe Riley was seated at a corner booth when Leslie walked in. He rose as she approached him.

'Thank you for being here,' Leslie said. They sat down.

'I came because you said there might be a way for me to get my contract.'

'There is. I think the board is being stupid and short-sighted. I tried to talk to them, but they wouldn't listen.'

He nodded, 'I know. You advised them to give us the new contract.'

'That's right. They don't realize how important you pressmen are to our newspaper.'

He was studying her, puzzled. 'But if they voted you down, how can we . . . ?'

'The only reason they voted me down is that they're not taking your union seriously. If you want to avoid a long strike, and maybe the death of the paper, you have to show them you mean business.'

'How do you mean?'

Leslie said nervously, 'What I'm telling you is very confidential, but it's the only way that you're going to get what you want. The problem is simple. They think you're bluffing. They don't believe you mean business. You have to show them that you do. Your contract is up this Friday at midnight.'

'Yes . . .'

'They'll expect you just to quietly walk out.' She leaned forward. 'Don't!' He was listening intently. 'Show them that they can't run the *Star* without you. Don't just go out like lambs. Do some damage.'

His eyes widened.

'I don't mean anything serious,' Leslie said quickly. 'Just enough to show them that you mean business. Cut a few cables, put a press or two out of commission. Let them

75

learn that they need you to operate them. Everything can be repaired in a day or two, but meanwhile, you'll have scared them into their senses. They'll finally know what they're dealing with.'

Joe Riley sat there for a long time, studying Leslie. 'You're a remarkable lady.'

'Not really. I thought it over, and I have a very simple choice. You can cause a little damage that can be easily corrected, and force the board to deal with you, or you can walk out quietly and resign yourself to a long strike that the paper may never recover from. All I care about is protecting the paper.'

A slow smile lit Riley's face. 'Let me buy you a cup of coffee, Mrs Chambers.'

'We're striking!'

Friday night, at one minute past midnight, under Joe Riley's direction, the pressmen attacked. They stripped parts from the machines, overturned tables full of equipment, and set two printing presses on fire. A guard who tried to stop them was badly beaten. The pressmen, who had started out merely to disable a few presses, got caught up in the fever of the excitement, and they became more and more destructive.

'Let's show the bastards that they can't shove us around!' one of the men cried.

'There's no paper without us!'

'We're the *Star*!'

Cheers went up. The men attacked harder. The press-room was turning into a shambles.

In the midst of the wild excitement, floodlights suddenly flashed on from the four corners of the room. The men stopped, looking around in bewilderment. Near the doors, television cameras were recording the fiery scene and the destruction. Next to them were reporters from the *Arizona Republic*, the *Phoenix Gazette*, and several news services, covering the havoc. There were at least a dozen policemen and firemen.

Joe Riley was looking around in shock. *How the hell had they all gotten here so fast?* As the police started to close in and the firemen turned on their hoses, the answer suddenly came to Riley, and he felt as though someone had kicked him in the stomach. Leslie Chambers had set him up! When these pictures of the destruction the union had caused got out, there would be no sympathy for them. Public opinion would turn against them. *The bitch had planned this all along . . .*

The television pictures were aired within the hour, and the radio waves were filled with details of the wanton destruction. News services around the world printed the story, and they all carried the theme of the vicious employees who had turned on the hand that fed them. It was a public relations triumph for the *Phoenix Star*.

* * *

Leslie had prepared well. Earlier, she had secretly sent some of the *Star*'s executives to Kansas to learn how to run the giant presses, and to teach nonunion employees cold-type production. Immediately after the sabotage incident, two other striking unions, the mailers and photoengravers, came to terms with the *Star*.

With the unions defeated, and the way open to modernize the paper's technology, profits began to soar. Overnight, productivity jumped 20 percent.

The morning after the strike, Amy was fired.

On a late Friday afternoon, two years from the date of their wedding, Henry had a touch of indigestion. By Saturday morning, it had become chest pains, and Leslie called for an ambulance to rush him to the hospital. On Sunday, Henry Chambers passed away.

He left his entire estate to Leslie.

The Monday after the funeral, Craig McAllister came to see Leslie. 'I wanted to go over some legal matters with you, but if it's too soon –'

'No,' Leslie said. 'I'm all right.'

Henry's death had affected Leslie more than she had expected. He had been a dear, sweet man, and she had used him because she wanted him to help her get revenge against Oliver. And somehow, in Leslie's mind, Henry's death became another reason to destroy Oliver.

'What do you want to do with the *Star*?' McAllister asked. 'I don't imagine you'll want to spend your time running it.'

'That's exactly what I intend to do. We're going to expand.'

Leslie sent for a copy of the *Managing Editor*, the trade magazine that lists newspaper brokers all over the United States. Leslie selected Dirks, Van Essen and Associates in Santa Fe, New Mexico.

'This is Mrs Henry Chambers. I'm interested in acquiring another newspaper, and I wondered what might be available . . .'

It turned out to be the *Sun* in Hammond, Oregon.

'I'd like you to fly up there and take a look at it,' Leslie told McAllister.

Two days later, McAllister telephoned Leslie. 'You can forget about the *Sun*, Mrs Chambers.'

'What's the problem?'

'The problem is that Hammond is a two-newspaper town. The daily circulation of the *Sun* is fifteen thousand. The other newspaper, the *Hammond Chronicle*, has a circulation of twenty-eight thousand, almost double. And the owner of the *Sun* is asking five million dollars. The deal doesn't make any sense.'

Leslie was thoughtful for a moment. 'Wait for me,' she said. 'I'm on my way.'

* * *

Leslie spent the following two days examining the newspaper and studying its books.

'There's no way the *Sun* can compete with the *Chronicle*,' McAllister assured her. 'The *Chronicle* keeps growing. The *Sun*'s circulation has gone down every year for the past five years.'

'I know,' Leslie said. 'I'm going to buy it.'

He looked at her in surprise. 'You're going to what?'

'I'm going to buy it.'

The deal was completed in three days. The owner of the *Sun* was delighted to get rid of it. 'I suckered the lady into making a deal,' he crowed. 'She paid me the full five million.'

Walt Meriwether, the owner of the *Hammond Chronicle*, came to call on Leslie.

'I understand you're my new competitor,' he said genially.

Leslie nodded. 'That's right.'

'If things don't work out here for you, maybe you'd be interested in selling the *Sun* to me.'

Leslie smiled. 'And if things do work out, perhaps you'd be interested in selling the *Chronicle* to me.'

Meriwether laughed. 'Sure. Lots of luck, Mrs Chambers.'

When Meriwether got back to the *Chronicle*, he said confidently, 'In six months, we're going to own the *Sun*.'

* * *

Leslie returned to Phoenix and talked to Lyle Bannister, the *Star*'s managing editor. 'You're going with me to Hammond, Oregon. I want you to run the newspaper there until it gets on its feet.'

'I talked to Mr McAllister,' Bannister said. 'The paper has no feet. He said it's a disaster waiting to happen.'

She studied him a moment. 'Humor me.'

In Oregon, Leslie called a staff meeting of the employees of the *Sun*.

'We're going to operate a little differently from now on,' she informed them. 'This is a two-newspaper town, and we're going to own them both.'

Derek Zornes, the managing editor of the *Sun*, said, 'Excuse me, Mrs Chambers. I'm not sure you understand the situation. Our circulation is way below the *Chronicle*'s, and we're slipping every month. There's no way we can ever catch up to it.'

'We're not only going to catch up to it,' Leslie assured him, 'we're going to put the *Chronicle* out of business.'

The men in the room looked at one another and they all had the same thought: Females and amateurs should stay the hell out of the newspaper business.

'How do you plan to do that?' Zornes asked politely.

'Have you ever watched a bullfight?' Leslie asked.

He blinked. 'A bullfight? No . . .'

'Well, when the bull rushes into the ring, the matador

81

doesn't go for the kill right away. He bleeds the bull until it's weak enough to be killed.'

Zornes was trying not to laugh. 'And we're going to bleed the *Chronicle*?'

'Exactly.'

'How are we going to do that?'

'Starting Monday, we're cutting the price of the *Sun* from thirty-five cents to twenty cents. We're cutting our advertising rates by thirty percent. Next week, we're starting a giveaway contest where our readers can win free trips all over the world. We'll begin publicizing the contest immediately.'

When the employees gathered later to discuss the meeting, the consensus was that their newspaper had been bought by a crazy woman.

The bleeding began, but it was the *Sun* that was being bled.

McAllister asked Leslie, 'Do you have any idea how much money the *Sun* is losing?'

'I know exactly how much it's losing,' Leslie said.

'How long do you plan to go on with this?'

'Until we win,' Leslie said. 'Don't worry. We will.'

But Leslie was worried. The losses were getting heavier every week. Circulation continued to dwindle, and advertisers' reactions to the rate reduction had been lukewarm.

'Your theory's not working,' McAllister said. 'We've

got to cut our losses. I suppose you can keep pumping in money, but what's the point?'

The following week, the circulation stopped dropping.

It took eight weeks for the *Sun* to begin to rise.

The reduction in the price of the newspaper and in the cost of advertising was attractive, but what made the circulation of the *Sun* move up was the giveaway contest. It ran for twelve weeks, and entrants had to compete every week. The prizes were cruises to the South Seas and trips to London and Paris and Rio. As the prizes were handed out and publicized with front-page photographs of the winners, the circulation of the *Sun* began to explode.

'You took a hell of a gamble,' Craig McAllister said grudgingly, 'but it's working.'

'It wasn't a gamble,' Leslie said. 'People can't resist getting something for nothing.'

When Walt Meriwether was handed the latest circulation figures, he was furious. For the first time in years, the *Sun* was ahead of the *Chronicle*.

'All right,' Meriwether said grimly. 'Two can play that stupid game. I want you to cut our advertising rates and start some kind of contest.'

But it was too late. Eleven months after Leslie had bought the *Sun*, Walt Meriwether came to see her.

'I'm selling out,' he said curtly. 'Do you want to buy the *Chronicle*?'

'Yes.'

The day the contract for the *Chronicle* was signed, Leslie called in her staff.

'Starting Monday,' she said, 'we raise the price of the *Sun*, double our advertising rates, and stop the contest.'

One month later, Leslie said to Craig McAllister, 'The *Evening Standard* in Detroit is up for sale. It owns a television station, too. I think we should make a deal.'

McAllister protested. 'Mrs Chambers, we don't know anything about television, and —'

'Then we'll have to learn, won't we?'

The empire Leslie needed was beginning to build.

Six

Oliver's days were full, and he loved every minute of what he was doing. There were political appointments to be made, legislation to be put forward, appropriations to be approved, meetings and speeches and press interviews. The *State Journal* in Frankfort, the *Herald-Leader* in Lexington, and the *Louisville Courier-Journal* gave him glowing reports. He was earning the reputation of being a governor who got things done. Oliver was swept up in the social life of the superwealthy, and he knew that a large part of that was because he was married to the daughter of Senator Todd Davis.

Oliver enjoyed living in Frankfort. It was a lovely, historic city nestled in a scenic river valley among the rolling hills of Kentucky's fabled bluegrass region. He wondered what it would be like to live in Washington, D.C.

The busy days merged into weeks, and the weeks merged into months. Oliver began the last year of his term.

Oliver had made Peter Tager his press secretary. He was the perfect choice. Tager was always forthright with the press, and because of the decent, old-fashioned values he stood for and liked to talk about, he gave the party substance and dignity. Peter Tager and his black eye patch became almost as well recognized as Oliver.

Todd Davis made it a point to fly down to Frankfort to see Oliver at least once a month.

He said to Peter Tager, 'When you've got a Thorough-bred running, you have to keep an eye on him to make sure he doesn't lose his timing.'

On a chilly evening in October, Oliver and Senator Davis were seated in Oliver's study. The two men and Jan had gone out to dinner at Gabriel's and had returned to the Executive Mansion. Jan had left the men to talk.

'Jan seems very happy, Oliver. I'm pleased.'

'I try to make her happy, Todd.'

Senator Davis looked at Oliver and wondered how often he used the apartment. 'She loves you a lot, son.'

'And I love her.' Oliver sounded very sincere.

Senator Davis smiled. 'I'm glad to hear that. She's already redecorating the White House.'

Oliver's heart skipped a beat. 'I beg your pardon?'

'Oh, didn't I tell you? It's begun. Your name's becoming a byword in Washington. We're going to begin our campaign the first of the year.'

Oliver was almost afraid to ask the next question. 'Do you honestly think I have a chance, Todd?'

'The word "chance" implies a gamble, and I don't gamble, son. I won't get involved in anything unless I know it's a sure thing.'

Oliver took a deep breath. *You can be the most important man in the world.* 'I want you to know how very much I appreciate everything you've done for me, Todd.'

Todd patted Oliver's arm. 'It's a man's duty to help his son-in-law, isn't it?'

The emphasis on 'son-in-law' was not lost on Oliver.

The senator said casually, 'By the way, Oliver, I was very disappointed that your legislature passed that tobacco tax bill.'

'That money will take care of the shortfall in our fiscal budget, and –'

'But of course you're going to veto it.'

Oliver stared at him. 'Veto it?'

The senator gave him a small smile. 'Oliver, I want you to know that I'm not thinking about myself. But I have a lot of friends who invested their hard-earned money in tobacco plantations, and I wouldn't want to see them get hurt by oppressive new taxes, would you?'

There was a silence.

'Would you, Oliver?'

'No,' Oliver finally said. 'I guess it wouldn't be fair.'

'I appreciate that. I really do.'

Oliver said, 'I had heard that you'd sold your tobacco plantations, Todd.'

Todd Davis looked at him, surprised. 'Why would I want to do that?'

'Well, the tobacco companies are taking a beating in the courts. Sales are way down, and –'

'You're talking about the United States, son. There's a great big world out there. Wait until our advertising campaigns start rolling in China and Africa and India.' He looked at his watch and rose. 'I have to head back to Washington. I have a committee meeting.'

'Have a good flight.'

Senator Davis smiled. 'Now I will, son. Now I will.'

Oliver was upset. 'What the hell am I going to do, Peter? The tobacco tax is by far the most popular measure the legislature has passed this year. What excuse do I have for vetoing it?'

Peter Tager took several sheets of paper from his pocket. 'All the answers are right here, Oliver. I've discussed it with the senator. You won't have any problem. I've set up a press conference for four o'clock.'

Oliver studied the papers. Finally, he nodded. 'This is good.'

'It's what I do. Is there anything else you need me for?'

'No. Thank you. I'll see you at four.'

Peter Tager started to leave.

'Peter.'

Tager turned. 'Yes?'

'Tell me something. Do you think I really have a chance of becoming president?'

'What does the senator say?'

'He says I do.'

Tager walked back to the desk. 'I've known Senator Davis for many years, Oliver. In all that time, he hasn't been wrong once. Not once. The man has incredible instincts. If Todd Davis says you're going to be the next President of the United States, you can bet the farm on it.'

There was a knock at the door. 'Come in.'

The door opened, and an attractive young secretary walked in, carrying some faxes. She was in her early twenties, bright and eager.

'Oh, excuse me, Governor. I didn't know you were in a –'

'That's all right, Miriam.'

Tager smiled. 'Hi, Miriam.'

'Hello, Mr Tager.'

Oliver said, 'I don't know what I'd do without Miriam. She does everything for me.'

Miriam blushed. 'If there's nothing else –' She put the faxes on Oliver's desk and turned and hurried out of the office.

'That's a pretty woman,' Tager said. He looked over at Oliver.

'Yes.'

'Oliver, you are being careful, aren't you?'

'Of course I am. That's why I had you get that little apartment for me.'

'I mean big-time careful. The stakes have gone up. The next time you get horny, just stop and think about whether a Miriam or Alice or Karen is worth the Oval Office.'

'I know what you're saying, Peter, and I appreciate it. But you don't have to worry about me.'

'Good.' Tager looked at his watch. 'I have to go. I'm taking Betsy and the kids out to lunch.' He smiled. 'Did I tell you what Rebecca did this morning? She's my five-year-old. There was a tape of a kid's show she wanted to watch at eight o'clock this morning. Betsy said, "Darling, I'll run it for you after lunch." Rebecca looked at her and said, "Mama, I want lunch now." Pretty smart, huh?'

Oliver had to smile at the pride in Tager's voice.

At ten o'clock that evening, Oliver walked into the den where Jan was reading and said, 'Honey, I have to leave. I have a conference to go to.'

Jan looked up. 'At this time of night?'

He sighed. 'I'm afraid so. There's a budget committee meeting in the morning, and they want to brief me before the meeting.'

'You're working too hard. Try to come home early,

will you, Oliver?' She hesitated a moment. 'You've been out a lot lately.'

He wondered whether that was intended as a warning. He walked over to her, leaned down, and kissed her. 'Don't worry, honey. I'll be home as early as I can.'

Downstairs Oliver said to his chauffeur, 'I won't need you tonight. I'm taking the small car.'

'Yes, Governor.'

'You're late, darling.' Miriam was naked.

He grinned and walked over to her. 'Sorry about that. I'm glad you didn't start without me.'

She smiled. 'Hold me.'

He took her in his arms and held her close, her warm body pressed against his.

'Get undressed. Hurry.'

Afterward, he said, 'How would you like to move to Washington, D.C.?'

Miriam sat up in bed. 'Are you serious?'

'Very. I may be going there. I want you to be with me.'

'If your wife ever found out about us . . .'

'She won't.'

'Why Washington?'

'I can't tell you that now. All I can say is that it's going to be very exciting.'

'I'll go anywhere you want me to go, as long as you love me.'

'You know I love you.' The words slipped out easily, as they had so many times in the past.

'Make love to me again.'

'Just a second. I have something for you.' He got up and walked over to the jacket he had flung over a chair. He took a small bottle out of his pocket and poured the contents into a glass. It was a clear liquid.

'Try this.'

'What is it?' Miriam asked.

'You'll like it. I promise.' He lifted the glass and drank half of it.

Miriam took a sip, then swallowed the rest of it. She smiled. 'It's not bad.'

'It's going to make you feel real sexy.'

'I already feel real sexy. Come back to bed.'

They were making love again when she gasped and said, 'I – I'm not feeling well.' She began to pant. 'I can't breathe.' Her eyes were closing.

'Miriam!' There was no response. She fell back on the bed. 'Miriam!'

She lay there, unconscious.

Son of a bitch! Why are you doing this to me?

He got up and began to pace. He had given the liquid to a dozen women, and only once had it harmed anyone. He had to be careful. Unless he handled this right, it was going to be the end of everything. All his dreams, everything he had worked for. He could not let

that happen. He stood at the side of the bed, looking down at her. He felt her pulse. She was still breathing, thank God. But he could not let her be discovered in this apartment. It would be traced back to him. He had to leave her somewhere where she would be found and be given medical help. He could trust her not to reveal his name.

It took him almost half an hour to get her dressed and to remove all traces of her from his apartment. He opened the door a crack to make sure that the hallway was empty, then picked her up, put her over his shoulder, and carried her downstairs and put her in the car. It was almost midnight, and the streets were deserted. It was beginning to rain. He drove to Juniper Hill Park, and when he was sure that no one was in sight, he lifted Miriam out of the car and gently laid her down on a park bench. He hated to leave her there, but he had no choice. None. His whole future was at stake.

There was a public phone booth a few feet away. He hurried over to it and dialed 911.

Jan was waiting up for Oliver when he returned home. 'It's after midnight,' she said. 'What took you –?'

'I'm sorry, darling. We got into a long, boring discussion on the budget, and – well, everyone had a different opinion.'

'You look pale,' Jan said. 'You must be exhausted.'

'I am a little tired,' he admitted.

She smiled suggestively. 'Let's go to bed.'

He kissed her on the forehead. 'I've really got to get some sleep, Jan. That meeting knocked me out.'

The story was on the front page of the *State Journal* the following morning:

> GOVERNOR'S SECRETARY FOUND UNCON-
> SCIOUS IN PARK.
>
> At two o'clock this morning, police found the unconscious woman, Miriam Friedland, lying on the bench in the rain and immediately called for an ambulance. She was taken to Memorial Hospital, where her condition is said to be critical.

As Oliver was reading the story, Peter came hurrying into his office, carrying a copy of the newspaper.

'Have you seen this?'

'Yes. It's – it's terrible. The press has been calling all morning.'

'What do you suppose happened?' Tager asked.

Oliver shook his head. 'I don't know. I just talked to the hospital. She's in a coma. They're trying to learn what caused it. The hospital is going to let me know as soon as they find out.'

Tager looked at Oliver. 'I hope she's going to be all right.'

94

Leslie Chambers missed seeing the newspaper stories. She was in Brazil, buying a television station.

The telephone call from the hospital came the following day. 'Governor, we've just finished the laboratory tests. She's ingested a substance called methylenedioxymeth-amphetamine, commonly known as Ecstasy. She took it in liquid form, which is even more lethal.'

'What's her condition?'

'I'm afraid it's critical. She's in a coma. She could wake up or –' He hesitated. 'It could go the other way.'

'Please keep me informed.'

'Of course. You must be very concerned, Governor.'

'I am.'

Oliver Russell was in a conference when a secretary buzzed.

'Excuse me, Governor. There's a telephone call for you.'

'I told you no interruptions, Heather.'

'It's Senator Davis on line three.'

'Oh.'

Oliver turned to the men in the room. 'We'll finish this later, gentlemen. If you'll excuse me . . .'

He watched them leave the room, and when the door closed behind them, he picked up the telephone. 'Todd?'

'Oliver, what's this about a secretary of yours found drugged on a park bench?'

'Yes,' Oliver said. 'It's a terrible thing, Todd. I –'

'How terrible?' Senator Davis demanded.

'What do you mean?'

'You know damn well what I mean.'

'Todd, you don't think I – I swear I don't know anything about what happened.'

'I hope not.' The senator's voice was grim. 'You know how fast gossip gets around in Washington, Oliver. It's the smallest town in America. We don't want anything negative linked to you. We're getting ready to make our move. I'd be very, very upset if you did anything stupid.'

'I promise you, I'm clean.'

'Just make sure you keep it that way.'

'Of course I will. I –' The line went dead.

Oliver sat there thinking. *I'll have to be more careful. I can't let anything stop me now.* He glanced at his watch, then reached for the remote control that turned on the television set. The news was on. On the screen was a picture of a besieged street, with snipers shooting at random from buildings. The sound of mortar fire could be heard in the background.

An attractive young female reporter, dressed in battle fatigues and holding a microphone, was saying, 'The new treaty is supposed to take effect at midnight tonight, but regardless of whether it holds, it can never bring back the peaceful villages in this war-torn country or restore the

lives of the innocents who have been swept up in the ruthless reign of terror.'

The scene shifted to a close-up of Dana Evans, a passionate, lovely young woman in a flak jacket and combat boots. 'The people here are hungry and tired. They ask for only one thing – peace. Will it come? Only time will tell. This is Dana Evans reporting from Sarajevo for WTE, Washington Tribune Enterprises.' The scene dissolved into a commercial.

Dana Evans was a foreign correspondent for the Washington Tribune Enterprises Broadcasting System. She reported the news every day, and Oliver tried not to miss her broadcasts. She was one of the best reporters on the air.

She's a great-looking woman, Oliver thought, not for the first time. *Why the hell would someone that young and attractive want to be in the middle of a shooting war?*

Seven

Dana Evans was an army brat, the daughter of a colonel who traveled from base to base as an armaments instructor. By the time Dana was eleven years old, she had lived in five American cities and in four foreign countries. She had moved with her father and mother to the Aberdeen Proving Ground in Maryland, Fort Benning in Georgia, Fort Hood in Texas, Fort Leavenworth in Kansas, and Fort Monmouth in New Jersey. She had gone to schools for officers' children at Camp Zama in Japan, Chiemsee in Germany, Camp Darby in Italy, and Fort Buchanan in Puerto Rico.

Dana was an only child, and her friends were the army personnel and their families who were stationed at the various postings. She was precocious, cheerful, and outgoing, but her mother worried about the fact that Dana was not having a normal childhood.

'I know that moving every six months must be terribly hard on you, darling,' her mother said.

Dana looked at her mother, puzzled. 'Why?'

Whenever Dana's father was assigned to a new post,

Dana was thrilled. 'We're going to move again!' she would exclaim.

Unfortunately, although Dana enjoyed the constant moving, her mother hated it.

When Dana was thirteen, her mother said, 'I can't live like a gypsy any longer. I want a divorce.'

Dana was horrified when she heard the news. Not about the divorce so much, but by the fact that she would no longer be able to travel around the world with her father.

'Where am I going to live?' Dana asked her mother.

'In Claremont, California. I grew up there. It's a beautiful little town. You'll love it.'

Dana's mother had been right about Claremont's being a beautiful little town. She was wrong about Dana's loving it. Claremont was at the base of the San Gabriel Mountains in Los Angeles County, with a population of about thirty-three thousand. Its streets were lined with lovely trees and it had the feel of a quaint college community. Dana hated it. The change from being a world traveler to settling down in a small town brought on a severe case of culture shock.

'Are we going to live here forever?' Dana asked gloomily.

'Why, darling?'

'Because it's too small for me. I need a bigger town.'

* * *

On Dana's first day at school, she came home depressed.

'What's the matter? Don't you like your school?'

Dana sighed. 'It's all right, but it's full of kids.'

Dana's mother laughed. 'They'll get over that, and so will you.'

Dana went on to Claremont High School and became a reporter for the *Wolfpacket*, the school newspaper. She found that she enjoyed newspaper work, but she desperately missed traveling.

'When I grow up,' Dana said, 'I'm going to go all over the world again.'

When Dana was eighteen, she enrolled in Claremont McKenna College, majored in journalism, and became a reporter for the college newspaper, the *Forum*. The following year, she was made editor of the paper.

Students were constantly coming to her for favors. 'Our sorority is having a dance next week, Dana. Would you mention it in the paper . . . ?'

'The debating club is having a meeting Tuesday . . .'

'Could you review the play the drama club is putting on . . . ?'

'We need to raise funds for the new library . . .'

It was endless, but Dana enjoyed it enormously. She was in a position to help people, and she liked that. In her senior year, Dana decided that she wanted a newspaper career.

'I'll be able to interview important people all over the world,' Dana told her mother. 'It will be like helping to make history.'

Growing up, whenever young Dana looked in a mirror, she became depressed. Too short, too thin, too flat. Every other girl was awesomely beautiful. It was some kind of California law. *I'm an ugly duckling in a land of swans,* she thought. She made it a point to avoid looking in mirrors. If Dana had looked, she would have realized that at the age of fourteen, her body was beginning to blossom. At the age of sixteen, she had become very attractive. When she was seventeen, boys began seriously to pursue her. There was something about her eager, heart-shaped face, large inquisitive eyes, and husky laugh that was both adorable and a challenge.

Dana had known since she was twelve how she wanted to lose her virginity. It would be on a beautiful, moon-lit night on some faraway tropical island, with the waves gently lapping against the shore. There would be soft music playing in the background. A handsome, sophisticated stranger would approach her and look deeply into her eyes, into her soul, and he would take her in his arms without a word and suavely carry her to a nearby palm tree. They would get undressed and make love and the music in the background would swell to a climax.

* * *

She actually lost her virginity in the back of an old Chevrolet, after a school dance, to a skinny eighteen-year-old redhead named Richard Dobbins, who worked on the *Forum* with her. He gave Dana his ring and a month later, moved to Milwaukee with his parents. Dana never heard from him again.

The month before she was graduated from college with a B.A. in journalism, Dana went down to the local newspaper, the *Claremont Examiner*, to see about a job as a reporter.

A man in the personnel office looked over her résumé. 'So you were the editor of the *Forum*, eh?'

Dana smiled modestly. 'That's right.'

'Okay. You're in luck. We're a little short-handed right now. We'll give you a try.'

Dana was thrilled. She had already made a list of the countries she wanted to cover: Russia ... China ... Africa ...

'I know I can't start as a foreign correspondent,' Dana said, 'but as soon as –'

'Right. You'll be working here as a gofer. You'll see that the editors have coffee in the morning. They like it strong, by the way. And you'll run copy down to the printing presses.'

Dana stared at him in shock. 'I can't –'

He leaned forward, frowning. 'You can't what?'

'I can't tell you how glad I am to have this job.'

* * *

The reporters all complimented Dana on her coffee, and she became the best runner the paper had ever had. She was at work early every day and made friends with everyone. She was always eager to help out. She knew that was the way to get ahead.

The problem was that at the end of six months, Dana was still a gofer. She went to see Bill Crowell, the managing editor.

'I really think I'm ready,' Dana said earnestly. 'If you give me an assignment, I'll –'

He did not even look up. 'There's no opening yet. My coffee's cold.'

It isn't fair, Dana thought. *They won't even give me a chance.* Dana had heard a line that she firmly believed in. 'If something can stop you, you might as well let it.' *Well, nothing's going to stop me*, Dana thought. *Nothing. But how am I going to get started?*

One morning, as Dana was walking through the deserted Teletype room, carrying cups of hot coffee, a police scanner printout was coming over the wires. Curious, Dana walked over and read it:

ASSOCIATED PRESS – CLAREMONT, CALI-
FORNIA. IN CLAREMONT THIS MORNING,
THERE WAS AN ATTEMPTED KIDNAPPING.

Dana read the rest of the story, wide-eyed. She took a deep breath, ripped the story from the teletype, and put it in her pocket. No one else had seen it.

Dana hurried into Bill Crowell's office, breathless. 'Mr Crowell, someone tried to kidnap a little boy in Claremont this morning. He offered to take him on a pony ride. The boy wanted some candy first, and the kidnapper took him to a candy store, where the owner recognized the boy. The owner called the police and the kidnapper fled.'

Bill Crowell was excited. 'There was nothing on the wires. How did you hear about this?'

'I – I happened to be in the store, and they were talking about it and –'

'I'll get a reporter over there right away.'

'Why don't you let me cover it?' Dana said quickly. 'The owner of the candy store knows me. He'll talk to me.'

He studied Dana a moment and said reluctantly, 'All right.'

Dana interviewed the owner of the candy store, and her story appeared on the front page of the *Claremont Examiner* the next day and was well received.

'That wasn't a bad job,' Bill Crowell told her. 'Not bad at all.'

'Thank you.'

* * *

It was almost a week before Dana found herself alone again in the teletype room. There was a story coming in on the wire from the Associated Press:

POMONA, CALIFORNIA: FEMALE JUDO IN-
STRUCTOR CAPTURES WOULD-BE RAPIST.

Perfect, Dana decided. She tore off the printout, crumpled it, stuffed it in her pocket, and hurried in to see Bill Crowell.

'My old roommate just called me,' Dana said excitedly. 'She was looking out the window and saw a woman attack a would-be rapist. I'd like to cover it.'

Crowell looked at her a moment. 'Go ahead.'

Dana drove to Pomona to get an interview with the judo instructor, and again her story made the front page.

Bill Crowell asked Dana to come into his office. 'How would you like to have a regular beat?'

Dana was thrilled. 'Great!' *It's begun,* she thought. *My career has finally begun.*

The following day, the *Claremont Examiner* was sold to the *Washington Tribune* in Washington, D.C.

When the news of the sale came out, most of the *Claremont Examiner* employees were dismayed. It was inevitable that there would be downsizing and that some of them would lose their jobs. Dana did not think of it that way. *I work for the* Washington Tribune *now,* she thought,

and the next logical thought was, *Why don't I go to work at its headquarters?*

She marched into Bill Crowell's office. 'I'd like a ten-day leave.'

He looked at her curiously. 'Dana, most of the people around here won't go to the bathroom because they're scared to death that their desks won't be there when they get back. Aren't you worried?'

'Why should I be? I'm the best reporter you have,' she said confidently. 'I'm going to get a job at the *Washington Tribune*.'

'Are you serious?' He saw her expression. 'You're serious.' He sighed. 'All right. Try to see Matt Baker. He's in charge of Washington Tribune Enterprises – newspapers, TV stations, radio, everything.'

'Matt Baker. Right.'

Eight

Washington, D.C., was a much larger city than Dana had imagined. This was the power center of the world, and Dana could feel the electricity in the air. This is where I belong, she thought happily.

Her first move was to check into the Stouffer Renaissance Hotel. She looked up the address of the *Washington Tribune* and headed there. The *Tribune* was located on 6th Street and took up the entire block. It consisted of four separate buildings that seemed to reach to infinity. Dana found the main lobby and confidently walked up to the uniformed guard behind the desk.

'Can I help you, miss?'

'I work here. That is, I work for the *Tribune*. I'm here to see Matt Baker.'

'Do you have an appointment?'

Dana hesitated. 'Not yet, but –'

'Come back when you have one.' He turned his attention to several men who had come up to the desk.

'We have an appointment with the head of the circulation department,' one of the men said.

'Just a moment, please.' The guard dialed a number.

In the background, one of the elevators had arrived and people were getting out. Dana casually headed for it. She stepped inside, praying that it would go up before the guard noticed her. A woman got into the elevator and pressed the button, and they started up.

'Excuse me,' Dana said. 'What floor is Matt Baker on?'

'Third.' She looked at Dana. 'You're not wearing a pass.'

'I lost it,' Dana said.

When the elevator reached the third floor, Dana got out. She stood there, speechless at the scale of what she was seeing. She was looking at a sea of cubicles. It seemed as though there were hundreds of them, occupied by thousands of people. There were different-colored signs over each cubicle. EDITORIAL ... ART ... METRO ...SPORTS... CALENDAR...

Dana stopped a man hurrying by. 'Excuse me. Where's Mr Baker's office?'

'Matt Baker?' He pointed. 'Down at the end of the hall to the right, last door.'

'Thank you.'

As Dana turned, she bumped into an unshaven, rumpled-looking man carrying some papers. The papers fell to the floor.

'Oh, I'm sorry. I was –'

'Why don't you look where the hell you're going?' the man snapped. He stooped to pick up the papers.

'It was an accident. Here. I'll help you. I —' Dana reached down, and as she started to pick up the papers, she knocked several sheets under a desk.

The man stopped to glare at her. 'Do me a favor. Don't help me anymore.'

'As you like,' Dana said icily. 'I just hope everyone in Washington isn't as rude as you.'

Haughtily, Dana rose and walked toward Mr Baker's office. The legend on the glass window read 'MATT BAKER.' The office was empty. Dana walked inside and sat down. Looking through the office window, she watched the frenetic activity going on.

It's nothing like the Claremont Examiner, she thought. There were thousands of people working here. Down the corridor, the grumpy, rumpled-looking man was heading toward the office.

No! Dana thought. *He's not coming in here. He's on his way somewhere else —*

And the man walked in the door. His eyes narrowed. 'What the hell are you doing here?'

Dana swallowed. 'You must be Mr Baker,' she said brightly. 'I'm Dana Evans.'

'I asked you what you're doing here.'

'I'm a reporter with the *Claremont Examiner*.'

'And?'

'You just bought it.'

'I did?'

'I — I mean the newspaper bought it. The newspaper bought the newspaper.' Dana felt it was not going well.

'Anyway, I'm here for a job. Of course, I already have a job here. It's more like a transfer, isn't it?'

He was staring at her.

'I can start right away.' Dana babbled on. 'That's no problem.'

Matt Baker moved toward the desk. 'Who the hell let you in here?'

'I told you. I'm a reporter for the *Claremont Examiner* and –'

'Go back to Claremont,' he snapped. 'Try not to knock anyone down on your way out.'

Dana rose and said stiffly, 'Thank you very much, Mr Baker. I appreciate your courtesy.' She stormed out of the office.

Matt Baker looked after her, shaking his head. The world was full of weirdos.

Dana retraced her steps to the huge editorial room, where dozens of reporters were typing out stories on their computers. *This is where I'm going to work*, Dana thought fiercely. *Go back to Claremont. How dare he!*

As Dana looked up, she saw Matt Baker in the distance, moving in her direction. The damned man was everywhere! Dana quickly stepped behind a cubicle so he could not see her.

Baker walked past her to a reporter seated at a desk. 'Did you get the interview, Sam?'

'No luck. I went to the Georgetown Medical Center,

110

and they said there's nobody registered by that name. Tripp Taylor's wife isn't a patient there.'

Matt Baker said, 'I know damn well she is. They're covering something up, dammit. I want to know why she's in the hospital.'

'If she is in there, there's no way to get to her, Matt.'

'Did you try the flower delivery routine?'

'Sure. It didn't work.'

Dana stood there watching Matt Baker and the reporter walk away. *What kind of reporter is it*, Dana wondered, *who doesn't know how to get an interview?*

Thirty minutes later, Dana was entering the Georgetown Medical Center. She went into the flower shop.

'May I help you?' a clerk asked.

'Yes. I'd like –' She hesitated a moment. '– fifty dollars' worth of flowers.' She almost choked on the word 'fifty.'

When the clerk handed her the flowers, Dana said, 'Is there a shop in the hospital that might have a little cap of some kind?'

'There's a gift shop around the corner.'

'Thank you.'

The gift shop was a cornucopia of junk, with a wide array of greeting cards, cheaply made toys, balloons and banners, junk-food racks, and gaudy items of clothing. On a shelf were some souvenir caps. Dana bought one that resembled a chauffeur's cap and put it on. She

111

purchased a get-well card and scribbled something on the inside.

Her next stop was at the information desk in the hospital lobby. 'I have flowers here for Mrs Tripp Taylor.'

The receptionist shook her head. 'There's no Mrs Tripp Taylor registered here.'

Dana sighed. 'Really? That's too bad. These are from the Vice President of the United States.' She opened the card and showed it to the receptionist. The inscription read, 'Get well quickly.' It was signed, 'Arthur Cannon.'

Dana said, 'Guess I'll have to take these back.' She turned to leave.

The receptionist looked after her uncertainly. 'Just a moment!'

Dana stopped. 'Yes?'

'I can have those flowers delivered to her.'

'Sorry,' Dana said. 'Vice President Cannon asked that they be delivered personally.' She looked at the receptionist. 'Could I have your name, please? They'll want to tell Mr Cannon why I couldn't deliver the flowers.'

Panic. 'Oh, well. All right. I don't want to cause any problems. Take them to Room 615. But as soon as you deliver them, you'll have to leave.'

'Right,' Dana said.

Five minutes later, she was talking to the wife of the famous rock star Tripp Taylor.

Stacy Taylor was in her middle twenties. It was difficult

to tell whether she was attractive or not, because at the moment, her face was badly battered and swollen. She was trying to reach for a glass of water on a table near the bed when Dana walked in.

'Flowers for –' Dana stopped in shock as she saw the woman's face.

'Who are they from?' The words were a mumble.

Dana had removed the card. 'From – from an admirer.'

The woman was staring at Dana suspiciously. 'Can you reach that water for me?'

'Of course.' Dana put the flowers down and handed the glass of water to the woman in bed. 'Can I do anything else for you?' Dana asked.

'Sure,' she said through swollen lips. 'You can get me out of this stinking place. My husband won't let me have visitors. I'm sick of seeing all these doctors and nurses.'

Dana sat down on a chair next to the bed. 'What happened to you?'

The woman snorted. 'Don't you know? I was in an auto accident.'

'You were?'

'Yes.'

'That's awful,' Dana said skeptically. She was filled with a deep anger, for it was obvious that this woman had been beaten.

Forty-five minutes later, Dana emerged with the true story.

113

When Dana returned to the lobby of the *Washington Tribune*, a different guard was there. 'Can I help –?'

'It's not my fault,' Dana said breathlessly. 'Believe me, it's the darned traffic. Tell Mr Baker I'm on my way up. He's going to be furious with me for being late.' She hurried toward the elevator and pressed the button. The guard looked after her uncertainly, then began dialing. 'Hello. Tell Mr Baker there's a young woman who –'

The elevator arrived. Dana stepped in and pressed three. On the third floor, the activity seemed to have increased, if that was possible. Reporters were rushing to make their deadlines. Dana stood there, looking around frantically. Finally, she saw what she wanted. In a cubicle with a green sign that read GARDENING was an empty desk. Dana hurried over to it and sat down. She looked at the computer in front of her, then began typing. She was so engrossed in the story she was writing that she lost all track of time. When she was finished, she printed it and pages began spewing out. She was putting them together when she sensed a shadow over her shoulder.

'What the hell are you doing?' Matt Baker demanded.

'I'm looking for a job, Mr Baker. I wrote this story, and I thought –'

'You thought wrong,' Baker exploded. 'You don't just walk in here and take over someone's desk. Now get the hell out before I call security and have you arrested.'

'But –'

'Out!'

Dana rose. Summoning all her dignity, she thrust the pages in Matt Baker's hand and walked around the corner to the elevator.

Matt Baker shook his head in disbelief. *Jesus! What the hell is the world coming to?* There was a wastebasket under the desk. As Matt moved toward it, he glanced at the first sentence of Dana's story: 'Stacy Taylor, her face battered and bruised, claimed from her hospital bed today that she was there because her famous rock star husband, Tripp Taylor, beat her. "Every time I get pregnant, he beats me up. He doesn't want children."' Matt started to read further and stood there rooted. He looked up, but Dana was gone.

Clutching the pages in his hand, Matt raced toward the elevators, hoping to find her before she disappeared. As he ran around the corner, he bumped into her. She was leaning against the wall, waiting.

'How did you get this story?' he demanded.

Dana said simply, 'I told you. I'm a reporter.'

He took a deep breath. 'Come on back to my office.'

They were seated in Matt Baker's office again. 'That's a good job,' he said grudgingly.

'Thank you! I can't tell you how much I appreciate this,' Dana said excitedly. 'I'm going to be the best reporter you ever had. You'll see. What I really want

is to be a foreign correspondent, but I'm willing to work my way up to that, even if it takes a year.' She saw the expression on his face. 'Or maybe two.'

'The *Tribune* has no job openings, and there's a waiting list.'

She looked at him in astonishment. 'But I assumed –'

'Hold it.'

Dana watched as he picked up a pen and wrote out the letters of the word 'assume,' ASS U ME. He pointed to the word. 'When a reporter assumes something, Miss Evans, it makes an *ass* out of *you* and *me*. Do you understand?'

'Yes, sir.'

'Good.' He was thoughtful for a moment, then came to a decision. 'Do you ever watch WTE? The Tribune Enterprises television station.'

'No, sir. I can't say that I –'

'Well, you will now. You're in luck. There's a job opening there. One of the writers just quit. You can take his place.'

'Doing what?' Dana asked tentatively.

'Writing television copy.'

Her face fell. 'Television copy? I don't know anything about –'

'It's simple. The producer of the news will give you the raw material from all the news services. You'll put it into English and put it on the TelePrompTer for the anchors to read.'

Dana sat there, silent.

'What?'

'Nothing, it's just that – I'm a reporter.'

'We have five hundred reporters here, and they've all spent years earning their stripes. Go over to Building Four. Ask for Mr Hawkins. If you have to start somewhere, television isn't bad.' Matt Baker reached for the phone. 'I'll give Hawkins a call.'

Dana sighed. 'Right. Thank you, Mr Baker. If you ever need –'

'Out.'

The WTE television studios took up the entire sixth floor of Building Four. Tom Hawkins, the producer of the nightly news, led Dana into his office.

'Have you ever worked in television?'

'No, sir. I've worked on newspapers.'

'Dinosaurs. They're the past. We're the present. And who knows what the future will be? Let me show you around.'

There were dozens of people working at desks and monitors. Wire copy from half a dozen news services was appearing on computers.

'Here's where stories and news breaks come in from all over the world,' Hawkins explained. 'I decide which ones we're going with. The assignment desk sends out crews to cover those stories. Our reporters in the field send in their stories by microwave or transmitters. Besides our wire services, we have one hundred and sixty police channels,

reporters with cell phones, scanners, monitors. Every story is planned to the second. The writers work with tape editors to get the timing exact. The average news story runs between a minute and a half and a minute and forty-five seconds.'

'How many writers work here?' Dana asked.

'Six. Then you have a video coordinator, news tape editors, producers, directors, reporters, anchors . . .' He stopped. A man and woman were approaching them. 'Speaking of anchors, meet Julia Brinkman and Michael Tate.'

Julia Brinkman was a stunning woman, with chestnut-colored hair, tinted contacts that made her eyes a sultry green, and a practiced, disarming smile. Michael Tate was an athletic-looking man with a burstingly genial smile and an outgoing manner.

'Our new writer,' Hawkins said. 'Donna Evanston.'

'Dana Evans.'

'Whatever. Let's get to work.'

He took Dana back to his office. He nodded toward the assignment board on the wall. 'Those are the stories I'll choose from. They're called slugs. We're on twice a day. We do the noon news from twelve to one and the nightly news from ten to eleven. When I tell you which stories I want to run with, you'll put them together and make everything sound so exciting that the viewers can't switch channels. The tape editor will feed you video clips, and you'll work them into the scripts and indicate where the clips go.'

'Right.'

'Sometimes there's a breaking story, and then we'll cut into our regular programming with a live feed.'

'That's interesting,' Dana said.

She had no idea that one day it was going to save her life.

The first night's program was a disaster. Dana had put the news leads in the middle instead of the beginning, and Julia Brinkman found herself reading Michael Tate's stories while Michael was reading hers.

When the broadcast was over, the director said to Dana, 'Mr Hawkins would like to see you in his office. Now.'

Hawkins was sitting behind his desk, grim-faced.

'I know,' Dana said contritely. 'It was a new low in television, and it's all my fault.'

Hawkins sat there watching her.

Dana tried again. 'The good news, Tom, is that from now on it can only get better. Right?'

He kept staring at her.

'And it will never happen again because' – she saw the look on his face – 'I'm fired.'

'No,' Hawkins said curtly. 'That would be letting you off too easily. You're going to do this until you get it right. And I'm talking about the noon news tomorrow. Am I making myself clear?'

'Very.'

'Good. I want you here at eight o'clock in the morning.'

'Right, Tom.'

'And since we're going to be working together – you can call me Mr Hawkins.'

The noon news the next day went smoothly. Tom Hawkins had been right, Dana decided. It was just a matter of getting used to the rhythm. Get your assignment ... write the story ... work with the tape editor ... set up the TelePrompTer for the anchors to read.

From that point on, it became routine.

Dana's break came eight months after she had started working at WTE. She had just finished putting the evening news report on the TelePrompTer at nine forty-five and was preparing to leave. When she walked into the television studio to say good night, there was chaos. Everyone was talking at once.

Rob Cline, the director, was shouting, 'Where the hell is she?'

'I don't know.'

'Hasn't anyone seen her?'

'No.'

'Did you phone her apartment?'

'I got the answering machine.'

'Wonderful. We're on the air' – he looked at his watch – 'in twelve minutes.'

'Maybe Julia was in an accident,' Michael Tate said. 'She could be dead.'

'That's no excuse. She should have phoned.'

Dana said, 'Excuse me . . .'

The director turned to her impatiently. 'Yes?'

'If Julia doesn't show up, I could do the newscast.'

'Forget it.' He turned back to his assistant. 'Call security and see if she's come into the building.'

The assistant picked up the phone and dialed. 'Has Julia Brinkman checked in yet . . . ? Well, when she does, tell her to get up here, fast.'

'Have him hold an elevator for her. We're on the air in' – he looked at his watch again – 'seven damned minutes.'

Dana stood there, watching the growing panic.

Michael Tate said, 'I could do both parts.'

'No,' the director snapped. 'We need two of you up there.' He looked at his watch again. 'Three minutes. Goddammit. How could she do this to us? We're on the air in –'

Dana spoke up. 'I know all the words. I wrote them.'

He gave her a quick glance. 'You have no makeup on. You're dressed wrong.'

A voice came from the sound engineer's booth. 'Two minutes. Take your places, please.'

Michael Tate shrugged and took his seat on the platform in front of the cameras.

'Places, please!'

Dana smiled at the director. 'Good night, Mr Cline.' She started toward the door.

'Wait a minute!' He was rubbing his hand across his forehead. 'Are you sure you can do this?'

'Try me,' Dana said.

'I don't have any choice, do I?' he moaned. 'All right. Get up there. My God! Why didn't I listen to my mother and become a doctor?'

Dana hurried up to the platform and took the seat next to Michael Tate.

'Thirty seconds . . . twenty . . . ten . . . five . . .'

The director signaled with his hand, and the red light on the camera flashed on.

'Good evening,' Dana said smoothly. 'Welcome to the WTE ten-o'clock news. We have a breaking story for you in Holland. There was an explosion at an Amsterdam school this afternoon and . . .'

The rest of the broadcast went smoothly.

The following morning, Rob Cline came into Dana's office. 'Bad news. Julia was in an automobile accident last night. Her face is' – he hesitated – 'disfigured.'

'I'm sorry,' Dana said, concerned. 'How bad is it?'

'Pretty bad.'

'But today plastic surgery can –'

He shook his head. 'Not this time. She won't be coming back.'

'I'd like to go see her. Where is she?'

'They're taking her back to her family, in Oregon.'

'I'm so sorry.'

'You win some, you lose some.' He studied Dana a moment. 'You were okay last night. We'll keep you on until we find someone permanent.'

Dana went to see Matt Baker. 'Did you see the news last night?' she asked.

'Yes,' he grunted. 'For God's sakes, try putting on some makeup and a more appropriate dress.'

Dana felt deflated. 'Right.'

As she turned to leave, Matt Baker said grudgingly, 'You weren't bad.' Coming from him, it was a high compliment.

On the fifth night of the news broadcast, the director said to Dana, 'By the way, the big brass said to keep you on.'

She wondered if the big brass was Matt Baker.

Within six months, Dana became a fixture on the Washington scene. She was young and attractive and her intelligence shone through. At the end of the year, she was given a raise and special assignments. One of her shows, *Here and Now*, interviews with celebrities, had zoomed to the top of the ratings. Her interviews were personal and sympathetic, and celebrities who hesitated to appear on other talk shows asked to be on Dana's show.

Magazines and newspapers began interviewing Dana. She was becoming a celebrity herself.

At night, Dana would watch the international news. She envied the foreign correspondents. They were doing something important. They were reporting history, informing the world about the important events that were happening around the globe. She felt frustrated.

Dana's two-year contract with WTE was nearly up. Philip Cole, the chief of correspondents, called her in.

'You're doing a great job, Dana. We're all proud of you.'

'Thank you, Philip.'

'It's time for us to be talking about your new contract. First of all –'

'I'm quitting.'

'I beg your pardon?'

'When my contract's up, I'm not doing the show anymore.'

He was looking at her incredulously. 'Why would you want to quit? Don't you like it here?'

'I like it a lot,' Dana said. 'I want to be with WTE, but I want to be a foreign correspondent.'

'That's a miserable life,' he exploded. 'Why in God's name would you want to do that?'

'Because I'm tired of hearing what celebrities want to

cook for dinner and how they met their fifth husband. There are wars going on, and people are suffering and dying. The world doesn't give a damn. I want to make them care.' She took a deep breath. 'I'm sorry. I can't stay on here.' She rose and started toward the door.

'Wait a minute! Are you sure this is what you want to do?'

'It's what I've always wanted to do,' Dana said quietly.

He was thoughtful for a moment. 'Where do you want to go?'

It took her a moment for the import of his words to sink in. When Dana found her voice, she said, 'Sarajevo.'

Nine

Being governor was even more exciting than Oliver Russell had anticipated. Power was a seductive mistress, and Oliver loved it. His decisions influenced the lives of hundreds of thousands of people. He became adept at swaying the state legislature, and his influence and reputation kept expanding. I really am making a difference, Oliver thought happily. He remembered Senator Davis's words: *'This is just a stepping-stone, Oliver. Walk carefully.'*

And he was careful. He had numerous affairs, but they were always handled with the greatest discretion. He knew that they had to be.

From time to time, Oliver checked with the hospital about Miriam's condition.

'She's still in a coma, Governor.'

'Keep me informed.'

* * *

One of Oliver's duties as governor was hosting state dinners. The guests of honor were supporters, sports figures, entertainers, people with political clout, and visiting dignitaries. Jan was a gracious hostess, and Oliver enjoyed the way people reacted to her.

One day Jan came to Oliver and said, 'I just talked to Father. He's giving a party next weekend at his home. He would like us to come. There are some people he wants you to meet.'

That Saturday, at Senator Davis's sumptuous home in Georgetown, Oliver found himself shaking hands with some of the most important wheelers and dealers in Washington. It was a beautiful party, and Oliver was enjoying himself immensely.

'Having a good time, Oliver?'

'Yes. It's a wonderful party. You couldn't wish for a better one.'

Peter Tager said, 'Speaking of wishes, that reminds me. The other day, Elizabeth, my six-year-old, was in a cranky mood and wouldn't get dressed. Betsy was getting desperate. Elizabeth looked at her and said, "Mama, what are you thinking?" Betsy said, "Honey, I was just wishing that you were in a good mood, and that you would get dressed and have your breakfast like a good girl." And Elizabeth said, "Mama, your wish is not being granted!" Isn't that great? Those kids are fantastic. See you later, Governor.'

A couple walked in the door and Senator Davis went to greet them.

The Italian ambassador, Atilio Picone, was an imposing-looking man in his sixties, with dark, Sicilian features. His wife, Sylva, was one of the most beautiful women Oliver had ever seen. She had been an actress before she married Atilio and was still popular in Italy. Oliver could see why. She had large, sensuous brown eyes, the face of a Madonna, and the voluptuous body of a Rubens nude. She was twenty-five years younger than her husband.

Senator Davis brought the couple over to Oliver and introduced them.

'I'm delighted to meet you,' Oliver said. He could not take his eyes off her.

She smiled. 'I've been hearing a great deal about you.'

'Nothing bad, I hope.'

'I –'

Her husband cut in. 'Senator Davis speaks very highly of you.'

Oliver looked at Sylva and said, 'I'm flattered.'

Senator Davis led the couple away. When he returned to Oliver, he said, 'That's off limits, Governor. Forbidden fruit. Take a bite of that, and you can kiss your future goodbye.'

'Relax, Todd. I wasn't –'

'I'm serious. You can alienate two countries at once.'

At the end of the evening, when Sylva and her husband were leaving, Atilio said, 'It was nice to meet you.'

'It was a pleasure.'

Sylva took Oliver's hand in hers and said softly, 'We look forward to seeing you again.'

Their eyes met. 'Yes.'

And Oliver thought, *I must be careful.*

Two weeks later, back in Frankfort, Oliver was working in his office when his secretary buzzed him.

'Governor, Senator Davis is here to see you.'

'Senator Davis is *here*?'

'Yes, sir.'

'Send him in.' Oliver knew that his father-in-law was fighting for an important bill in Washington, and Oliver wondered what he was doing in Frankfort. The door opened, and the senator walked in. Peter Tager was with him.

Senator Todd Davis smiled and put his arm around Oliver. 'Governor, it's good to see you.'

'It's great to see you, Todd.' He turned to Peter Tager. 'Morning, Peter.'

'Morning, Oliver.'

'Hope I'm not disturbing you,' Senator Davis said.

'No, not at all. Is – is anything wrong?'

Senator Davis looked at Tager and smiled. 'Oh, I don't think you could say anything's wrong, Oliver. In fact, I would say that everything's just fine.'

Oliver was studying the two of them, puzzled. 'I don't understand.'

'I have some good news for you, son. May we sit down?'

'Oh, forgive me. What would you like? Coffee? Whiskey –?'

'No. We're pretty well stimulated already.'

Again, Oliver wondered what was going on.

'I've just flown in from Washington. There's a pretty influential group there who think you're going to be our next president.'

Oliver felt a small thrill go through him. 'I – really?'

'As a matter of fact, the reason I flew down here is that it's time for us to start your campaign. The election is less than two years away.'

'It's perfect timing,' Peter Tager said enthusiastically. 'Before we're through, everyone in the world is going to know who you are.'

Senator Davis added, 'Peter is going to take charge of your campaign. He'll handle everything for you. You know you won't find anyone better.'

Oliver looked at Tager and said warmly, 'I agree.'

'It's my pleasure. We're going to have a lot of fun, Oliver.'

Oliver turned to Senator Davis. 'Isn't this going to cost a lot?'

'Don't worry about that. You'll go first-class all the way. I've convinced a lot of my good friends that you're the man to put their money on.' He leaned forward in his chair. 'Don't underestimate yourself, Oliver. The survey that came out a couple of months ago listed you as the

third most effective governor in the country. Well, you have something that the other two don't have. I told you this before – charisma. That is something that money can't buy. People like you, and they're going to vote for you.'

Oliver was getting more and more excited. 'When do we get started?'

'We've already started,' Senator Davis told him. 'We're going to build a strong campaign team, and we're going to start lining up delegates around the country.'

'How realistic are my chances?'

'In the primaries, you're going to blow everyone away,' Tager replied. 'As for the general election, President Norton is riding pretty high. If you had to run against him, he'd be pretty tough to beat. The good news, of course, is that since this is his second term, he can't run again and Vice President Cannon is a pale shadow. A little sunshine will make him disappear.'

The meeting lasted for four hours. When it was over, Senator Davis said to Tager, 'Peter, would you excuse us for a minute?'

'Certainly, Senator.'

They watched him go out the door.

Senator Davis said, 'I had a talk with Jan this morning.'

Oliver felt a small frisson of alarm. 'Yes?'

Senator Davis looked at Oliver and smiled. 'She's very happy.'

131

Oliver breathed a sigh of relief. 'I'm glad.'

'So am I, son. So am I. Just keep the home fires burning. You know what I mean?'

'Don't worry about that, Todd. I –'

Senator Davis's smile faded. 'I do worry about it, Oliver. I can't fault you for being horny – just don't let it turn you into a toad.'

As Senator Davis and Peter Tager were walking through the corridor of the state capitol, the senator said, 'I want you to start putting a staff together. Don't spare any expense. To begin with, I want campaign offices in New York, Washington, Chicago, and San Francisco. Primaries begin in twelve months. The convention is eighteen months away. After that, we should have smooth sailing.' They had reached the car. 'Ride with me to the airport, Peter.'

'He'll make a wonderful president.'

Senator Davis nodded. *And I'll have him in my pocket,* he thought. *He's going to be my puppet. I'll pull the strings, and the President of the United States will speak.*

The senator pulled a gold cigar case from his pocket. 'Cigar?'

The primaries around the country started well. Senator Davis had been right about Peter Tager. He was one of the best political managers in the world, and the

organization he created was superb. Because Tager was a strong family man and a deeply religious churchgoer, he attracted the religious right. Because he knew what made politics work, he was also able to persuade the liberals to put aside their differences and work together. Peter Tager was a brilliant campaign manager, and his raffish black eye patch became a familiar sight on all the networks.

Tager knew that if Oliver was to be successful, he would have to go into the convention with a minimum of two hundred delegate votes. He intended to see to it that Oliver got them.

The schedule Tager drew up included multiple trips to every state in the union.

Oliver looked at the program and said, 'This – this is impossible, Peter!'

'Not the way we've set it up,' Tager assured him. 'It's all been coordinated. The senator's lending you his Challenger. There will be people to guide you every step of the way, and I'll be at your side.'

Senator Davis introduced Sime Lombardo to Oliver. Lombardo was a giant of a man, tall and burly, dark both physically and emotionally, a brooding man who spoke little.

'How does he fit into the picture?' Oliver asked the senator when they were alone.

Senator Davis said, 'Sime is our problem-solver. Some-times people need a little persuasion to go along. Sime is very convincing.'

Oliver did not pursue it any further.

When the presidential campaign began in earnest, Peter Tager gave Oliver detailed briefings on what to say, when to say it, and how to say it. He saw to it that Oliver made appearances in all the key electoral states. And wherever Oliver went, he said what people wanted to hear.

In Pennsylvania: 'Manufacturing is the lifeblood of this country. We're not going to forget that. We're going to open up the factories again and get America back on the track!'

Cheers.

In California: 'The aircraft industry is one of America's most vital assets. There's no reason for a single one of your plants to be shut down. We're going to open them up again.'

Cheers.

In Detroit: 'We invented cars, and the Japanese took the technology away from us. Well, we're going to get back our rightful place as number one. Detroit's going to be the automobile center of the world again!'

Cheers.

At college campuses, it was federally guaranteed student loans.

In speeches at army bases around the country, it was preparedness.

In the beginning, when Oliver was relatively unknown, the odds were stacked against him. As the campaign went on, the polls showed him moving up.

The first week in July, more than four thousand delegates and alternates, along with hundreds of party officials and candidates, gathered at the convention in Cleveland and turned the city upside down with parades and floats and parties. Television cameras from all over the world recorded the spectacle. Peter Tager and Sime Lombardo saw to it that Governor Oliver Russell was always in front of the lenses.

There were half a dozen possible nominees in Oliver's party, but Senator Todd Davis had worked behind the scenes to assure that, one by one, they were eliminated. He ruthlessly called in favors owed, some as old as twenty years.

'Toby, it's Todd. How are Emma and Suzy? . . . Good. I want to talk to you about your boy, Andrew. I'm worried about him, Toby. You know, in my opinion, he's too liberal. The South will never accept him. Here's what I suggest . . .'

'Alfred, it's Todd. How's Roy doing? . . . No need to thank me. I was happy to help him out. I want to talk to you about your candidate, Jerry. In my opinion, he's too right-wing. If we go with him, we'll lose the North. Now, here's what I would suggest . . .'

'Kenneth – Todd. I just wanted to tell you that I'm glad that real estate deal worked out for you. We all did pretty well, didn't we? By the way, I think we ought to have a little talk about Slater. He's weak. He's a loser. We can't afford to back a loser, can we? . . .'

And so it went, until practically the only viable candidate left to the party was Governor Oliver Russell.

The nomination process went smoothly. On the first ballot, Oliver Russell had seven hundred votes: more than two hundred from six northeastern industrial states, one hundred and fifty from six New England states, forty from four southern states, another one hundred and eighty from two farm states, and the balance from three Pacific states.

Peter Tager was working frantically to make sure the publicity train kept rolling. When the final tally was counted, Oliver Russell was the winner. And with the excitement of the circus atmosphere that had carefully been created, Oliver Russell was nominated by acclamation.

The next step was to choose a vice president. Melvin Wicks was a perfect choice. He was a politically correct Californian, a wealthy entrepreneur, and a personable congressman.

'They'll complement each other,' Tager said. 'Now the real work begins. We're going after the magic number – two hundred and seventy.' The number of electoral votes needed to win the presidency.

Tager told Oliver, 'The people want a young leader ... Good-looking, a little humor and a vision ... They want you to tell them how great they are – and they want to believe it. ... Let them know you're smart, but don't be too smart ... If you attack your opponent, keep it impersonal ... Never look down on a reporter. Treat them as friends, and they'll be your friends ... Try to avoid any show of pettiness. Remember – you're a statesman.'

The campaign was nonstop. Senator Davis's jet carried Oliver to Texas for three days, California for a day, Michigan for half a day, Massachusetts for six hours. Every minute was accounted for. Some days Oliver would visit as many as ten towns and deliver ten speeches. There was a different hotel every night, the Drake in Chicago, the St Regis in Detroit, the Carlyle in New York City, the Place d'Armes in New Orleans, until, finally, they all seemed to blend into one. Wherever Oliver went, there were police cars leading the procession, large crowds, and cheering voters.

Jan accompanied Oliver on most of the trips, and he had to admit that she was a great asset. She was attractive and intelligent, and the reporters liked her. From time to time, Oliver read about Leslie's latest acquisitions: a newspaper in Madrid, a television station in Mexico, a

radio station in Kansas. He was happy for her success. It made him feel less guilty about what he had done to her.

Everywhere Oliver went, the reporters photographed him, interviewed him, and quoted him. There were more than a hundred correspondents covering his campaign, some of them from countries at the far ends of the earth. As the campaign neared its climax, the polls showed that Oliver Russell was the front-runner. But unexpectedly, his opponent, Vice President Cannon, began overtaking him.

Peter Tager became worried. 'Cannon's moving up in the polls. We've got to stop him.'

Two television debates between Vice President Cannon and Oliver had been agreed upon.

'Cannon is going to discuss the economy,' Tager told Oliver, 'and he'll do a good job. We have to fake him out. Here's my plan . . .'

The night of the first debate, in front of the television cameras, Vice President Cannon talked about the economy. 'America has never been more economically sound. Business is flourishing.' He spent the next ten minutes elaborating on his theme, proving his points with facts and figures.

When it was Oliver Russell's turn at the microphone, he said, 'That was very impressive. I'm sure we're all

pleased that big business is doing so well and that corporate profits have never been higher.' He turned to his opponent. 'But you forgot to mention that one of the reasons corporations are doing so well is because of what is euphemistically termed "down-sizing." To put it bluntly, downsizing simply means that people are being fired to make way for machines. More people are out of work than ever before. It's the human side of the picture we should be examining. I don't happen to share your view that corporate financial success is more important than people . . .' And so it went.

Where Vice President Cannon had talked about business, Oliver Russell took a humanitarian approach and talked about emotions and opportunities. By the time he was through, Russell had managed to make Cannon sound like a cold-blooded politician who cared nothing about the American people.

The morning after the debate, the polls shifted, putting Oliver Russell within three points of the vice president. There was to be one more national debate.

Arthur Cannon had learned his lesson. At the final debate, he stood before the microphone and said, 'Ours is a land where all people must have equal opportunities. America has been blessed with freedom, but that alone is not enough. Our people must have the freedom to work, and earn a decent living . . .'

He stole Oliver Russell's thunder by concentrating on

all the wonderful plans he had in mind for the welfare of the people. But Peter Tager had anticipated that. When Cannon was finished, Oliver Russell stepped to the microphone.

'That was very touching. I'm sure we were all very moved by what you had to say about the plight of the unemployed, and, as you called him, the "forgotten man." What disturbs me is that you forgot to say how you are going to do all those wonderful things for those people.' And from then on, where Vice President Cannon had dealt in emotions, Oliver Russell talked about issues and his economic plans, leaving the vice president hanging high and dry.

Oliver, Jan, and Senator Davis were having dinner at the senator's mansion in Georgetown. The senator smiled at Jan. 'I've just seen the latest polls. I think you can begin redecorating the White House.'

Her face lit up. 'Do you really think we're going to win, Father?'

'I'm wrong about a lot of things, honey, but never about politics. That's my life's blood. In November, we're going to have a new president, and he's sitting right next to you.'

Ten

'Fasten your seat belts, please.'

Here we go! Dana thought excitedly. She looked over at Benn Albertson and Wally Newman. Benn Albertson, Dana's producer, was a hyperkinetic bearded man in his forties. He had produced some of the top-rated news shows in television and was highly respected. Wally Newman, the cameraman, was in his early fifties. He was talented and enthusiastic, and eagerly looking forward to his new assignment.

Dana thought about the adventure that lay ahead. They would land in Paris and then fly to Zagreb, Croatia, and finally to Sarajevo.

During her last week in Washington, Dana had been briefed by Shelley McGuire, the foreign editor. 'You'll need a truck in Sarajevo to transmit your stories to the satellite,' McGuire told her. 'We don't own one there so we'll rent a truck and buy time from the Yugoslav company that owns the satellite. If things go well, we'll

get our own truck later. You'll be operating on two different levels. Some stories you'll cover live, but most of them will be taped. Benn Albertson will tell you what he wants, and you'll shoot the footage and then do a sound track in a local studio. I've given you the best producer and cameraman in the business. You shouldn't have any problem.'

Dana was to remember those optimistic words later.

The day before Dana left, Matt Baker had telephoned. 'Get over to my office.' His voice was gruff.

'I'll be right there.' Dana had hung up with a feeling of apprehension. *He's changed his mind about approving my transfer and he's not going to let me go. How could he do this to me? Well,* she thought determinedly, *I'm going to fight him.*

Ten minutes later, Dana was marching into Matt Baker's office.

'I know what you're going to say,' she began, 'but it won't do you any good. I'm going! I've dreamed about this since I was a little girl. I think I can do some good over there. You've got to give me a chance to try.' She took a deep breath. 'All right,' Dana said defiantly. 'What did you want to say?'

Matt Baker looked at her and said mildly, '*Bon voyage.*'

Dana blinked. 'What?'

'*Bon voyage.* It means "good journey."'

'I know what it means. I – didn't you send for me to –?'

'I sent for you because I've spoken to a few of our foreign correspondents. They gave me some advice to pass on to you.'

This gruff bear of a man had taken the time and trouble to talk to some foreign correspondents so that he could help her! 'I – I don't know how to –'

'Then don't,' he grunted. 'You're going into a shooting war. There's no guarantee you can protect yourself a hundred percent, because bullets don't give a damn who they kill. But when you're in the middle of action, the adrenaline starts to flow. It can make you reckless, and you do stupid things you wouldn't ordinarily do. You have to control that. Always play it safe. Don't wander around the streets alone. No news story is worth your life. Another thing . . .'

The lecture had gone on for almost an hour. Finally, he said, 'Well, that's it. Take care of yourself. If you let anything happen to you, I'm going to be damned mad.'

Dana had leaned over and kissed him on the cheek.

'Don't ever do that again,' he snapped. He stood up. 'It's going to be rough over there, Dana. If you should change your mind when you get there and want to come home, just let me know, and I'll arrange it.'

'I won't change my mind,' Dana said confidently.

As it turned out, she was wrong.

* * *

The flight to Paris was uneventful. They landed at Charles de Gaulle Airport and the trio took an airport minibus to Croatia Airlines. There was a three-hour delay.

At ten o'clock that night, the Croatia Airlines plane landed at Butmir Airport in Sarajevo. The passengers were herded into a security building, where their passports were checked by uniformed guards and they were waved on. As Dana moved toward the exit, a short, unpleasant-looking man in civilian clothes stepped in front of her, blocking her way. 'Passport.'

'I showed them my –'

'I am Colonel Gordan Divjak. Your passport.'

Dana handed her passport to him, along with her press credentials.

He flipped through it. 'A journalist?' He looked at her sharply. 'Whose side are you on?'

'I'm not on anyone's side,' Dana said evenly.

'Just be careful what you report,' Colonel Divjak warned. 'We do not treat espionage lightly.'

Welcome to Sarajevo.

A bulletproof Land Rover was at the airport to meet them. The driver was a swarthy-looking man in his early twenties. 'I am Jovan Tolj, for your pleasure. I will be your driver in Sarajevo.'

Jovan drove fast, swerving around corners and racing through deserted streets as though they were being pursued.

'Excuse me,' Dana said nervously. 'Is there any special hurry?'

'Yes, if you want to get there alive.'

'But –'

In the distance, Dana heard the sound of rumbling thunder, and it seemed to be coming closer.

What she was hearing was not thunder.

In the darkness, Dana could make out buildings with shattered fronts, apartments without roofs, stores without windows. Ahead, she could see the Holiday Inn, where they were staying. The front of the hotel was badly pockmarked, and a deep hole had been gouged in the driveway. The car sped past it.

'Wait! This is our hotel,' Dana cried. 'Where are you going?'

'The front entrance is too dangerous,' Jovan said. He turned the corner and raced into an alley. 'Everyone uses the back entrance.'

Dana's mouth was suddenly dry. 'Oh.'

The lobby of the Holiday Inn was filled with people milling about and chatting. An attractive young Frenchman approached Dana. 'Ah, we have been expecting you. You are Dana Evans?'

'Yes.'

'Jean Paul Hubert, M6, Métropole Télévision.'

'I'm happy to meet you. This is Benn Albertson and Wally Newman.' The men shook hands.

'Welcome to what's left of our rapidly disappearing city.'

Others were approaching the group to welcome them. One by one, they stepped up and introduced themselves.

'Steffan Mueller, Kabel Network.'

'Roderick Munn, BBC 2.'

'Marco Benelli, Italia I.'

'Akihiro Ishihara, TV Tokyo.'

'Juan Santos, Channel 6, Guadalajara.'

'Chun Qian, Shanghai Television.'

It seemed to Dana that every country in the world had a journalist there. The introductions seemed to go on forever. The last one was a burly Russian with a gleaming gold front tooth. 'Nikolai Petrovich, Gorizont 22.'

'How many reporters are here?' Dana asked Jean Paul.

'Over two hundred and fifty. We don't see many wars as colorful as this one. Is this your first?'

He made it sound as though it were some kind of tennis match. 'Yes.'

Jean Paul said, 'If I can be of any help, please let me know.'

'Thank you.' She hesitated. 'Who is Colonel Gordan Divjak?'

'You don't want to know. We all think he is with the Serbian equivalent of the Gestapo, but we're not sure. I would suggest you stay out of his way.'

'I'll remember.'

Later, as Dana got into her bed, there was a sudden loud explosion from across the street, and then another, and

the room began to shake. It was terrifying, and at the same time exhilarating. It seemed unreal, something out of a movie. Dana lay awake all night, listening to the sounds of the terrible killing machines and watching the flashes of light reflected in the grimy hotel windows.

In the morning, Dana got dressed – jeans, boots, flak jacket. She felt self-conscious, and yet: *'Always play it safe. . . . No news story is worth your life.'*

Dana, Benn, and Wally were in the lobby restaurant, talking about their families.

'I forgot to tell you the good news,' Wally said. 'I'm going to have a grandson next month.'

'That's great!' And Dana thought: *Will I ever have a child and a grandchild? Que será será.*

'I have an idea,' Benn said. 'Let's do a general story first on what's happening here and how the people's lives have been affected. I'll go with Wally and scout locations. Why don't you get us some satellite time, Dana?'

'Fine.'

Jovan Tolj was in the alley, in the Land Rover. *'Dobro jutro.* Good morning.'

'Good morning, Jovan. I want to go to the place where they rent satellite time.'

As they drove, Dana was able to get a clear look at Sarajevo for the first time. It seemed to her that there

was not a building that had been untouched. The sound of gunfire was continuous.

'Don't they ever stop?' Dana asked.

'They will stop when they run out of ammunition,' Jovan said bitterly. 'And they will never run out of ammunition.'

The streets were deserted, except for a few pedestrians, and all the cafés were closed. Pavements were pockmarked with shell craters. They passed the *Oslobodjenje* building.

'That is our newspaper,' Jovan said proudly. 'The Serbs keep trying to destroy it, but they cannot.'

A few minutes later, they reached the satellite offices. 'I will wait for you,' Jovan said.

Behind a desk in the lobby, there was a receptionist who appeared to be in his eighties.

'Do you speak English?' Dana asked.

He looked at her wearily. 'I speak nine languages, madam. What do you wish?'

'I'm with WTE. I want to book some satellite time and arrange –'

'Third floor.'

The sign on the door read: YUGOSLAVIA SATELLITE DIVISION. The reception room was filled with men seated on wooden benches lined against the walls.

Dana introduced herself to the young woman at the

reception desk. 'I'm Dana Evans, with WTE. I want to book some satellite time.'

'Take a seat, please, and wait your turn.'

Dana looked around the room. 'Are all these people here to book satellite time?'

The woman looked up at her and said, 'Of course.'

Almost two hours later, Dana was ushered into the office of the manager, a short, squat man with a cigar in his mouth; he looked like the old cliché prototype of a Hollywood producer.

He had a heavy accent. 'How can I help you?'

'I'm Dana Evans, with WTE. I'd like to rent one of your trucks and book the satellite for half an hour. Six o'clock in Washington would be a good time. And I'll want that same time every day indefinitely.' She looked at his expression. 'Any problem?'

'One. There are no satellite trucks available. They have all been booked. I will give you a call if someone cancels.'

Dana looked at him in dismay. 'No –? But I need some satellite time,' she said. 'I'm –'

'So does everybody else, madam. Except for those who have their own trucks, of course.'

When Dana returned to the reception room, it was full. *I have to do something about this,* she thought.

* * *

When Dana left the satellite office, she said to Jovan, 'I'd like you to drive me around the city.'

He turned to look at her, then shrugged. 'As you wish.' He started the car and began to race through the streets.

'A little slower, please. I need to get a feel of this place.'

Sarajevo was a city under siege. There was no running water or electricity, and more houses were being bombed every hour. The air raid alarm went on so frequently that people ignored it. A miasma of fatalism seemed to hang over the city. If the bullet had your name on it, there was nowhere to hide.

On almost every street corner, men, women, and children were peddling the few possessions they had left.

'They are refugees from Bosnia and Croatia,' Jovan explained, 'trying to get enough money to buy food.'

Fires were raging everywhere. There were no firemen in sight.

'Isn't there a fire department?' Dana asked.

He shrugged. 'Yes, but they don't dare come. They make too good a target for Serb snipers.'

In the beginning, the war in Bosnia and Herzegovina had made little sense to Dana. It was not until she had been in Sarajevo for a week that she realized that it made no sense at all. No one could explain it. Someone had mentioned a professor from the university, who was a well-known historian. He had been wounded and was confined to his home. Dana decided to have a talk with him.

Jovan drove her to one of the old neighborhoods in the city, where the professor lived. Professor Mladic Staka was a small, gray-haired man, almost ethereal in appearance. A bullet had shattered his spine and paralyzed him.

'Thank you for coming,' he said. 'I do not get many visitors these days. You said you needed to talk to me.'

'Yes. I'm supposed to be covering this war,' Dana told him. 'But to tell the truth, I'm having trouble understanding it.'

'The reason is very simple, my dear. This war in Bosnia and Herzegovina is beyond understanding. For decades, the Serbs, Croats, Bosnians, and Muslims lived together in peace, under Tito. They were friends and neighbors. They grew up together, worked together, went to the same schools, intermarried.'

'And now?'

'These same friends are torturing and murdering one another. Their hatred has made them do things so disgusting that I cannot even speak about them.'

'I've heard some of the stories,' Dana said. The stories she had heard were almost beyond belief: a well filled with bloody human testicles, babies raped and slaughtered, innocent villagers locked in churches that were then set on fire.

'Who started this?' Dana asked.

He shook his head. 'It depends on whom you ask. During the Second World War, hundreds of thousand of Serbs, who were on the side of the Allies, were wiped

out by the Croats, who were on the side of the Nazis. Now the Serbs are taking their bloody revenge. They are holding the country hostage, and they are merciless. More than two hundred thousand shells have fallen on Sarajevo alone. At least ten thousand people have been killed and more than sixty thousand injured. The Bosnians and Muslims must bear the responsibility for their share of the torture and killing. Those who do not want war are being forced into it. No one can trust anyone. The only thing they have left is hate. What we have is a conflagration that keeps feeding on itself, and what fuels the fires is the bodies of the innocent.'

When Dana returned to her hotel that afternoon, Benn Albertson was waiting there to tell her that he had received a message that a truck and satellite time would be available to them the following day at 6:00 P.M.

'I found the ideal place for us to shoot,' Wally Newman told her. 'There's a square with a Catholic church, a mosque, a Protestant church, and a synagogue, all within a block of one another. They've all been bombed out. You can write a story about equal-opportunity hatred, and what it has done to the people who live here, who don't want anything to do with the war but are forced to be a part of it.'

Dana nodded, excited. 'Great. I'll see you at dinner. I'm going to work.' She headed for her room.

* * *

At six o'clock the following evening, Dana and Wally and Benn were gathered in front of the square where the bombed-out churches and synagogue were located. Wally's television camera had been set up on a tripod, and Benn was waiting for confirmation from Washington that the satellite signal was good. Dana could hear sniper fire in the near background. She was suddenly glad she was wearing her flak jacket. *There's nothing to be afraid of. They're not shooting at us. They're shooting at one another. They need us to tell the world their story.*

Dana saw Wally signal. She took a deep breath, looked into the camera lens, and began.

'The bombed-out churches you see behind me are a symbol of what is happening in this country. There are no walls for people to hide behind anymore, no place that is safe. In earlier times, people could find sanctuary in their churches. But here, the past and the present and the future have all blended together and –'

At that second, she heard a shrill approaching whistle, looked up, and saw Wally's head explode into a red melon. *It's a trick of the light,* was Dana's first thought. And then she watched, aghast, as Wally's body slammed to the pavement. Dana stood there, frozen, unbelieving. People around her were screaming.

The sound of rapid sniper fire came closer, and Dana began to tremble uncontrollably. Hands grabbed her and rushed her down the street. She was fighting them, trying to free herself.

No! We have to go back. We haven't used up our ten

minutes. Waste not, want not ... it was wrong to waste things. 'Finish your soup, darling. Children in China are starving.' You think you're some kind of God up there, sitting on a white cloud? Well, let me tell you something. You're a fake. A real God would never, never, never let Wally's head be blown off. Wally was expecting his first grandson. Are you listening to me? Are you? Are you?

She was in a state of shock, unaware that she was being led through a back street to the car.

When Dana opened her eyes, she was in her bed. Benn Albertson and Jean Paul Hubert were standing over her.

Dana looked up into their faces. 'It happened, didn't it?' She squeezed her eyes tightly shut.

'I'm so sorry,' Jean Paul said. 'It's an awful thing to see. You're lucky you weren't killed.'

The telephone jarred the stillness of the room. Benn picked it up. 'Hello.' He listened a moment. 'Yes. Hold on.' He turned to Dana. 'It's Matt Baker. Are you able to talk to him?'

'Yes.' Dana sat up. After a moment, she rose and walked over to the telephone. 'Hello.' Her throat was dry, and it was difficult to speak.

Matt Baker's voice boomed over the line. 'I want you to come home, Dana.'

Her voice was a whisper. 'Yes. I want to come home.'

'I'll arrange for you to be on the first plane out of there.'

'Thank you.' She dropped the telephone.

Jean Paul and Benn helped her back into bed.

'I'm sorry,' Jean Paul said, again. 'There's – there's nothing anyone can say.'

Tears were running down her cheeks. 'Why did they kill him? He never harmed anyone. What's happening? People are being slaughtered like animals and no one cares. No one cares!'

Benn said, 'Dana, there's nothing we can do about –'

'There has to be!' Dana's voice was filled with fury. 'We have to make them care. This war isn't about bombed-out churches or buildings or streets. It's about people – innocent people – getting their heads blown off. Those are the stories we should be doing. That's the only way to make this war real.' She turned to Benn and took a deep breath. 'I'm staying, Benn. I'm not going to let them scare me away.'

He was watching her, concerned. 'Dana, are you sure you –?'

'I'm sure. I know what I have to do now. Will you call Matt and tell him?'

He said reluctantly, 'If that's what you really want.'

Dana nodded. 'It's what I really want.' She watched Benn leave the room.

Jean Paul said, 'Well, I had better go and let you –'

'No.' For an instant, Dana's mind was filled with a vision of Wally's head exploding, and his body falling to the ground. 'No,' Dana said. She looked up at Jean Paul. 'Please stay. I need you.'

Jean Paul sat down on the bed. And Dana took him in her arms and held him close to her.

The following morning, Dana said to Benn Albertson, 'Can you get hold of a cameraman? Jean Paul told me about an orphanage in Kosovo that's just been bombed. I want to go there and cover it.'

'I'll round up someone.'

'Thanks, Benn. I'll go on ahead and meet you there.'

'Be careful.'

'Don't worry.'

Jovan was waiting for Dana in the alley.

'We're going to Kosovo,' Dana told him.

Jovan turned to look at her. 'That is dangerous, madam. The only road there is through the woods, and –'

'We've already had our share of bad luck, Jovan. We'll be all right.'

'As you wish.'

They sped through the city, and fifteen minutes later were driving through a heavily forested area.

'How much farther?' Dana asked.

'Not far. We should be there in –'

And at that moment, the Land Rover struck a land mine.

Eleven

As election day approached, the presidential race became too close to call.

'We've got to win Ohio,' Peter Tager said. 'That's twenty-one electoral votes. We're all right with Alabama – that's nine votes – and we have Florida's twenty-five votes.' He held up a chart. 'Illinois, twenty-two votes . . . New York, thirty-three, and California, forty-four. It's just too damned early to call it.'

Everyone was concerned except Senator Davis.

'I've got a nose,' he said. 'I can smell victory.'

In a Frankfort hospital, Miriam Friedland was still in a coma.

On election day, the first Tuesday in November, Leslie stayed home to watch the returns on television. Oliver Russell won by more than two million popular votes and a huge majority of electoral votes. Oliver Russell was the

president now, the biggest target in the world.

No one had followed the election campaign more closely than Leslie Stewart Chambers. She had been busily expanding her empire and had acquired a chain of newspapers and television and radio stations across the United States, as well as in England, Australia, and Brazil.

'When are you going to have enough?' her chief editor, Darin Solana, asked.

'Soon,' Leslie said. 'Soon.'

There was one more step she had to take, and the last piece fell into place at a dinner party in Scottsdale.

A guest said, 'I heard confidentially that Margaret Portman is getting a divorce.' Margaret Portman was the owner of the *Washington Tribune*, in the nation's capital.

Leslie had no comment, but early the following morning, she was on the telephone with Chad Morton, one of her attorneys. 'I want you to find out if the *Washington Tribune* is for sale.'

The answer came back later that day. 'I don't know how you heard about it, Mrs Chambers, but it looks as though you could be right. Mrs Portman and her husband are quietly getting a divorce, and they're dividing up their property. I think Washington Tribune Enterprises is going up for sale.'

'I want to buy it.'

'You're talking about a megadeal. Washington Tribune Enterprises owns a newspaper chain, a magazine, a television network, and –'

'I want it.'

That afternoon, Leslie and Chad Morton were on their way to Washington, D.C.

Leslie telephoned Margaret Portman, whom she had met casually a few years earlier.

'I'm in Washington,' Leslie said, 'and I –'

'I know.'

Word gets around fast, Leslie thought. 'I heard that you might be interested in selling Tribune Enterprises.'

'Possibly.'

'I wonder if you would arrange a tour of the paper for me?'

'Are you interested in buying it, Leslie?'

'Possibly.'

Margaret Portman sent for Matt Baker. 'Do you know who Leslie Chambers is?'

'The Ice Princess. Sure.'

'She'll be here in a few minutes. I'd like you to take her on a tour of the plant.'

Everyone at the *Tribune* was aware of the impending sale.

'It would be a mistake to sell the *Tribune* to Leslie Chambers,' Matt Baker said flatly.

'What makes you say that?'

'First of all, I doubt if she really knows a damn thing about the newspaper business. Have you looked at what she's done to the other papers she bought?

She's turned respectable newspapers into cheap tabloids. She'll destroy the *Tribune*. She's –' He looked up. Leslie Chambers was standing in the doorway, listening.

Margaret Portman spoke up. 'Leslie! How nice to see you. This is Matt Baker, our editor in chief of Tribune Enterprises.'

They exchanged cool greetings.

'Matt is going to show you around.'

'I'm looking forward to it.'

Matt Baker took a deep breath. 'Right. Let's get started.'

At the beginning of the tour, Matt Baker said condescendingly, 'The structure is like this: At the top is the editor in chief –'

'That would be you, Mr Baker.'

'Right. And under me, the managing editor and the editorial staff. That includes Metro, National, Foreign, Sports, Business, Life and Style, People, Calendar, Books, Real Estate, Travel, Food ... I'm probably leaving a few out.'

'Amazing. How many employees does Washington Tribune Enterprises have, Mr Baker?'

'Over five thousand.'

They passed a copy desk. 'Here's where the news editor lays out the pages. He's the one who decides where the photos are going to go and which stories appear on which pages. The copy desk writes the headlines,

edits the stories, and then puts them together in the composing room.'

'Fascinating.'

'Are you interested in seeing the printing plants?'

'Oh, yes. I'd like to see everything.'

He mumbled something under his breath.

'I'm sorry?'

'I said, "Fine."'

They took the elevator down and walked over to the next building. The printing plant was four stories high and the size of four football fields. Everything in the huge space was automated. There were thirty robot carts in the building, carrying enormous rolls of paper that they dropped off at various stations.

Baker explained, 'Each roll of paper weighs about twenty-five hundred pounds. If you unrolled one, it would be eight miles long. The paper goes through the presses at twenty-one miles an hour. Some of the bigger carts can carry sixteen rolls at once.'

There were six presses, three on each side of the room. Leslie and Matt Baker stood there and watched as the newspapers were automatically assembled, cut, folded, put into bales, and delivered to the trucks waiting to carry them off.

'In the old days it took about thirty men to do what one man can do today,' Matt Baker said. 'The age of technology.'

Leslie looked at him a moment. 'The age of downsizing.'

'I don't know if you're interested in the economics of the operation?' Matt Baker asked dryly. 'Perhaps you'd prefer your lawyer or accountant to –'

'I'm very interested, Mr Baker. Your editorial budget is fifteen million dollars. Your daily circulation is eight hundred and sixteen thousand, four hundred and seventy-four, and one million, one hundred and forty thousand, four hundred and ninety-eight on Sunday, and your advertising is sixty-eight point two.'

Matt looked at her and blinked.

'With the ownership of all your newspapers, your daily circulation is over two million, with two million four Sunday circulation. Of course, that's not the largest paper in the world, is it, Mr Baker? Two of the largest newspapers in the world are printed in London. The *Sun* is the biggest, with a circulation of four million daily. The *Daily Mirror* sells over three million.'

He took a deep breath. 'I'm sorry. I didn't realize you –

'In Japan, there are over two hundred dailies, including *Asahi Shimbun*, *Mainchi Shimbun*, and *Yomiuri Shimbun*. Do you follow me?'

'Yes. I apologize if I seemed patronizing.'

'Accepted, Mr Baker. Let's go back to Mrs Portman's office.'

The next morning, Leslie was in the executive conference room of the *Washington Tribune*, facing Mrs Portman and half a dozen attorneys.

'Let's talk about price,' Leslie said. The discussion lasted four hours, and when it was over, Leslie Stewart Chambers was the owner of Washington Tribune Enterprises.

It was more expensive than Leslie had anticipated. It did not matter.

There was something more important.

The day the deal was finalized, Leslie sent for Matt Baker. 'What are your plans?' Leslie asked.

'I'm leaving.'

She looked at him curiously. 'Why?'

'You have quite a reputation. People don't like working for you. I think the word they use most is "ruthless." I don't need that. This is a good newspaper, and I hate to leave it, but I have more job offers than I can handle.'

'How long have you worked here?'

'Fifteen years.'

'And you're going to just throw that away?'

'I'm not throwing anything away, I'm –'

She looked him in the eye. 'Listen to me. I think the *Tribune* is a good newspaper, too, but I want it to be a great newspaper. I want you to help me.'

'No. I don't –'

'Six months. Try it for six months. We'll start by doubling your salary.'

He studied her for a long moment. Young and beautiful and intelligent. And yet . . . He had an uneasy feeling about her.

'Who will be in charge here?'

She smiled. 'You're the editor in chief of Washington Tribune Enterprises. You will be.'

And he believed her.

Twelve

It had been six months since Dana's Land Rover had been blown up. She escaped with nothing worse than a concussion, a cracked rib, a broken wrist, and painful bruises. Jovan suffered a fractured leg and scrapes and bruises. Matt Baker had telephoned Dana that night and ordered her to return to Washington, but the incident had made Dana more determined than ever to stay.

'These people are desperate,' Dana told him. 'I can't just walk away from this. If you order me home, then I quit.'

'Are you blackmailing me?'

'Yes.'

'That's what I thought,' Matt snapped. 'I don't let anyone blackmail me. Do you understand?'

Dana waited.

'What about a leave of absence?' he asked.

'I don't need a leave of absence.' She could hear his sigh over the phone.

'All right. Stay there. But, Dana –'

'Yes?'

'Promise me that you'll be careful.'

From outside the hotel, Dana could hear the sound of machine-gun fire. 'Right.'

The city had been under heavy attack all night. Dana had been unable to sleep. Each explosion of a mortar landing meant another building destroyed, another family homeless, or worse, dead.

Early in the morning, Dana and her crew were out on the street, ready to shoot. Benn Albertson waited for the thunder of a mortar to fade away, then nodded to Dana. 'Ten seconds.'

'Ready,' Dana said.

Benn pointed a finger, and Dana turned away from the ruins behind her and faced the television camera.

'This is a city that is slowly disappearing from the face of the earth. With its electricity cut off, its eyes have been put out ... Its television and radio stations have been shut down, and it has no ears ... All public transportation has come to a halt, so it has lost its legs ...'

The camera panned to show a deserted, bombed-out playground, with the rusty skeletons of swings and slides.

'In another life, children played here, and the sound of their laughter filled the air.'

Mortar fire could be heard again in the near distance. An air raid alarm suddenly sounded. The people walking the streets behind Dana continued as though they had heard nothing.

'The sound you're hearing is another air raid alarm. It's the signal for people to run and hide. But the citizens of Sarajevo have found that there is no place to hide, so they walk on in their own silence. Those who can, flee the country, and give up their apartments and all their possessions. Too many who stay, die. It's a cruel choice. There are rumors of peace. Too many rumors, too little peace. Will it come? And when? Will the children come out of their cellars and use this playground again one day? Nobody knows. They can only hope. This is Dana Evans reporting from Sarajevo for WTE.'

The red light on the camera blinked off. 'Let's get out of here,' Benn said.

Andy Casarez, the new cameraman, hurriedly started to pack up his gear.

A young boy was standing on the sidewalk, watching Dana. He was a street urchin, dressed in filthy, ragged clothes and torn shoes. Intense brown eyes flashed out of a face streaked with dirt. His right arm was missing.

Dana watched the boy studying her. Dana smiled. 'Hello.'

There was no reply. Dana shrugged and turned to Benn.

'Let's go.'

A few minutes later, they were on their way back to the Holiday Inn.

The Holiday Inn was filled with newspaper, radio, and

television reporters, and they formed a disparate family. They were rivals, but because of the dangerous circumstances they found themselves in, they were always ready to help one another. They covered breaking stories together:

There was a riot in Montenegro . . .

There was a bombing in Vukovar . . .

A hospital had been shelled in Petrovo Selo . . .

Jean Paul Hubert was gone. He had been given another assignment, and Dana missed him terribly.

As Dana was leaving the hotel one morning, the little boy she had seen on the street was standing in the alley.

Jovan opened the door of the replacement Land Rover for Dana. 'Good morning, madam.'

'Good morning.' The boy stood there, staring at Dana. She walked over to him. 'Good morning.'

There was no reply. Dana said to Jovan, 'How do you say "good morning" in Slovene?'

The little boy answered, '*Dobro jutro.*'

Dana turned to him. 'So you understand English.'

'Maybe.'

'What's your name?'

'Kemal.'

'How old are you, Kemal?'

He turned and walked away.

'He's frightened of strangers,' Jovan said.

Dana looked after the boy. 'I don't blame him. So am I.'

Four hours later, when the Land Rover returned to the alley in back of the Holiday Inn, Kemal was waiting near the entrance.

As Dana got out of the car, Kemal said, 'Twelve.'

'What?' Then Dana remembered. 'Oh.' He was small for his age. She looked at his empty right shirtsleeve and started to ask him a question, then stopped herself. 'Where do you live, Kemal? Can we take you home?' She watched him turn and walk away.

Jovan said, 'He has no manners.'

Dana said quietly, 'Maybe he lost them when he lost his arm.'

That evening in the hotel dining room, the reporters were talking about the new rumors of an imminent peace. 'The UN has finally gotten involved,' Gabriella Orsi declared.

'It's about time.'

'If you ask me, it's too late.'

'It's never too late,' Dana said quietly.

The following morning, two news stories came over the wires. The first one was about a peace agreement brokered by the United States and the United Nations. The second story was that *Oslobodjenje*, Sarajevo's newspaper, had been bombed out of existence.

'Our Washington bureaus are covering the peace agreement,' Dana told Benn. 'Let's do a story on *Oslobodjenje*.'

Dana was standing in front of the demolished building that had once housed *Oslobodjenje*. The camera's red light was on.

'People die here every day,' Dana said into the lens, 'and buildings are destroyed. But this building was murdered. It housed the only free newspaper in Sarajevo, *Oslobodjenje*. It was a newspaper that dared to tell the truth. When it was bombed out of its headquarters, it was moved into the basement, to keep the presses alive. When there were no more newsstands to sell the papers from, its reporters went out on the streets to peddle them themselves. They were selling more than newspapers. They were selling freedom. With the death of *Oslobodjenje*, another piece of freedom has died here.'

In his office, Matt Baker was watching the news broadcast. 'Dammit, she's good!' He turned to his assistant. 'I want her to have her own satellite truck. Move on it.'

'Yes, sir.'

When Dana returned to her room, there was a visitor waiting for her. Colonel Gordan Divjak was lounging in a chair when Dana walked in.

She stopped, startled. 'They didn't tell me I had a visitor.'

'This is not a social visit.' His beady black eyes focused on her. 'I watched your broadcast about *Oslobodjenje*.'

Dana studied him warily. 'Yes?'

'You were permitted to come into our country to report, not to make judgments.'

'I didn't make any –'

'Do not interrupt me. Your idea of freedom is not necessarily our idea of freedom. Do you understand me?'

'No. I'm afraid I –'

'Then let me explain it to you, Miss Evans. You are a guest in my country. Perhaps you are a spy for your government.'

'I am not a –'

'Do not interrupt me. I warned you at the airport. We are not playing games. We are at war. Anyone involved in espionage will be executed.' His words were all the more chilling because they were spoken softly.

He got to his feet. 'This is your last warning.'

Dana watched him leave. *I'm not going to let him frighten me*, she thought defiantly.

She was frightened.

A care package arrived from Matt Baker. It was an enormous box filled with candy, granola bars, canned foods, and a dozen other nonperishable items. Dana took

it into the lobby to share it with the other reporters. They were delighted.

'Now, that's what I call a boss,' Satomi Asaka said.

'How do I get a job with the *Washington Tribune?*' Juan Santos joked.

Kemal was waiting in the alley again. The frayed, thin jacket he had on looked as though it was about to fall apart.

'Good morning, Kemal.'

He stood there, silent, watching her from under half-closed lids.

'I'm going shopping. Would you like to go with me?'

No answer.

'Let me put it another way,' Dana said, exasperated. She opened the back door of the vehicle. 'Get in the car. Now!'

The boy stood there a moment, shocked, then slowly moved toward the car.

Dana and Jovan watched him climb into the backseat.

Dana said to Jovan, 'Can you find a department store or clothing shop that's open?'

'I know one.'

'Let's go there.'

They rode in silence for the first few minutes.

'Do you have a mother or father, Kemal?'

He shook his head.

'Where do you live?'

He shrugged.

Dana felt him move closer to her as though to absorb the warmth of her body.

The clothing store was in the Bascarsija, the old market of Sarajevo. The front had been bombed out, but the store was open. Dana took Kemal's left hand and led him into the store.

A clerk said, 'Can I help you?'

'Yes. I want to buy a jacket for a friend of mine.' She looked at Kemal. 'He's about his size.'

'This way, please.'

In the boy's section there was a rack of jackets. Dana turned to Kemal. 'Which one do you like?'

Kemal stood there, saying nothing.

Dana said to the clerk, 'We'll take the brown one.' She looked at Kemal's trousers. 'And I think we need a pair of trousers and some new shoes.'

When they left the store half an hour later, Kemal was dressed in his new outfit. He slid into the backseat of the car without a word.

'Don't you know how to say thank you?' Jovan demanded angrily.

Kemal burst into tears. Dana put her arms around him. 'It's all right,' she said. 'It's all right.'

What kind of a world does this to children?

* * *

When they returned to the hotel, Dana watched Kemal turn and walk away without a word.

'Where does someone like that live?' Dana asked Jovan.

'On the streets, madam. There are hundreds of orphans in Sarajevo like him. They have no homes, no families . . .'

'How do they survive?'

He shrugged. 'I do not know.'

The next day, when Dana walked out of the hotel, Kemal was waiting for her, dressed in his new outfit. He had washed his face.

The big news at the luncheon table was the peace treaty and whether it would work. Dana decided to go back to visit Professor Mladic Staka and ask what he thought about it.

He looked even more frail than the last time she had seen him.

'I am happy to see you, Miss Evans. I hear you are doing wonderful broadcasts, but –' He shrugged. 'Unfortunately, I have no electricity for my television set. What can I do for you?'

'I wanted to get your opinion of the new peace treaty, Professor.'

He leaned back in his chair and said thoughtfully, 'It is interesting to me that in Dayton, Ohio, they made a

decision about what is going to happen to the future of Sarajevo.'

'They've agreed to a troika, a three-person presidency, composed of a Muslim, a Croat, and a Serb. Do you think it can work, Professor?'

'Only if you believe in miracles.' He frowned. 'There will be eighteen national legislative bodies and another hundred and nine different local governments. It is a Tower of political Babel. It is what you Americans call a "shotgun marriage." None of them wants to give up their autonomy. They insist on having their own flags, their own license plates, their own currency.' He shook his head. 'It is a morning peace. Beware of the night.'

Dana Evans had gone beyond being a mere reporter and was becoming an international legend. What came through in her television broadcasts was an intelligent human being filled with passion. And because Dana cared, her viewers cared, and shared her feelings.

Matt Baker began getting calls from other news outlets saying that they wanted to syndicate Dana Evans's broadcasts. He was delighted for her. *She went over there to do good*, he thought, *and she's going to wind up doing well.*

With her own new satellite truck, Dana was busier than ever. She was no longer at the mercy of the Yugoslav satellite company. She and Benn decided what stories

they wanted to do, and Dana would write them and broadcast them. Some of the stories were broadcast live, and others were taped. Dana and Benn and Andy would go out on the streets and photograph whatever background was needed, then Dana would tape her commentary in an editing room and send it back on the line to Washington.

At lunchtime, in the hotel dining room, large platters of sandwiches were placed in the center of the table. Journalists were busily helping themselves. Roderick Munn, from the BBC, walked into the room with an AP clipping in his hand.

'Listen to this, everybody.' He read the clipping aloud. '"Dana Evans, a foreign correspondent for WTE, is now being syndicated by a dozen news stations. Miss Evans has been nominated for the coveted Peabody Award ..."' The story went on from there.

'Aren't we lucky to be associated with somebody so famous?' one of the reporters said sarcastically.

At that moment, Dana walked into the dining room. 'Hi, everybody. I don't have time for lunch today. I'm going to take some sandwiches with me.' She scooped up several sandwiches and covered them with paper napkins. 'See you later.' They watched in silence as she left.

When Dana got outside, Kemal was there, waiting.

'Good afternoon, Kemal.'

No response.

'Get into the car.'

Kemal slid into the backseat. Dana handed him a sand-wich and sat there, watching him silently wolf it down. She handed him another sandwich, and he started to eat it.

'Slowly,' Dana said.

'Where to?' Jovan asked.

Dana turned to Kemal. 'Where to?' He looked at her uncomprehendingly. 'We're taking you home, Kemal. Where do you live?'

He shook his head.

'I need to know. Where do you live?'

Twenty minutes later, the car stopped in front of a large vacant lot near the banks of the Miljacka. Dozens of big cardboard boxes were scattered around, and the lot was littered with debris of all kinds.

Dana got out of the car and turned to Kemal. 'Is this where you live?'

He reluctantly nodded.

'And other boys live here, too?'

He nodded again.

'I want to do a story about this, Kemal.'

He shook his head. 'No.'

'Why not?'

'The police will come and take us away. Don't.'

Dana studied him a moment. 'All right. I promise.'

* * *

The next morning, Dana moved out of her room at the Holiday Inn. When she did not appear at breakfast, Gabriella Orsi from the Altre Station in Italy asked, 'Where's Dana?'

Roderick Munn replied, 'She's gone. She's rented a farmhouse to live in. She said she wanted to be by herself.'

Nikolai Petrovich, the Russian from Gorizont 22, said, 'We would all like to be by ourselves. So we are not good enough for her?'

There was a general feeling of disapproval.

The following afternoon, another large care package arrived for Dana.

Nikolai Petrovich said, 'Since she is not here, we might as well enjoy it, eh?'

The hotel clerk said, 'I'm sorry. Miss Evans is having it picked up.'

A few minutes later, Kemal arrived. The reporters watched him take the package and leave.

'She doesn't even share with us anymore,' Juan Santos grumbled. 'I think her publicity has gone to her head.'

During the next week, Dana filed her stories, but she did not appear at the hotel again. The resentment against her was growing.

Dana and her ego were becoming the main topic of

conversation. A few days later, when another huge care package was delivered to the hotel, Nikolai Petrovich went to the hotel clerk. 'Is Miss Evans having this package picked up?'

'Yes, sir.'

The Russian hurried back into the dining room. 'There is another package,' he said. 'Someone is going to pick it up. Why don't we follow him and tell Miss Evans our opinion of reporters who think they're too good for everyone else?'

There was a chorus of approval.

When Kemal arrived to pick up the package, Nikolai said to him, 'Are you taking that to Miss Evans?'

Kemal nodded.

'She asked to see us. We'll go along with you.'

Kemal looked at him a moment, then shrugged.

'We'll take you in one of our cars,' Nikolai Petrovich said. 'You tell us where to go.'

Ten minutes later, a caravan of cars was making its way along deserted side streets. On the outskirts of the city, Kemal pointed to an old bombed-out farmhouse. The cars came to a stop.

'You go ahead and bring her the package,' Nikolai said. 'We're going to surprise her.'

They watched Kemal walk into the farmhouse. They waited a moment, then moved toward the farmhouse and burst in through the front door. They stopped, in shock. The room was filled with children of all ages, sizes, and colors. Most of them were crippled. A dozen army cots

had been set up along the walls. Dana was parceling out the contents of the care package to the children when the door flew open. She looked up in astonishment as the group charged in.

'What – what are you doing here?'

Roderick Munn looked around, embarrassed. 'I'm sorry, Dana. We made a – a mistake. We thought –'

Dana turned to face the group. 'I see. They're orphans. They have nowhere to go and no one to take care of them. Most of them were in a hospital when it was bombed. If the police find them, they'll be put in what passes for an orphanage, and they'll die there. If they stay here, they'll die. I've been trying to figure out a way to get them out of the country, but so far, nothing has worked.' She looked at the group pleadingly. 'Do you have any ideas?'

Roderick Munn said slowly, 'I think I have. There's a Red Cross plane leaving for Paris tonight. The pilot is a friend of mine.'

Dana asked hopefully, 'Would you talk to him?'

Munn nodded. 'Yes.'

Nikolai Petrovich said, 'Wait! We can't get involved in anything like that. They'll throw us all out of the country.'

'You don't have to be involved,' Munn told him. 'We'll handle it.'

'I'm against it,' Nikolai said stubbornly. 'It will place us all in danger.'

'What about the children?' Dana asked. 'We're talking about their lives.'

* * *

180

Late in the afternoon, Roderick Munn came to see Dana. 'I talked to my friend. He said he would be happy to take the children to Paris, where they'll be safe. He has two boys of his own.'

Dana was thrilled. 'That's wonderful. Thank you so much.'

Munn looked at her. 'It is we who should thank you.'

At eight o'clock that evening, a van with the Red Cross insignia on its sides pulled up in front of the farmhouse. The driver blinked the lights, and under the cover of darkness, Dana and the children hurried into the van.

Fifteen minutes later, it was rolling toward Butmir Airport. The airport had been temporarily closed except to the Red Cross planes that delivered supplies and took away the seriously wounded. The drive was the longest ride of Dana's life. It seemed to take forever. When she saw the lights of the airport ahead, she said to the children, 'We're almost there.' Kemal was squeezing her hand.

'You'll be fine,' Dana assured him. 'All of you will be taken care of.' And she thought, *I'm going to miss you.*

At the airport, a guard waved the van through, and it drove up to a waiting cargo plane with the Red Cross markings painted on the fuselage. The pilot was standing next to the plane.

He hurried up to Dana. 'For God's sake, you're late! Get them aboard, fast. We were due to take off twenty minutes ago.'

Dana herded the children up the ramp into the plane. Kemal was the last.

He turned to Dana, his lips trembling. 'Will I see you again?'

'You bet you will,' Dana said. She hugged him and held him close for a moment, saying a silent prayer. 'Get aboard now.'

Moments later, the door closed. There was a roar of the engines, and the plane began to taxi down the runway.

Dana and Munn stood there, watching. At the end of the runway, the plane soared into the air and speared into the eastern sky, banking north toward Paris.

'That was a wonderful thing you did,' the driver said. 'I want you to know –'

A car screeched to a stop behind them, and they turned. Colonel Gordan Divjak jumped out of the car and glared up at the sky where the plane was disappearing. At his side was Nikolai Petrovich, the Russian journalist.

Colonel Divjak turned to Dana. 'You are under arrest. I warned you that the punishment for espionage is death.'

Dana took a deep breath. 'Colonel, if you're going to put me on trial for espionage –'

He looked into Dana's eyes and said softly, 'Who said anything about a trial?'

Thirteen

The inaugural celebrations, the parades, and the swearing-in ceremonies were over, and Oliver was eager to begin his presidency. Washington, D.C., was probably the only city anywhere completely devoted to and obsessed with politics. It was the power hub of the world, and Oliver Russell was the center of that hub. It seemed that everyone was connected in one way or another to the federal government. In the metropolitan area of Washington, there were fifteen thousand lobbyists and more than five thousand journalists, all of them nursing at the mother's milk of government. Oliver Russell remembered John Kennedy's sly put-down: 'Washington, D.C., is a city of southern efficiency and northern charm.'

On the first day of his presidency, Oliver wandered around the White House with Jan. They were familiar with its statistics: 132 rooms, 32 bathrooms, 29 fireplaces, 3 elevators, a swimming pool, putting green, tennis court, jogging track, exercise room, horseshoe pit, bowling alley,

and movie theater, and eighteen acres of beautifully tended grounds. But actually living in it, being a part of it, was overwhelming.

'It's like a dream, isn't it?' Jan sighed.

Oliver took her hand. 'I'm glad we're sharing it, darling.' And he meant it. Jan had become a wonderful companion. She was always there for him, supportive and caring. More and more, he found that he enjoyed being with her.

When Oliver returned to the Oval Office, Peter Tager was waiting to see him. Oliver's first appointment had been to make Tager his chief of staff.

Oliver said, 'I still can't believe this, Peter.'

Peter Tager smiled. 'The people believe it. They voted you in, Mr President.'

Oliver looked up at him. 'It's still Oliver.'

'All right. When we're alone. But you have to realize that from this moment on, anything you do can affect the entire world. Anything you say could shake up the economy or have an impact on a hundred other countries around the globe. You have more power than any other person in the world.'

The intercom buzzed. 'Mr President, Senator Davis is here.'

'Send him in, Heather.'

Tager sighed. 'I'd better get started. My desk looks like a paper mountain.'

The door opened and Todd Davis walked in. 'Peter . . .'

'Senator . . .' The two men shook hands.

Tager said, 'I'll see you later, Mr President.'

Senator Davis walked over to Oliver's desk and nodded. 'That desk fits you just fine, Oliver. I can't tell you what a real thrill it is for me to see you sitting there.'

'Thank you, Todd. I'm still trying to get used to it. I mean – Adams sat here . . . and Lincoln . . . and Roosevelt . . .'

Senator Davis laughed. 'Don't let that scare you. Before they became legends, they were men just like you, sitting there trying to do the right thing. Putting their asses in that chair terrified them all, in the beginning. I just left Jan. She's in seventh heaven. She's going to make a great First Lady.'

'I know she is.'

'By the way, I have a little list here I'd like to discuss with you, Mr President.' The emphasis on 'Mr President' was jovial.

'Of course, Todd.'

Senator Davis slid the list across the desk.

'What is this?'

'Just a few suggestions I have for your cabinet.'

'Oh. Well, I've already decided –'

'I thought you might want to look these over.'

'But there's no point in –'

'Look them over, Oliver.' The senator's voice had cooled.

Oliver's eyes narrowed. 'Todd . . .'

Senator Davis held up a hand. 'Oliver, I don't want you to think for one minute that I'm trying to impose my will or my wishes on you. You would be wrong. I put together that list because I think they're the best men who can help you serve your country. I'm a patriot, Oliver, and I'm not ashamed of it. This country means everything to me.' There was a catch in his voice. 'Everything. If you think I helped put you in this office just because you're my son-in-law, you're gravely mistaken. I fought to make sure you got here because I firmly believe you're the man best suited for the job. That's what I care most about.' He tapped a finger on the piece of paper. 'And these men can help you do that job.'

Oliver sat there, silent.

'I've been in this town for a lot of years, Oliver. And do you know what I've learned? That there's nothing sadder than a one-term president. And do you know why? Because during the first four years, he's just beginning to get an idea of what he can do to make this country better. He has all those dreams to fulfill. And just when he's ready to do that – just when he's ready to really make a difference' – he glanced around the office – 'someone else moves in here, and those dreams just vanish. Sad to think about, isn't it? All those men with grand dreams who serve only one term. Did you know that since McKinley took office in 1897, more than half the presidents who followed him were one-term presidents? But you, Oliver – I'm going to see to it that you're a two-term president. I want you to be able to

fulfill all your dreams. I'm going to see to it that you're reelected.'

Senator Davis looked at his watch and rose. 'I have to go. We have a quorum call at the Senate. I'll see you at dinner tonight.' He walked out the door.

Oliver looked after him for a long time. Then he reached down and picked up the list Senator Todd Davis had left.

In his dream, Miriam Friedland awakened and sat up in bed. A policeman was at her bedside. He looked down at her and said, 'Now you can tell us who did this to you.'

'Yes.'

He woke up, soaked in perspiration.

Early the following morning, Oliver telephoned the hospital where Miriam was.

'I'm afraid there's no change, Mr President,' the chief of staff told him. 'Frankly, it doesn't look good.'

Oliver said hesitantly, 'She has no family. If you don't think she's going to make it, would it be more humane to take her off the life-support systems?'

'I think we should wait a little while longer and see what happens,' the doctor said. 'Sometimes there's a miracle.'

Jay Perkins, chief of protocol, was briefing the president.

'There are one hundred and forty-seven diplomatic missions in Washington, Mr President. The blue book – the Diplomatic List – lists the name of every representative of a foreign government and spouse. The green book – the Social List – names the top diplomats, Washington residents, and members of Congress.'

He handed Oliver several sheets of paper. 'This is a list of the potential foreign ambassadors you will receive.'

Oliver looked down the list and found the Italian ambassador and his wife: Atilio Picone and Sylva. *Sylva.* Oliver asked innocently, 'Will they bring their wives with them?'

'No. The wives will be introduced later. I would suggest that you begin seeing the candidates as quickly as possible.'

'Fine.'

Perkins said, 'I'll try to arrange it so that by next Saturday, all the foreign ambassadors will be accredited. You might want to consider having a White House dinner to honor them.'

'Good idea.' Oliver glanced again at the list on his desk. Atilio and Sylva Picone.

Saturday evening, the State Dining Room was decorated with flags from the various countries represented by the foreign ambassadors. Oliver had spoken with Atilio Picone two days earlier when he had presented his credence papers.

'How is Mrs Picone?' Oliver had asked.

There was a small pause. 'My wife is fine. Thank you, Mr President.'

The dinner was going beautifully. Oliver went from table to table, chatting with his guests and charming them all. Some of the most important people in the world were gathered in that room.

Oliver Russell approached three ladies who were socially prominent and married to important men. But they were movers and shakers in their own right. 'Leonore . . . Delores . . . Carol . . .'

As Oliver was making his way across the room, Sylva Picone went up to him and held out her hand. 'This is a moment I've been looking forward to.' Her eyes were sparkling.

'I, too,' Oliver murmured.

'I knew you were going to be elected.' It was almost a whisper.

'Can we talk later?'

There was no hesitation. 'Of course.'

After dinner, there was dancing in the grand ballroom to the music of the Marine Band. Oliver watched Jan dancing, and he thought: *What a beautiful woman. What a great body.*

The evening was a huge success.

* * *

The following week, on the front page of the *Washington Tribune*, the headline blazed out: PRESIDENT ACCUSED OF CAMPAIGN FRAUD.

Oliver stared at it in disbelief. It was the worst timing possible. How could this have happened? And then he suddenly realized how it had happened. The answer was in front of him on the masthead of the newspaper: 'Publisher, Leslie Stewart.'

The following week, a front-page item in the *Washington Tribune* read: PRESIDENT TO BE QUESTIONED ABOUT FALSIFIED KENTUCKY STATE INCOME TAX RETURNS.

Two weeks later, another story appeared on the front page of the *Tribune*: FORMER ASSISTANT TO PRESIDENT RUSSELL PLANS TO FILE LAWSUIT CHARGING SEXUAL HARASSMENT.

The door to the Oval Office flew open and Jan walked in. 'Have you seen the morning paper?'

'Yes, I –'

'How could you do this to us, Oliver? You –'

'Wait a minute! Don't you see what's happening, Jan? Leslie Stewart is behind it. I'm sure she bribed that woman to do this. She's trying to get her revenge because I jilted her for you. All right. She got it. It's over.'

Senator Davis was on the telephone. 'Oliver. I would like to see you in one hour.'

'I'll be here, Todd.'

Oliver was in the small library when Todd Davis

arrived. Oliver rose to greet him. 'Good morning.'

'Like hell it's a good morning.' Senator Davis's voice was filled with fury. 'That woman is going to destroy us.'

'No, she's not. She just –'

'Everyone reads that damned gossip rag, and people believe what they read.'

'Todd, this is going to blow over and –'

'It's not going to blow over. Did you hear the editorial on WTE this morning? It was about who our next president is going to be. You were at the bottom of the list. Leslie Stewart is out to get you. You must stop her. What's the line – "hell hath no fury . . ."?'

'There's another adage, Todd, about freedom of the press. There's nothing we can do about this.'

Senator Davis looked at Oliver speculatively. 'But there is.'

'What are you talking about?'

'Sit down.' The two men sat. 'The woman is obviously still in love with you, Oliver. This is her way of punishing you for what you did to her. Never argue with someone who buys ink by the ton. My advice is to make peace.'

'How do I do that?'

Senator Davis looked at Oliver's groin. 'Use your head.'

'Wait a minute, Todd! Are you suggesting that I –?'

'What I'm suggesting is that you cool her down. Let her know that you're sorry. I'm telling you she still loves you. If she didn't, she wouldn't be doing this.'

'What exactly do you expect me to do?'

'Charm her, my boy. You did it once, you can do it

again. You've got to win her over. You're having a State Department dinner here Friday evening. Invite her. You must persuade her to stop what she's doing.'

'I don't know how I can –'

'I don't care how you do it. Perhaps you could take her away somewhere, where you can have a quiet chat. I have a country house in Virginia. It's very private. I'm going to Florida for the weekend, and I've arranged for Jan to go with me.' He took out a slip of paper and some keys and handed them to Oliver. 'Here are the directions and the keys to the house.'

Oliver was staring at him. 'Jesus! You had this all planned? What if Leslie won't – what if she's not interested? If she refuses to go?'

Senator Davis rose. 'She's interested. She'll go. I'll see you Monday, Oliver. Good luck.'

Oliver sat there for a long time. And he thought: *No. I can't do this to her again. I won't.*

That evening as they were getting dressed for dinner, Jan said, 'Oliver, Father asked me to go to Florida with him for the weekend. He's getting some kind of award, and I think he wants to show off the president's wife. Would you mind very much if I went? I know there's a State Department dinner here Friday, so if you want me to stay . . .'

'No, no. You go ahead. I'll miss you.' *And I am going to miss her*, he thought. *As soon as I solve this problem with*

Leslie, I'm going to start spending more time with Jan.

Leslie was on the telephone when her secretary came hurrying in. 'Miss Stewart —'

'Can't you see I'm —'

'President Russell is on line three.'

Leslie looked at her a moment, then smiled. 'Right.' She said into the phone, 'I'll call you back.'

She pressed the button on line three. 'Hello.'

'Leslie?'

'Hello, Oliver. Or should I call you Mr President?'

'You can call me anything you like.' He added lightly, 'And have.' There was a silence. 'Leslie, I want to see you.'

'Are you sure this is a good idea?'

'I'm very sure.'

'You're the president. I can't say no to you, can I?'

'Not if you're a patriotic American. There's a State Department dinner at the White House Friday night. Please come.'

'What time?'

'Eight o'clock.'

'All right. I'll be there.'

She looked stunning in a long, clinging black knit Mandarin-necked St John gown fastened in front with buttons over-coated in twenty-two-karat gold. There

was a revealing fourteen-inch slit on the left side of the dress.

The instant Oliver looked at her, memories came flooding back. 'Leslie . . .'

'Mr President.'

He took her hand, and it was moist. *It's a sign,* Oliver thought. *But of what? Nervousness? Anger? Old memories?*

'I'm so glad you came, Leslie.'

'Yes. I am, too.'

'We'll talk later.'

Her smile warmed him. 'Yes.'

Two tables away from where Oliver was seated was a group of Arab diplomats. One of them, a swarthy man with sharply etched features and dark eyes, seemed to be staring intently at Oliver.

Oliver leaned over to Peter Tager and nodded toward the Arab. 'Who's that?'

Tager took a quick look. 'Ali al-Fulani. He's the secretary at one of the United Arab Emirates. Why do you ask?'

'No reason.' Oliver looked again. The man's eyes were still focused on him.

Oliver spent the evening working the room, making his guests feel comfortable. Sylva was at one table, Leslie at another. It was not until the evening was almost over that

Oliver managed to get Leslie alone for a moment.

'We need to talk. I have a lot to tell you. Can we meet somewhere?'

There was the faintest hesitation in her voice. 'Oliver, perhaps it would be better if we didn't –'

'I have a house in Manassas, Virginia, about an hour out of Washington. Will you meet me there?'

She looked into his eyes. This time there was no hesitation. 'If you want me to.'

Oliver described the location of the house. 'Tomorrow night at eight?'

Leslie's voice was husky. 'I'll be there.'

At a National Security Council meeting the following morning, Director of Central Intelligence James Frisch dropped a bomb-shell.

'Mr President, we received word this morning that Libya is buying a variety of atomic weapons from Iran and China. There's a strong rumor that they're going to be used to attack Israel. It will take a day or two to get a confirmation.'

Lou Werner, the secretary of state, said, 'I don't think we should wait. Let's protest now, in the strongest possible terms.'

Oliver said to Werner, 'See what additional information you can get.'

The meeting lasted all morning. From time to time, Oliver found himself thinking about the rendezvous with

Leslie. *'Charm her, my boy . . . You've got to win her over.'*

On Saturday evening, Oliver was in one of the White House staff cars, driven by a trusted Secret Service agent, heading for Manassas, Virginia. He was strongly tempted to cancel the rendezvous, but it was too late. *I'm worrying for no reason. She probably won't even show up.*

At eight o'clock, Oliver looked out the window and saw Leslie's car pull into the driveway of the senator's house. He watched her get out of the car and move toward the entrance. Oliver opened the front door. The two of them stood there, silently staring at each other, and time disappeared and somehow it was as though they had never been apart.

Oliver was the first to find his voice. 'My God! Last night when I saw you . . . I had almost forgotten how beautiful you are.' Oliver took Leslie's hand, and they walked into the living room. 'What would you like to drink?'

'I don't need anything. Thank you.'

Oliver sat down next to her on the couch. 'I have to ask you something, Leslie. Do you hate me?'

She shook her head slowly. 'No. I thought I hated you.' She smiled wryly. 'In a way, I suppose that's the reason for my success.'

'I don't understand.'

'I wanted to get back at you, Oliver. I bought news-papers and television stations so that I could attack you. You're the only man I've ever loved. And when you – when you deserted me, I – I didn't think I could stand it.' She was fighting back tears.

Oliver put his arm around her. 'Leslie –' And then his lips were on hers, and they were kissing passionately.

'Oh, my God,' she said. 'I didn't expect this to happen.' And they were in a fierce embrace, and he took her hand and led her into the bedroom. They began undressing each other.

'Hurry, my darling,' Leslie said. 'Hurry . . .'

And they were in bed, holding each other, their bodies touching, remembering. Their lovemaking was gentle and fierce, as it had been in the beginning. And this was a new beginning. The two of them lay there, happy, spent.

'It's so funny,' Leslie said.

'What?'

'All those terrible things I published about you. I did it to get your attention.' She snuggled closer. 'And I did, didn't I?'

He grinned. 'I'll say.'

Leslie sat up and looked at him. 'I'm so proud of you, Oliver. The President of the United States.'

'I'm trying to be a damn good one. That's what's really important to me. I want to make a difference.' Oliver looked at his watch. 'I'm afraid I have to get back.'

'Of course. I'll let you leave first.'

'When am I going to see you again, Leslie?'

'Anytime you want to.'

'We're going to have to be careful.'

'I know. We will be.'

Leslie lay there, dreamily watching Oliver as he dressed.

When Oliver was ready to leave, he leaned over and said, 'You're my miracle.'

'And you're mine. You always have been.'

He kissed her. 'I'll call you tomorrow.'

Oliver hurried out to the car and was driven back to Washington. *The more things change, the more they stay the same,* Oliver thought. *I have to be careful never to hurt her again.* He picked up the car telephone and dialed the number in Florida that Senator Davis had given him.

The senator answered the phone himself. 'Hello.'

'It's Oliver.'

'Where are you?'

'On my way back to Washington. I just called to tell you some good news. We don't have to worry about that problem anymore. Everything is under control.'

'I can't tell you how glad I am to hear that.' There was a note of deep relief in Senator Davis's voice.

'I knew you would be, Todd.'

The following morning, as Oliver was getting dressed, he picked up a copy of the *Washington Tribune*. On the front page was a photograph of Senator Davis's country home in Manassas. The caption under it read: PRESIDENT RUSSELL'S SECRET LOVE NEST.

Fourteen

Oliver stared at the paper unbelievingly. How could she have done that? He thought about how passionate she had been in bed. And he had completely misread it. It was a passion filled with hate, not love. *There's no way I can ever stop her*, Oliver thought despairingly.

Senator Todd Davis looked at the front-page story and was aghast. He understood the power of the press, and he knew how much this vendetta could cost him. *I'll have to stop her myself*, Senator Davis decided.

When he got to his Senate office, he telephoned Leslie. 'It's been a long time,' Senator Davis said warmly. 'Too long. I think about you a lot, Miss Stewart.'

'I think about you, too, Senator Davis. In a way, everything I have I owe to you.'

He chuckled. 'Not at all. When you had a problem, I was happy to be able to assist you.'

'Is there something I can do for you, Senator?'

'No, Miss Stewart. But there's something I'd like to do

for you. I'm one of your faithful readers, you know, and I think the *Tribune* is a truly fine paper. I just realized that we haven't been doing any advertising in it, and I want to correct that. I'm involved in several large companies, and they do a lot of advertising. I mean a *lot* of advertising. I think that a good portion of that should go to a fine paper like the *Tribune*.'

'I'm delighted to hear that, Senator. We can always use more advertising. Whom shall I have my advertising manager talk to?'

'Well, before he talks to anyone, I think you and I should settle a little problem between us.'

'What's that?' Leslie asked.

'It concerns President Russell.'

'Yes?'

'This is a rather delicate matter, Miss Stewart. You said a few moments ago that you owed everything you have to me. Now I'm asking you to do me a little favor.'

'I'll be happy to, if I can.'

'In my own small way, I helped the president get elected to office.'

'I know.'

'And he's doing a fine job. Of course, it makes it more difficult for him when he's attacked by a powerful newspaper like the *Tribune* every time he turns around.'

'What are you asking me to do, Senator?'

'Well, I would greatly appreciate it if those attacks would stop.'

'And in exchange for that, I can count on getting advertising from some of your companies.'

'A great deal of advertising, Miss Stewart.'

'Thank you, Senator. Why don't you call me back when you have something more to offer?'

And the line went dead.

In his office at the *Washington Tribune*, Matt Baker was reading the story about President Russell's secret love nest.

'Who the hell authorized this?' he snapped at his assistant.

'It came from the White Tower.'

'Goddammit. She's not running this paper, I am.' *Why the hell do I put up with her?* he wondered, not for the first time. *Three hundred and fifty thousand dollars a year plus bonuses and stock options,* he told himself wryly. Every time he was ready to quit, she seduced him with more money and more power. Besides, he had to admit to himself that it was fascinating working for one of the most powerful women in the world. There were things about her that he would never understand.

When she had first bought the *Tribune*, Leslie had said to Matt, 'There's an astrologer I want you to hire. His name is Zoltaire.'

'He's syndicated by our competition.'

'I don't care. Hire him.'

Later that day, Matt Baker told her, 'I checked on

Zoltaire. It would be too expensive to buy out his contract.'

'Buy it.'

The following week, Zoltaire, whose real name Matt learned was David Hayworth, came to work for the *Washington Tribune*. He was in his fifties, small and dark and intense.

Matt was puzzled. Leslie did not seem like the kind of woman who would have any interest in astrology. As far as he could see, there was no contact between Leslie and David Hayworth.

What he did not know was that Hayworth went to visit Leslie at her home whenever she had an important decision to make.

On the first day, Matt had had Leslie's name put on the masthead: 'Leslie Chambers, Publisher.' She had glanced at it and said, 'Change it. It's Leslie Stewart.'

The lady is on an ego trip, Matt had thought. But he was wrong. Leslie had decided to revert to her maiden name because she wanted Oliver Russell to know exactly who was responsible for what was going to happen to him.

The day after Leslie took over the newspaper, she said, 'We're going to buy a health magazine.'

Matt looked at her curiously. 'Why?'

'Because the health field is exploding.'

She had proved to be right. The magazine was an instant success.

'We're going to start expanding,' Leslie told Baker. 'Let's get some people looking for publications overseas.'

'All right.'

'And there's too much fat around here. Get rid of the reporters who aren't pulling their weight.'

'Leslie —'

'I want young reporters who are hungry.'

When an executive position became open, Leslie insisted on being there for the interview. She would listen to the applicant, and then would ask one question: 'What's your golf score?' The job would often depend on the answer.

'What the hell kind of question is that?' Matt Baker asked the first time he heard it. 'What difference does a golf score make?'

'I don't want people here who are dedicated to golf. If they work here, they're going to be dedicated to the *Washington Tribune*.'

Leslie Stewart's private life was a subject of endless discussions at the *Tribune*. She was a beautiful woman, unattached, and as far as anyone knew, she was not involved with any man and had no personal life. She was one of the capital's preeminent hostesses, and important people vied for an invitation to her dinner parties. But

people speculated about what she did when all the guests had left and she was alone. There were rumors that she was an insomniac who spent the nights working, planning new projects for the Stewart empire.

There were other rumors, more titillating, but there was no way of proving them.

Leslie involved herself in everything: editorials, news stories, advertising. One day, she said to the head of the advertising department, 'Why aren't we getting any ads from Gleason's?' – an upscale store in Georgetown.

'I've tried, but –'

'I know the owner. I'll give him a call.'

She called him and said, 'Allan, you're not giving the *Tribune* any ads. Why?'

He had laughed and said, 'Leslie, your readers are our shoplifters.'

Before Leslie went into a conference, she read up on everyone who would be there. She knew everyone's weaknesses and strengths, and she was a tough nego-tiator.

'Sometimes you can be too tough,' Matt Baker warned her. 'You have to leave them something, Leslie.'

'Forget it. I believe in the scorched-earth policy.'

* * *

In the course of the next year, Washington Tribune Enterprises acquired a newspaper and radio station in Australia, a television station in Denver, and a newspaper in Hammond, Indiana. Whenever there was a new acquisition, its employees were terrified of what was coming. Leslie's reputation for being ruthless was growing.

Leslie Stewart was intensely jealous of Katharine Graham.

'She's just lucky,' Leslie said. 'And she has the reputation of being a bitch.'

Matt Baker was tempted to ask Leslie what she thought her own reputation was, but he decided not to.

One morning when Leslie arrived at her office, she found that someone had placed a small wooden block with two brass balls on her desk.

Matt Baker was upset. 'I'm sorry,' he said. 'I'll take –'

'No. Leave it.'

'But –'

'Leave it.'

Matt Baker was having a conference in his office when Leslie's voice came on over the intercom. 'Matt, come up here.'

No 'please,' no 'good morning.' *It's going to be a bad-hair day*, Matt Baker thought grimly. The Ice Princess was in one of her moods.

'That's it for now,' Matt said.

He left his office and walked through the corridors, where hundreds of employees were busily at work. He took the elevator up to the White Tower and entered the sumptuous publisher's office. Half a dozen editors were already gathered in the room.

Behind an enormous desk sat Leslie Stewart. She looked up as Matt Baker entered. 'Let's get started.'

She had called an editorial meeting. Matt Baker remembered her saying, 'You'll be running the newspaper. I'll keep my hands off.' He should have known better. She had no business calling meetings like this. That was his job. On the other hand, she was the publisher and owner of the *Washington Tribune*, and she could damn well do anything she pleased.

Matt Baker said, 'I want to talk to you about the story about President Russell's love nest in Virginia.'

'There's nothing to talk about,' Leslie said. She held up a copy of *The Washington Post*, their rival. 'Have you seen this?'

Matt had seen it. 'Yes, it's just –'

'In the old days it was called a scoop, Matt. Where were you and your reporters when the *Post* was getting the news?'

The headline in *The Washington Post* read: SECOND LOBBYIST TO BE INDICTED FOR GIVING ILLEGAL GIFTS TO SECRETARY OF DEFENSE.

'Why didn't we get that story?'

'Because it isn't official yet. I checked on it. It's just –'

'I don't like being scooped.'

Matt Baker sighed and sat back in his chair. It was going to be a stormy session.

'We're number one, or we're nothing,' Leslie Stewart announced to the group. 'And if we're nothing, there won't be any jobs here for anyone, will there?'

Leslie turned to Arnie Cohn, the editor of the Sunday magazine section. 'When people wake up Sunday morning, we want them to read the magazine section. We don't want to put our readers back to sleep. The stories we ran last Sunday were boring.'

He was thinking, *If you were a man, I'd* – 'Sorry,' he mumbled. 'I'll try to do better next time.'

Leslie turned to Jeff Connors, the sports editor. Connors was a good-looking man in his mid-thirties, tall, with an athletic build, blond hair, intelligent gray eyes. He had the easy manner of someone who knew that he was good at what he did. Matt had heard that Leslie had made a play for him, and he had turned her down.

'You wrote that Fielding was going to be traded to the Pirates.'

'I was told –'

'You were told wrong! The *Tribune* is guilty of printing a story that never happened.'

'I got it from his manager,' Jeff Connors said, unperturbed. 'He told me thát –'

'Next time check out your stories, and then check them out again.'

Leslie turned and pointed to a framed, yellowed newspaper article hanging on the wall. It was the front page of the *Chicago Tribune*, dated November 3, 1948. The banner headline read: DEWEY DEFEATS TRUMAN.

'The worst thing a newspaper can do,' Leslie said, 'is to get the facts wrong. We're in a business where you always have to get it right.'

She glanced at her watch. 'That's it for now. I'll expect you all to do a lot better.' As they rose to leave, Leslie said to Matt Baker, 'I want you to stay.'

'Right.' He sank back into his chair and watched the others depart.

'Was I rough on them?' she asked.

'You got what you wanted. They're all suicidal.'

'We're not here to make friends, we're here to put out a newspaper.' She looked up again at the framed front page on the wall. 'Can you imagine what the publisher of that paper must have felt after that story hit the streets and Truman was president? I never want to have that feeling, Matt. Never.'

'Speaking of getting it wrong,' Matt said, 'that story on page one about President Russell was more suitable for a cheap tabloid publication. Why do you keep riding him? Give him a chance.'

Leslie said enigmatically, 'I gave him his chance.' She stood up and began to pace. 'I got a tip that Russell is going to veto the new communications bill. That means we'll have to call off the deal for the San Diego station and the Omaha station.'

'There's nothing we can do about that.'

'Oh, yes, there is. I want him out of office, Matt. We'll help put someone else in the White House, someone who knows what he's doing.'

Matt had no intention of getting into another argument with Leslie Stewart about the president. She was fanatic on the subject.

'He's not fit to be in that office, and I'm going to do everything I can to make sure that he's defeated in the next election.'

Philip Cole, chief of correspondents for WTE, hurried into Matt Baker's office as Matt was ready to leave. There was a worried expression on his face. 'We have a problem, Matt.'

'Can it wait until tomorrow? I'm late for a –'

'It's about Dana Evans.'

Matt said sharply, 'What about her?'

'She's been arrested.'

'Arrested?' Matt asked incredulously. 'What for?'

'Espionage. Do you want me to –?'

'No. I'll handle this.'

Matt Baker hurried back to his desk and dialed the State Department.

Fifteen

She was being dragged, naked, out of her cell into a cold, dark courtyard. She struggled wildly against the two men holding her, but she was no match for them. There were six soldiers with rifles outside, waiting for her as she was carried, screaming, to a wooden post hammered into the ground. Colonel Gordan Divjak watched his men tie her to the post.

'You can't do this to me! I'm not a spy!' she yelled. But she could not make her voice heard above the sounds of mortar fire in the near distance.

Colonel Divjak stepped away from her and nodded toward the firing squad. 'Ready, aim –'

'Stop that screaming!'

Rough hands were shaking her. Dana opened her eyes, her heart pounding. She was lying on the cot in her small, dark cell. Colonel Divjak was standing over her.

Dana sat up, panicky, trying to blink away the nightmare. 'What – what are you going to do to me?'

Colonel Divjak said coldly, 'If there were justice, you would be shot. Unfortunately, I have been given orders to release you.'

Dana's heart skipped a beat.

'You will be put on the first plane out of here.' Colonel Divjak looked into her eyes and said, 'Don't ever come back.'

It had taken all the pressure that the State Department and the president could muster to get Dana Evans released. When Peter Tager heard about the arrest, he had gone in to see the president.

'I just got a call from the State Department. Dana Evans has been arrested on charges of espionage. They're threatening to execute her.'

'Jesus! That's terrible. We can't let that happen.'

'Right. I'd like permission to use your name.'

'You've got it. Do whatever has to be done.'

'I'll work with the State Department. If we can pull this off, maybe the *Tribune* will go a little easier on you.'

Oliver shook his head. 'I wouldn't count on it. Let's just get her the hell out of there.'

Dozens of frantic telephone calls later, with pressure from the Oval Office, the secretary of state, and the secretary-general of the United Nations, Dana's captors reluctantly agreed to release her.

When the news came, Peter Tager hurried in to tell Oliver. 'She's free. She's on her way home.'

'Great.'

* * *

He thought about Dana Evans on his way to a meeting that morning. *I'm glad we were able to save her.*

He had no idea that that action was going to cost him his life.

When Dana's plane landed at Dulles International Airport, Matt Baker and two dozen reporters from newspapers and television and radio stations were waiting to greet her.

Dana looked at the crowd in disbelief. 'What's –?'

'This way, Dana. Smile!'

'How were you treated? Was there any brutality?'

'How does it feel to be back home?'

'Let's have a picture.'

'Do you have any plans to go back?'

They were all talking at once. Dana stood there, overwhelmed.

Matt Baker hustled Dana into a waiting limousine, and they sped away.

'What's – what's going on?' Dana asked.

'You're a celebrity.'

She shook her head. 'I don't need this, Matt.' She closed her eyes for a moment. 'Thanks for getting me out.'

'You can thank the president and Peter Tager. They pushed all the buttons. You also have Leslie Stewart to thank.'

When Matt told Leslie the news, she had said, 'Those bastards! They can't do that to the *Tribune*. I want you

to see that they free her. Pull every string you can and get her out of there.'

Dana looked out the window of the limousine. People were walking along the street, talking and laughing. There was no sound of gunfire or mortar shells. It was eerie.

'Our real estate editor found an apartment for you. I'm taking you there now. I want you to have some time off – as much as you like. When you're ready, we'll put you back to work.' He took a closer look at Dana. 'Are you feeling all right? If you want to see a doctor, I'll arrange –'

'I'm fine. Our bureau took me to a doctor in Paris.'

The apartment was on Calvert Street, an attractively furnished place with one bedroom, living room, kitchen, bath, and small study.

'Will this do?' Matt asked.

'This is perfect. Thank you, Matt.'

'I've had the refrigerator stocked for you. You'll probably want to go shopping for clothes tomorrow, after you get some rest. Charge everything to the paper.'

'Thanks, Matt. Thank you for everything.'

'You're going to be debriefed later. I'll set it up for you.'

She was on a bridge, listening to the gunfire and watching bloated bodies float by, and she woke up, sobbing. It had

213

been so real. It was a dream, but it was happening. At that moment, innocent victims – men, women, and children – were being senselessly and brutally slaughtered. She thought of Professor Staka's words. *'This war in Bosnia and Herzegovina is beyond understanding.'* What was incredible to her was that the rest of the world didn't seem to care. She was afraid to go back to sleep, afraid of the nightmares that filled her brain. She got up and walked over to the window and looked out at the city. It was quiet – no guns, no people running down the street, screaming. It seemed unnatural. She wondered how Kemal was, and whether she would ever see him again. *He's probably forgotten me by now.*

Dana spent part of the morning shopping for clothes. Wherever she went, people stopped to stare at her. She heard whispers: 'That's Dana Evans!' The sales clerks all recognized her. She was famous. She hated it.

Dana had had no breakfast and no lunch. She was hungry, but she was unable to eat. She was too tense. It was as though she were waiting for some disaster to strike. When she walked down the street, she avoided the eyes of strangers. She was suspicious of everyone. She kept listening for the sound of gunfire. *I can't go on like this*, Dana thought.

At noon, she walked into Matt Baker's office.

'What are you doing here? You're supposed to be on vacation.'

'I need to go back to work, Matt.'

He looked at her and thought about the young girl who had come to him a few years earlier. *'I'm here for a job. Of course, I already have a job here. It's more like a transfer, isn't it? . . . I can start right away . . .'* And she had more than fulfilled her promise. *If I ever had a daughter . . .*

'Your boss wants to meet you,' Matt told Dana.

They headed for Leslie Stewart's office.

The two women stood there appraising each other. 'Welcome back, Dana.'

'Thank you.'

'Sit down.' Dana and Matt took chairs opposite Leslie's desk.

'I want to thank you for getting me out of there,' Dana said.

'It must have been hell. I'm sorry.' Leslie looked at Matt. 'What are we going to do with her now, Matt?'

He looked at Dana. 'We're about to reassign our White House correspondent. Would you like the job?' It was one of the most prestigious television assignments in the country.

Dana's face lit up. 'Yes. I would.'

Leslie nodded. 'You've got it.'

Dana rose. 'Well – thank you, again.'

'Good luck.'

Dana and Matt left the office. 'Let's get you settled,' Matt said. He walked her over to the television building, where the whole staff was waiting to greet her. It took Dana fifteen minutes to work her way through the crowd of well-wishers.

'Meet your new White House correspondent,' Matt said to Philip Cole.

'That's great. I'll show you to your office.'

'Have you had lunch yet?' Matt asked Dana.

'No, I –'

'Why don't we get a bite to eat?'

The executive dining room was on the fifth floor, a spacious, airy room with two dozen tables. Matt led Dana to a table in the corner, and they sat down.

'Miss Stewart seemed very nice,' Dana said.

Matt started to say something. 'Yeah. Let's order.'

'I'm not hungry.'

'You haven't had lunch?'

'No.'

'Did you have breakfast?'

'No.'

'Dana – when did you eat last?'

She shook her head. 'I don't remember. It's not important.'

'Wrong. I can't have our new White House correspondent starving herself to death.'

The waiter came over to the table. 'Are you ready to order, Mr Baker?'

'Yes.' He scanned the menu. 'We'll start you off light. Miss Evans will have a bacon, lettuce, and tomato sandwich.' He looked over at Dana. 'Pastry or ice cream?'

'Noth –'

'Pie à la mode. And I'll have a roast beef sandwich.'

'Yes, sir.'

Dana looked around. 'All this seems so unreal. Life is what's happening over there, Matt. It's horrible. No one here cares.'

'Don't say that. Of course we care. But we can't run the world, and we can't control it. We do the best we can.'

'It's not good enough,' Dana said fiercely.

'Dana . . .' He stopped. She was far away, listening to distant sounds that he could not hear, seeing grisly sights that he could not see. They sat in silence until the waiter arrived with their food.

'Here we are.'

'Matt, I'm not really hung –'

'You're going to eat,' Matt commanded.

Jeff Connors was making his way over to the table. 'Hi, Matt.'

'Jeff.'

Jeff Connors looked at Dana. 'Hello.'

Matt said, 'Dana, this is Jeff Connors. He's the *Tribune*'s sports editor.'

Dana nodded.

'I'm a big fan of yours, Miss Evans. I'm glad you got out safely.'

Dana nodded again.

Matt said, 'Would you like to join us, Jeff?'

'Love to.' He took a chair and said to Dana, 'I tried never to miss any of your broadcasts. I thought they were brilliant.'

Dana mumbled, 'Thank you.'

'Jeff here is one of our great athletes. He's in the Baseball Hall of Fame.'

Another small nod.

'If you happen to be free,' Jeff said, 'on Friday, the Orioles are playing the Yankees in Baltimore. It's –'

Dana turned to look at him for the first time. 'That sounds really exciting. The object of the game is to hit the ball and then run around the field while the other side tries to stop you?'

He looked at her warily. 'Well –'

Dana got to her feet, her voice trembling. 'I've seen people running around a field – but they were running for their lives because someone was shooting at them and killing them!' She was near hysteria. 'It wasn't a game, and it – it wasn't about a stupid baseball.'

The other people in the room were turning to stare at her.

'You can go to hell,' Dana sobbed. And she fled from the room.

Jeff turned to Matt. 'I'm terribly sorry. I didn't mean to –'

'It wasn't your fault. She hasn't come home yet. And God knows she's entitled to a bad case of nerves.'

Dana hurried into her office and slammed the door. She went to her desk and sat down, fighting hysteria. *Oh, God. I've made a complete fool of myself. They'll fire me, and I deserve it. Why did I attack that man? How could I have done anything so awful? I don't belong here. I don't belong anywhere anymore.* She sat there with her head on the desk, sobbing.

A few minutes later, the door opened and someone came in. Dana looked up. It was Jeff Connors, carrying a tray with a bacon, lettuce, and tomato sandwich and a slice of pie à la mode.

'You forgot your lunch,' Jeff said mildly.

Dana wiped away her tears, mortified. 'I – I want to apologize. I'm so sorry. I had no right to –'

'You had every right,' he said quietly. 'Anyway, who needs to watch a dumb old baseball game?' Jeff put the tray on the desk. 'May I join you for lunch?' He sat down.

'I'm not hungry. Thank you.'

He sighed. 'You're putting me in a very difficult position, Miss Evans. Matt says you have to eat. You don't want to get me fired, do you?'

Dana managed a smile. 'No.' She picked up half of the sandwich and took a small bite.

'Bigger.'

Dana took another small bite.

'Bigger.'

She looked up at him. 'You're really going to make me eat this, aren't you?'

'You bet I am.' He watched her take a larger bite of the sandwich. 'That's better. By the way, if you're not doing anything Friday night, I don't know if I mentioned it, but there's a game between the Orioles and the Yankees. Would you like to go?'

She looked at him and nodded. 'Yes.'

At three o'clock that afternoon, when Dana walked into the White House entrance, the guard said, 'Mr Tager would like to see you, Miss Evans. I'll have someone take you to his office.'

A few minutes later, one of the guides led Dana down a long corridor to Peter Tager's office. He was waiting for her.

'Mr Tager . . .'

'I didn't expect to see you so soon, Miss Evans. Won't your station give you any time off?'

'I didn't want any,' Dana said. 'I – I need to work.'

'Please sit down.' She sat across from him. 'Can I offer you anything?'

'No, thanks. I just had lunch.' She smiled to herself at the recollection of Jeff Connors. 'Mr Tager, I want to thank you and President Russell so much for rescuing me.' She hesitated. 'I know the *Tribune* hasn't been too kind to the president, and I –'

Peter Tager raised a hand. 'This was something above politics. There was no chance that the president was going to let them get away with this. You know the story of Helen of Troy?'

'Yes.'

He smiled. 'Well, we might have started a war over you. You're a very important person.'

'I don't feel very important.'

'I want you to know how pleased both the president and I are that you've been assigned to cover the White House.'

'Thank you.'

He paused for a moment. 'It's unfortunate that the *Tribune* doesn't like President Russell, and there's nothing you can do about it. But in spite of that, on a very personal level, if there's anything the president or I can do to help . . . we both have an enormous regard for you.'

'Thank you. I appreciate that.'

The door opened and Oliver walked in. Dana and Peter Tager stood up.

'Sit down,' Oliver said. He walked over to Dana. 'Welcome home.'

'Thank you, Mr President,' Dana said. 'And I do mean – thank you.'

Oliver smiled. 'If you can't save someone's life, what's the point of being president? I want to be frank with you, Miss Evans. None of us here is a fan of your newspaper. All of us are your fans.'

'Thank you.'

'Peter is going to give you a tour of the White House. If you have any problems, we're here to help you.'

'You're very kind.'

'If you don't mind, I want you to meet with Mr Werner, the secretary of state. I'd like to have him get a firsthand briefing from you on the situation in Herzegovina.'

'I'd be happy to do that,' Dana said.

There were a dozen men seated in the secretary of state's private conference room, listening to Dana describe her experiences.

'Most of the buildings in Sarajevo have been damaged or destroyed ... There's no electricity, and the people there who still have cars unhook the car batteries at night to run their television sets ...

'The streets of the city are obstructed by the wreckage of bombed automobiles, carts, and bicycles. The main form of transportation is walking ...

'When there's a storm, people catch the water from the street gutters and put it into buckets ...

'There's no respect for the Red Cross or for the journalists there. More than forty correspondents have been killed covering the Bosnian war, and dozens have been wounded ... Whether the present revolt against Slobodan Milosevic is successful or not, the feeling is that because of the popular uprising, his regime has been badly damaged ...'

The meeting went on for two hours. For Dana it was both traumatic and cathartic, because as she described

what happened, she found herself living the terrible scenes all over again; and at the same time, she found it a relief to be able to talk about it. When she was finished, she felt drained.

The secretary of state said, 'I want to thank you, Miss Evans. This has been very informative.' He smiled. 'I'm glad you got back here safely.'

'So am I, Mr Secretary.'

Friday night, Dana was seated next to Jeff Connors in the press box at Camden Yards, watching the baseball game. And for the first time since she had returned, she was able to think about something other than the war. As Dana watched the players on the field, she listened to the announcer reporting the game.

'. . . it's the top of the sixth inning and Nelson is pitching. Alomar hits a line drive down the left-field line for a double. Palmeiro is approaching the plate. The count is two and one. Nelson throws a fastball down the middle and Palmeiro is going for it. What a hit! It looks like it's going to clear the right-field wall. It's over! Palmeiro is rounding the bases with a two-run homer that puts the Orioles in the lead . . .'

At the seventh-inning stretch, Jeff stood up and looked at Dana. 'Are you enjoying yourself?'

Dana looked at him and nodded. 'Yes.'

* * *

Back in D.C. after the game, they had supper at Bistro Twenty Fifteen.

'I want to apologize again for the way I behaved the other day,' Dana said. 'It's just that I've been living in a world where –' She stopped, not sure how to phrase it. 'Where everything is a matter of life and death. Everything. It's awful. Because unless someone stops the war, those people have no hope.'

Jeff said gently, 'Dana, you can't put your life on hold because of what's happening over there. You have to begin living again. Here.'

'I know. It's just . . . not easy.'

'Of course it isn't. I'd like to help you. Would you let me?'

Dana looked at him for a long time. 'Please.'

The next day, Dana had a luncheon date with Jeff Connors.

'Can you pick me up?' he asked. He gave her the address.

'Right.' Dana wondered what Jeff was doing there. It was in a very troubled inner-city neighborhood. When Dana arrived, she found the answer.

Jeff was surrounded by two teams of baseball players, ranging in age from nine to thirteen, dressed in a creative variety of baseball uniforms. Dana parked at the curb to watch.

'And remember,' Jeff was saying, 'don't rush. When the

pitcher throws the ball, imagine that it's coming at you very slowly, so that you have plenty of time to hit it. Feel your bat smacking the ball. Let your mind help guide your hands so –'

Jeff looked over and saw Dana. He waved. 'All right, fellows. That's it for now.'

One of the boys asked, 'Is that your girl, Jeff?'

'Only if I'm lucky.' Jeff smiled. 'See you later.' He walked over to Dana's car.

'That's quite a ball club,' Dana said.

'They're good boys. I coach them once a week.'

She smiled. 'I like that.' And she wondered how Kemal was and what he was doing.

As the days went on, Dana found herself coming to like Jeff Connors more and more. He was sensitive, intelligent, and amusing. She enjoyed being with him. Slowly, the horrible memories of Sarajevo were beginning to fade. The morning came when she woke up without having had nightmares.

When she told Jeff about it, he took her hand and said 'That's my girl.'

And Dana wondered whether she should read a deeper meaning into it.

There was a hand-printed letter waiting for Dana at the office. It read: 'miss evans, don't worry about me. i'm

happy. i am not lonely. i don't miss anybody. and i am going to send you back the clothes you bought me because i don't need them. i have my own clothes. goodbye.' It was signed 'kemal.'

The letter was postmarked Paris, and the letterhead read 'Xavier's Home for Boys.' Dana read the letter twice and then picked up the phone. It took her four hours to reach Kemal.

She heard his voice, a tentative 'Hello . . .'

'Kemal, this is Dana Evans.' There was no response. 'I got your letter.' Silence. 'I just wanted to tell you that I'm glad you're so happy, and that you're having such a good time.' She waited a moment, then went on, 'I wish I were as happy as you are. Do you know why I'm not? Because I miss you. I think about you a lot.'

'No, you don't,' Kemal said. 'You don't care about me.'

'You're wrong. How would you like to come to Washington and live with me?'

There was a long silence. 'Do you – do you mean that?'

'You bet I do. Would you like that?'

'I –' He began to cry.

'Would you, Kemal?'

'Yes – yes, ma'am.'

'I'll make the arrangements.'

'Miss Evans?'

'Yes?'

'I love you.'

* * *

226

Dana and Jeff Connors were walking in West Potomac Park. 'I think I'm going to have a roommate,' Dana said. 'He should be here in the next few weeks.'

Jeff looked at her in surprise. 'He?'

Dana found herself pleased at his reaction. 'Yes. His name is Kemal. He's twelve years old.' She told him the story.

'He sounds like a great kid.'

'He is. He's been through hell, Jeff. I want to help him forget.'

He looked at Dana and said, 'I'd like to help, too.'

That night they made love for the first time.

Sixteen

There are two Washington, D.C.'s. One is a city of inordinate beauty: imposing architecture, world-class museums, statues, monuments to the giants of the past: Lincoln, Jefferson, Washington ... a city of verdant parks, cherry blossoms, and velvet air.

The other Washington, D.C., is a citadel of the homeless, a city with one of the highest crime rates in the nation, a labyrinth of muggings and murders.

The Monroe Arms is an elegant boutique hotel discreetly tucked away not far from the corner of 27th and K streets. It does no advertising and caters mainly to its regular clientele. The hotel was built a number of years ago by an enterprising young real estate entrepreneur named Lara Cameron.

Jeremy Robinson, the hotel's general manager, had just arrived on his evening shift and was studying the guest register with a perplexed expression on his face. He checked the names of the occupants of the elite Terrace

Suites once again to make certain someone had not made a mistake.

In Suite 325, a faded actress was rehearsing for a play opening at the National Theater. According to a story in *The Washington Post*, she was hoping to make a comeback.

In 425, the suite above hers, was a well-known arms dealer who visited Washington regularly. The name on the guest register was J. L. Smith, but his looks suggested one of the Middle East countries. Mr Smith was an extraordinarily generous tipper.

Suite 525 was registered to William Quint, a congressman who headed the powerful drug oversight committee.

Above, Suite 625 was occupied by a computer software salesman who visited Washington once a month.

Registered in Suite 725 was Pat Murphy, an international lobbyist.

So far, so good, Jeremy Robinson thought. The guests were all well known to him. It was Suite 825, the Imperial Suite on the top floor, that was the enigma. It was the most elegant suite in the hotel, and it was always held in reserve for the most important VIPs. It occupied the entire floor and was exquisitely decorated with valuable paintings and antiques. It had its own private elevator leading to the basement garage, so that its guests who wished to be anonymous could arrive and depart in privacy.

What puzzled Jeremy Robinson was the name on the

hotel register: Eugene Gant. Was there actually a person by that name, or had someone who enjoyed reading Thomas Wolfe selected it as an alias?

Carl Gorman, the day clerk who had registered the eponymous Mr Gant, had left on his vacation a few hours earlier, and was unreachable. Robinson hated mysteries. Who was Eugene Gant and why had he been given the Imperial Suite?

In Suite 325, on the third floor, Dame Gisella Barrett was rehearsing for a play. She was a distinguished-looking woman in her late sixties, an actress who had once mesmerized audiences and critics from London's West End to Manhattan's Broadway. There were still faint traces of beauty in her face, but they were overlaid with bitterness.

She had read the article in *The Washington Post* that said she had come to Washington to make a comeback. *A comeback!* Dame Barrett thought indignantly. *How dare they! I've never been away.*

True, it had been more than twenty years since she had last appeared onstage, but that was only because a great actress needed a great part, a brilliant director, and an understanding producer. The directors today were too young to cope with the grandeur of real Theater, and the great English producers – H. M. Tenant, Binkie Beaumont, C. B. Cochran – were all gone. Even the reasonably competent American producers, Helburn, Belasco, and Golden, were no longer around. There was

no question about it: The current theater was controlled by know-nothing parvenus with no background. The old days had been so wonderful. There were playwrights back then whose pens were dipped in lightning. Dame Barrett had starred in the part of Ellie Dunn in Shaw's *Heartbreak House.*

How the critics raved about me. Poor George. He hated to be called George. He preferred Bernard. People thought of him as acerbic and bitter, but underneath it all, he was really a romantic Irishman. He used to send me red roses. I think he was too shy to go beyond that. Perhaps he was afraid I would reject him.

She was about to make her return in one of the most powerful roles ever written – Lady Macbeth. It was the perfect choice for her.

Dame Barrett placed a chair in front of a blank wall, so that she would not be distracted by the view outside. She sat down, took a deep breath, and began to get into the character Shakespeare had created.

> '*Come, you spirits*
> *That tend on mortal thoughts! Unsex me here,*
> *And fill me from the crown to the toe top-full*
> *Of direst cruelty; make thick my blood,*
> *Stop up the access and passage to remorse,*
> *That no compunctious visitings of nature*
> *Shake my fell purpose, nor keep peace between*
> *The effect and it!*'

'. . . For God's sake, how can they be so stupid? After

all the years I have been staying in this hotel, you would think that . . .'

The voice was booming through the open window, from the suite above.

In Suite 425, J.L. Smith, the arms dealer, was loudly berating a waiter from room service. '. . . they would know by now that I order only Beluga caviar. Beluga!' He pointed to a plate of caviar on the room-service table. 'That is a dish fit for peasants!'

'I'm so sorry, Mr Smith. I'll go down to the kitchen and –'

'Never mind.' J.L. Smith looked at his diamond-studded Rolex. 'I have no time. I have an important appointment.' He rose and started toward the door. He was due at his attorney's office. A day earlier, a federal grand jury had indicted him on fifteen counts of giving illegal gifts to the secretary of defense. If found guilty, he was facing three years in prison and a million-dollar fine.

In Suite 525, Congressman William Quint, a member of a prominent third-generation Washington family, was in conference with three members of his investigating staff.

'The drug problem in this city is getting completely out of hand,' Quint said. 'We have to get it back under

232

control.' He turned to Dalton Isaak. 'What's your take on it?'

'It's the street gangs. The Brentwood Crew is under-cutting the Fourteenth Street Crew and the Simple City Crew. That's led to four killings in the last month.'

'We can't let this go on,' Quint said. 'It's bad for business. I've been getting calls from the DEA and the chief of police asking what we're planning to do about it.'

'What did you tell them?'

'The usual. That we're investigating.' He turned to his assistant. 'Set up a meeting with the Brentwood Crew. Tell them if they want protection from us, they're going to have to get their prices in line with the others.' He turned to another of his assistants. 'How much did we take in last month?'

'Ten million here, ten million offshore.'

'Let's bump that up. This city is getting too damned expensive.'

In 625, the suite above, Norman Haff lay naked in the dark in bed, watching a porno film on the hotel's closed-circuit channel. He was a pale-skinned man with an enormous beer belly and a flabby body. He reached over and stroked the breast of his bedmate.

'Look what they're doing, Irma.' His voice was a strangled whisper. 'Would you like me to do that to you?' He circled his fingers around her belly, his eyes fastened to the screen where a woman was making

passionate love to a man. 'Does that excite you, baby? It sure gets me hot.'

He slipped two fingers between Irma's legs. 'I'm ready,' he groaned. He grabbed the inflated doll, rolled over, and pushed himself into her. The vagina of the battery-operated doll opened and closed on him, squeezing him tighter and tighter.

'Oh, my God!' he exclaimed. He gave a satisfied groan. 'Yes! Yes!'

He switched off the battery and lay there panting. He felt wonderful. He would use Irma again in the morning before he deflated her and put her in a suitcase.

Norman was a salesman, and he was on the road most of the time in strange towns where he had no companionship. He had discovered Irma years ago, and she was all the female company he needed. His stupid salesmen friends traveled around the country picking up sluts and professional whores, but Norman had the last laugh.

Irma would never give him a disease.

On the floor above, in Suite 725, Pat Murphy's family had just come back from dinner. Tim Murphy, twelve, was standing on the balcony overlooking the park. 'Tomorrow can we climb up to the top of the monument, Daddy?' he begged. 'Please?'

His younger brother said, 'No. I want to go to the Smithsonian Institute.'

'Institution,' his father corrected him.

'Whatever. I want to go.'

It was the first time the children had been in the nation's capital, although their father spent more than half of every year there. Pat Murphy was a successful lobbyist and had access to some of the most important people in Washington.

His father had been the mayor of a small town in Ohio, and Pat had grown up fascinated by politics. His best friend had been a boy named Joey. They had gone through school together, had gone to the same summer camps, and had shared everything. They were best friends in the truest sense of the phrase. That had all changed one holiday when Joey's parents were away and Joey was staying with the Murphys. In the middle of the night, Joey had come to Pat's room and climbed into his bed. 'Pat,' he whispered. 'Wake up.'

Pat's eyes had flown open. 'What? What's the matter?'

'I'm lonely,' Joey whispered. 'I need you.'

Pat Murphy was confused. 'What for?'

'Don't you understand? I love you. I want you.' And he had kissed Pat on the lips.

And the horrible realization had dawned that Joey was a homosexual. Pat was sickened by it. He refused ever to speak to Joey again.

Pat Murphy loathed homosexuals. They were freaks, faggots, fairies, cursed by God, trying to seduce innocent children. He turned his hatred and disgust into a lifelong campaign, voting for antihomosexual candidates and lecturing about the evils and dangers of homosexuality.

In the past, he had always come to Washington alone, but this time his wife had stubbornly insisted that he bring her and the children.

'We want to see what your life here is like,' she said. And Pat had finally given in.

He looked at his wife and children now and thought, *It's one of the last times I'll ever see them. How could I have ever made such a stupid mistake? Well, it's almost over now.* His family had such grand plans for tomorrow. But there would be no tomorrow. In the morning, before they were awake, he would be on his way to Brazil.

Alan was waiting for him.

In Suite 825, the Imperial Suite, there was total silence. *Breathe*, he told himself. *You must breathe ... slower, slower ...* He was at the edge of panic. He looked at the slim, naked body of the young girl on the floor and thought, *It wasn't my fault. She slipped.*

Her head had split open where she had fallen against the sharp edge of the wrought-iron table, and blood was oozing from her forehead. He had felt her wrist. There was no pulse. It was incredible. One moment she had been so alive, and the next moment ...

I've got to get out of here. Now! He turned away from the body and hurriedly began to dress. This would not be just another scandal. This would be a scandal that rocked the world. *They must never trace me to this suite.*

When he finished dressing, he went into the bathroom, moistened a towel, and began polishing the surfaces of every place he might have touched.

When he was finally sure he had left no fingerprints to mark his presence, he took one last look around. Her purse! He picked up the girl's purse from the couch, and walked to the far end of the apartment, where the private elevator waited.

He stepped inside, trying hard to control his breathing. He pressed G, and a few seconds later, the elevator door opened and he was in the garage. It was deserted. He started toward his car, then, suddenly remembering, hurried back to the elevator. He took out his handkerchief and wiped his fingerprints from the elevator buttons. He stood in the shadows, looking around again to make sure he was still alone. Finally satisfied, he walked over to his car, opened the door, and sat behind the wheel. After a moment, he turned on the ignition and drove out of the garage.

It was a Filipina maid who found the dead girl's body sprawled on the floor.

'O Dios ko, kawawa naman iyong babae!' She made the sign of the cross and hurried out of the room, screaming for help.

Three minutes later, Jeremy Robinson and Thom Peters, the hotel's head of security, were in the Imperial Suite staring down at the naked body of the girl.

'Jesus,' Thom said. 'She can't be more than sixteen or seventeen years old.' He turned to the manager. 'We'd better call the police.'

'Wait!' *Police. Newspapers. Publicity.* For one wild moment, Robinson wondered whether it would be possible to spirit the girl's body out of the hotel. 'I suppose so,' he finally said reluctantly.

Thom Peters took a handkerchief from his pocket and used it to pick up the telephone.

'What are you doing?' Robinson demanded. 'This isn't a crime scene. It was an accident.'

'We don't know that yet, do we?' Peters said.

He dialed a number and waited. 'Homicide.'

Detective Nick Reese looked like the paperback version of a street-smart cop. He was tall and brawny, with a broken nose that was a memento from an early boxing career. He had paid his dues by starting as an officer in Washington's Metropolitan Police Department and had slowly worked his way through the ranks: Master Patrol Officer, Sergeant, Lieutenant. He had been promoted from Detective D2 to Detective D1, and in the past ten years had solved more cases than anyone else in the department.

Detective Reese stood there quietly studying the scene. In the suite with him were half a dozen men. 'Has anyone touched her?'

Robinson shuddered. 'No.'

'Who is she?'

'I don't know.'

Reese turned to look at the hotel manager. 'A young girl is found dead in your Imperial Suite, and you don't have any idea who she is? Doesn't this hotel have a guest register?'

'Of course, Detective, but in this case –' He hesitated.

'In this case . . . ?'

'The suite is registered to a Eugene Gant.'

'Who's Eugene Gant?'

'I have no idea.'

Detective Reese was getting impatient. 'Look. If someone booked this suite, he had to have paid for it . . . cash, credit card – sheep – whatever. Whoever checked this Gant in must have gotten a look at him. Who checked him in?'

'Our day clerk, Gorman.'

'I want to talk to him.'

'I – I'm afraid that's impossible.'

'Oh? Why?'

'He left on his vacation today.'

'Call him.'

Robinson sighed. 'He didn't say where he was going.'

'When will he be back?'

'In two weeks.'

'I'll let you in on a little secret. I'm not planning to wait two weeks. I want some information now. Somebody must have seen someone entering or leaving this suite.'

'Not necessarily,' Robinson said apologetically. 'Besides the regular exit, this suite has a private elevator that goes

239

directly to the basement garage ... I don't know what the fuss is all about. It – it was obviously an accident. She was probably on drugs and took an overdose and tripped and fell.'

Another detective approached Detective Reese. 'I checked the closets. Her dress is from the Gap, shoes from the Wild Pair. No help there.'

'There's nothing to identify her at all?'

'No. If she had a purse, it's gone.'

Detective Reese studied the body again. He turned to a police officer standing there. 'Get me some soap. Wet it.'

The police officer was staring at him. 'I'm sorry?'

'Wet soap.'

'Yes, sir.' He hurried off.

Detective Reese knelt down beside the body of the girl and studied the ring on her finger. 'It looks like a school ring.'

A minute later, the police officer returned and handed Reese a bar of wet soap.

Reese gently rubbed the soap along the girl's finger and carefully removed the ring. He turned it from side to side, examining it. 'It's a class ring from Denver High. There are initials on it, P.Y.' He turned to his partner. 'Check it out. Call the school and find out who she is. Let's get an ID on her as fast as we can.'

Detective Ed Nelson, one of the fingerprint men, came up to Detective Reese. 'Something damned weird is going on, Nick. We're picking up prints all over the place, and

yet someone took the trouble to wipe the fingerprints off all the doorknobs.'

'So someone was here with her when she died. Why didn't he call a doctor? Why did he bother wiping out his fingerprints? And what the hell is a young kid doing in an expensive suite like this?'

He turned to Robinson. 'How was this suite paid for?'

'Our records show that it was paid for in cash. A messenger delivered the envelope. The reservation was made over the phone.'

The coroner spoke up. 'Can we move the body now, Nick?'

'Just hold it a minute. Did you find any marks of violence?'

'Only the trauma to the forehead. But of course we'll do an autopsy.'

'Any track marks?'

'No. Her arms and legs are clean.'

'Does it look like she's been raped?'

'We'll have to check that out.'

Detective Reese sighed. 'So what we have here is a school-girl from Denver who comes to Washington and gets herself killed in one of the most expensive hotels in the city. Someone wipes out his fingerprints and disappears. The whole thing stinks. I want to know who rented this suite.'

He turned to the coroner. 'You can take her out now.' He looked at Detective Nelson. 'Did you check the fingerprints in the private elevator?'

241

'Yes. The elevator goes from this suite directly to the basement. There are only two buttons. Both buttons have been wiped clean.'

'You checked the garage?'

'Right. Nothing unusual down there.'

'Whoever did this went to a hell of a lot of trouble to cover his tracks. He's either someone with a record, or a VIP who's been playing games out of school.' He turned to Robinson. 'Who usually rents this suite?'

Robinson said reluctantly, 'It's reserved for our most important guests. Kings, prime ministers . . .' He hesitated. '. . . Presidents.'

'Have any telephone calls been placed from this phone in the last twenty-four hours?'

'I don't know.'

Detective Reese was getting irritated. 'But you would have a record if there was?'

'Of course.'

Detective Reese picked up the telephone. 'Operator, this is Detective Nick Reese. I want to know if any calls were made from the Imperial Suite within the last twenty-four hours . . . I'll wait.'

He watched as the white-coated coroner's men covered the naked girl with a sheet and placed her on a gurney. *Jesus Christ*, Reese thought. *She hadn't even begun to live yet.*

He heard the operator's voice. 'Detective Reese?'

'Yes.'

'There was one call placed from the suite yesterday. It was a local call.'

Reese took out a notepad and pencil. 'What was the number? . . . Four-five-six-seven-zero-four-one? . . .' Reese started to write the numbers down, then suddenly stopped. He was staring at the notepad. 'Oh, shit!'

'What's the matter?' Detective Nelson asked.

Reese looked up. 'That's the number of the White House.'

Seventeen

The next morning at breakfast, Jan asked, 'Where were you last night, Oliver?'

Oliver's heart skipped a beat. But she could not possibly have known what happened. No one could. No one. 'I was meeting with –'

Jan cut him short. 'The meeting was called off. But you didn't get home until three o'clock in the morning. I tried to reach you. Where were you?'

'Well, something came up. Why? Did you need –? Was something wrong?'

'It doesn't matter now,' Jan said wearily. 'Oliver, you're not just hurting me, you're hurting yourself. You've come so far. I don't want to see you lose it all because – because you can't –' Her eyes filled with tears.

Oliver stood up and walked over to her. He put his arms around her. 'It's all right, Jan. Everything's fine. I love you very much.'

And I do, Oliver thought, *in my own way. What happened last night wasn't my fault. She was the one who called. I never should have gone to meet her.* He had taken every

possible precaution not to be seen. *I'm in the clear*, Oliver decided.

Peter Tager was worried about Oliver. He had learned that it was impossible to control Oliver Russell's libido, and he had finally worked out an arrangement with him. On certain nights, Peter Tager set up fictitious meetings for the president to attend, away from the White House, and arranged for the Secret Service escort to disappear for a few hours.

When Peter Tager had gone to Senator Davis to complain about what was happening, the senator had said calmly, 'Well, after all, Oliver is a very hot-blooded man, Peter. Sometimes it's impossible to control passions like that. I deeply admire your morals, Peter. I know how much your family means to you, and how distasteful the president's behavior must seem to you. But let's not be too judgmental. You just keep on seeing that everything is handled as discreetly as possible.'

Detective Nick Reese hated going into the forbidding, whitewalled autopsy room. It smelled of formaldehyde and death. When he walked in the door, the coroner, Helen Chuan, a petite, attractive woman, was waiting for him.

'Morning,' Reese said. 'Have you finished with the autopsy?'

'I have a preliminary report for you, Nick. Jane Doe didn't die from her head injury. Her heart stopped before she hit the table. She died of an overdose of methylenedioxymethamphetamine.'

He sighed. 'Don't do this to me, Helen.'

'Sorry. On the streets, it's called Ecstasy.' She handed him a coroner's report 'Here's what we have so far.'

AUTOPSY PROTOCOL
NAME OF DECEDENT: JANE DOE FILE NO: C-L96I

ANATOMIC SUMMARY
I. DILATED AND HYPERTROPHIC CARDIO-MYOPATHY
 A. CARDIOMEGALY (750 GM)
 B. LEFT VENTRICULAR HYPERTROPHY, HEART (2.3 CM)
 C. CONGESTIVE HEPATOMEGALY (2750 gm)
 D. CONGESTIVE SPLENOMEGALY (350 mg)
II. ACUTE OPIATE INTOXICATION
 A. ACUTE PASSIVE CONGESTION, ALL VISCERA
III. TOXICOLOGY (SEE SEPARATE REPORT)
IV. BRAIN HEMORRHAGE (SEE SEPARATE REPORT)
CONCLUSION: (CAUSE OF DEATH)

DILATED AND HYPERTROPHIC CARDIO-
MYOPATHY
ACUTE OPIATE INTOXICATION

Nick Reese looked up. 'So if you translated this into
English, she died of a drug overdose of Ecstasy?'

'Yes.'

'Was she sexually assaulted?'

Helen Chuan hesitated. 'Her hymen had been broken,
and there were traces of semen and a little blood along
her thighs.'

'So she was raped.'

'I don't think so.'

'What do you mean – you don't think so?' Reese
frowned.

'There were no signs of violence.'

Detective Reese was looking at her, puzzled. 'What are
you saying?'

'I think that Jane Doe was a virgin. This was her first
sexual experience.'

Detective Reese stood there, digesting the information.
Someone had been able to persuade a virgin to go up
to the Imperial Suite and have sex with him. It would
have had to be someone she knew. Or someone famous
or powerful.

The telephone rang. Helen Chuan picked it up. 'Cor-
oner's office.' She listened a moment, then handed the
phone to the detective. 'It's for you.'

Nick Reese took the phone. 'Reese.' His face brightened.

'Oh, yes, Mrs Holbrook. Thanks for returning my call. It's a class ring from your school with the initials P.Y. on it. Do you have a female student with those initials? . . . I'd appreciate it. Thank you. I'll wait.'

He looked up at the coroner. 'You're sure she couldn't have been raped?'

'I found no signs of violence. None.'

'Could she have been penetrated after she died?'

'I would say no.'

Mrs Holbrook's voice came back on the phone. 'Detective Reese?'

'Yes.'

'According to our computer, we do have a female student with the initials P.Y. Her name is Pauline Young.'

'Could you describe her for me, Mrs Holbrook?'

'Why, yes. Pauline is eighteen. She's short and stocky, with dark hair . . .'

'I see.' *Wrong girl.* 'And that's the only one?'

'The only female, yes.'

He picked up on it. 'You mean you have a male with those initials?

'Yes. Paul Yerby. He's a senior. As a matter of fact, Paul happens to be in Washington, D.C., right now.'

Detective Reese's heart began to beat faster. 'He's here?'

'Yes. A class of students from Denver High is on a trip to Washington to visit the White House and Congress and –'

'And they're all in the city now?'

'That's right.'

'Do you happen to know where they're staying?'

'At the Hotel Lombardy. They gave us a group rate there. I talked with several of the other hotels, but they wouldn't –'

'Thank you very much, Mrs Holbrook. I appreciate it.'

Nick Reese replaced the receiver and turned to the coroner. 'Let me know when the autopsy is complete, will you, Helen?'

'Of course. Good luck, Nick.'

He nodded. 'I think I've just had it.'

The Hotel Lombardy is located on Pennsylvania Avenue, two blocks from Washington Circle and within walking distance of the White House, some monuments, and a subway station. Detective Reese walked into the old-fashioned lobby and approached the clerk behind the desk. 'Do you have a Paul Yerby registered here?'

'I'm sorry. We don't give out –'

Reese flashed his badge. 'I'm in a big hurry, friend.'

'Yes, sir.' The clerk looked through his guest register. 'There's a Mr Yerby in Room 315. Shall I –?'

'No, I'll surprise him. Stay away from the phone.'

Reese took the elevator, got off on the third floor, and walked down the corridor. He stopped before Room 315. He could hear voices inside. He unfastened the button of his jacket and knocked on the door. It was opened by a boy in his late teens.

'Hello.'

'Paul Yerby?'

'No.' The boy turned to someone in the room. 'Paul, someone for you.'

Nick Reese pushed his way into the room. A slim, tousle-haired boy in jeans and a sweater was coming out of the bathroom.

'Paul Yerby?'

'Yes. Who are you?'

Reese pulled out his badge. 'Detective Nick Reese. Homicide.'

The boy's complexion turned pale. 'I – what can I do for you?'

Nick Reese could smell the fear. He took the dead girl's ring from his pocket and held it out. 'Have you ever seen this ring before, Paul?'

'No,' Yerby said quickly. 'I –'

'It has your initials on it.'

'It has? Oh. Yeah.' He hesitated. 'I guess it could be mine. I must have lost it somewhere.'

'Or given it to someone?'

The boy licked his lips, 'Uh, yeah. I might have.'

'Let's go downtown, Paul.'

The boy looked at him nervously. 'Am I under arrest?'

'What for?' Detective Reese asked. 'Have you committed a crime?'

'Of course not. I . . .' The words trailed off.

'Then why would I arrest you?'

'I – I don't know. I don't know why you want me to go downtown.'

He was eyeing the open door. Detective Reese reached out and took a grip on Paul's arm. 'Let's go quietly.'

The roommate said, 'Do you want me to call your mother or anybody, Paul?'

Paul Yerby shook his head, miserable. 'No. Don't call anyone.' His voice was a whisper.

The Henry I. Daly Building at 300 Indiana Avenue, NW, in downtown Washington is an unprepossessing six-story gray brick building that serves as police headquarters for the district. The Homicide Branch office is on the third floor. While Paul Yerby was being photographed and fingerprinted, Detective Reese went to see Captain Otto Miller.

'I think we got a break in the Monroe Arms case.'

Miller leaned back in his chair. 'Go on.'

'I picked up the girl's boyfriend. The kid's scared out of his wits. We're going to question him now. Do you want to sit in?'

Captain Miller nodded toward a pile of papers heaped on his desk. 'I'm busy for the next few months. Give me a report.'

'Right.' Detective Reese started toward the door.

'Nick – be sure to read him his rights.'

Paul Yerby was brought into an interrogation room. It was small, nine by twelve, with a battered desk, four

chairs, and a video camera. There was a one-way mirror so that officers could watch the interrogation from the next room.

Paul Yerby was facing Nick Reese and two other detectives, Doug Hogan and Edgar Bernstein.

'You're aware that we're videotaping this conversation?' – Detective Reese

'Yes, sir.'

'You have the right to an attorney. If you cannot afford an attorney, one will be appointed to represent you.'

'Would you like to have a lawyer present?' – Detective Bernstein

'I don't need a lawyer.'

'All right. You have a right to remain silent. If you waive that right, anything you say here can and will be used against you in a court of law. Is that clear?'

'Yes, sir.'

'What's your legal name?'

'Paul Yerby.'

'Your address?'

'Three-twenty Marion Street, Denver, Colorado. Look, I haven't done anything wrong. I –'

'No one says you have. We're just trying to get some information, Paul. You'd like to help us, wouldn't you?'

'Sure, but I – I don't know what it's all about.'

'Don't you have any idea?'

'No, sir.'

'Do you have any girlfriends, Paul?'

'Well, you know . . .'

'No, we don't know. Why don't you tell us?'

'Well, sure. I see girls . . .'

'You mean you date girls? You take girls out?'

'Yeah.'

'Do you date any one particular girl?'

There was a silence.

'Do you have a girlfriend, Paul?'

'Yes.'

'What's her name?' – Detective Bernstein

'Chloe.'

'Chloe what?' – Detective Reese

'Chloe Houston.'

Reese made a note. 'What's her address, Paul?'

'Six-oh-two Oak Street, Denver.'

'What are her parents' names?'

'She lives with her mother.'

'And her name?'

'Jackie Houston. She's the governor of Colorado.'

The detectives looked at one another. *Shit! That's all we need!*

Reese held up a ring. 'Is this your ring, Paul?'

He studied it a moment, then said reluctantly, 'Yeah.'

'Did you give Chloe this ring?'

He swallowed nervously. 'I – I guess I did.'

'You're not sure?'

'I remember now. Yes, I did.'

'You came to Washington with some classmates, right? Kind of a school group?'

'That's right.'

'Was Chloe part of that group?'

'Yes, sir.'

'Where's Chloe now, Paul?' – Detective Bernstein

'I – I don't know.'

'When did you last see her?' – Detective Hogan

'I guess a couple of days ago.'

'Two days ago?' – Detective Reese

'Yeah.'

'And where was that?' – Detective Bernstein

'In the White House.'

The detectives looked at one another in surprise. 'She was in the White House?' Reese asked.

'Yes, sir. We were all on a private tour. Chloe's mother arranged it.'

'And Chloe was with you?' – Detective Hogan

'Yes.'

'Did anything unusual happen on the tour?' – Detective Bernstein

'What do you mean?'

'Did you meet or talk to anyone on the tour?' – Detective Bernstein

'Well, sure, the guide.'

'And that's all?' – Detective Reese

'That's right.'

'Was Chloe with the group all the time?' – Detective Hogan

'Yes –' Yerby hesitated. 'No. She slipped away to go to the ladies' room. She was gone about fifteen minutes. When she came back, she –' He stopped.

'She what?' Reese asked.

'Nothing. She just came back.'

The boy was obviously lying.

'Son,' Detective Reese asked, 'do you know that Chloe Houston is dead?'

They were watching him closely. 'No! My God! How?' The surprised look on his face could have been feigned.

'Don't you know?' – Detective Bernstein

'No! I – I can't believe it.'

'You had nothing to do with her death?' – Detective Hogan

'Of course not! I love . . . I loved Chloe.'

'Did you ever go to bed with her?' – Detective Bernstein

'No. We – we were waiting. We were going to get married.'

'But sometimes you did drugs together?' – Detective Reese

'No! We never did drugs.'

The door opened and a burly detective, Harry Carter, came into the room. He walked over to Reese and whispered something in his ear. Reese nodded. He sat there staring at Paul Yerby.

'When was the last time you saw Chloe Houston?'

'I told you, in the White House.' He shifted uncomfortably in his chair.

Detective Reese leaned forward. 'You're in a lot of

trouble, Paul. Your fingerprints are all over the Imperial Suite at the Monroe Arms Hotel. How did they get there?'

Paul Yerby sat there, pale-faced.

'You can quit lying now. We've got you nailed.'

'I – I didn't do anything.'

'Did you book the suite at the Monroe Arms?' – Detective Bernstein

'No, I didn't.' The emphasis was on the 'I.'

Detective Reese pounced on it. 'But you know who did?'

'No.' The answer came too quickly.

'You admit you were in the suite?' – Detective Hogan

'Yes, but – but Chloe was alive when I left.'

'Why did you leave?' – Detective Hogan

'She asked me to. She – she was expecting someone.'

'Come on, Paul. We know you killed her.' – Detective Bernstein

'No!' He was trembling. 'I swear I had nothing to do with it. I – I just went up to the suite with her. I only stayed a little while.'

'Because she was expecting someone?' – Detective Reese

'Yes. She – she was kind of excited.'

'Did she tell you who she was going to meet?' – Detective Hogan

He was licking his lips. 'No.'

'You're lying. She did tell you.'

'You said she was excited. What about?' – Detective Reese

Paul licked his lips again. 'About – about the man she was going to meet there for dinner.'

'Who was the man, Paul?' – Detective Bernstein

'I can't tell you.'

'Why not?' – Detective Hogan

'I promised Chloe I would never tell anyone.'

'Chloe is dead.'

Paul Yerby's eyes filled with tears. 'I just can't believe it.'

'Give us the man's name.' – Detective Reese

'I can't do that. I promised.'

'Here's what's going to happen to you: You're going to spend tonight in jail. In the morning, if you give us the name of the man she was going to meet, we'll let you go. Otherwise, we're going to book you for murder one.' – Detective Reese

They waited for him to speak.

Silence.

Nick Reese nodded to Bernstein. 'Take him away.'

Detective Reese returned to Captain Miller's office.

'I have bad news and I have worse news.'

'I haven't time for this, Nick.'

'The bad news is that I'm not sure it was the boy who gave her the drug. The worse news is that the girl's mother is the governor of Colorado.'

'Oh, God! The papers will love this.' Captain Miller took a deep breath. 'Why don't you think the boy's guilty?'

'He admits he was in the girl's suite, but he said she told him to leave because she was expecting someone. I think the kid's too smart to come up with a story that stupid. What I do believe is that he knows who Chloe Houston was expecting. He won't say who it was.'

'Do you have any idea?'

'It was her first time in Washington, and they were on a tour of the White House. She didn't know anyone here. She said she was going to the ladies' room. There is no public rest room in the White House. She would have had to go outside to the Visitor's Pavilion on the Ellipse at 15th and E streets or to the White House Visitor Center. She was gone about fifteen minutes. What I think happened is that while trying to find a ladies' room, she ran into someone in the White House, someone she might have recognized. Maybe someone she saw on TV. Anyway, it must have been somebody important. He led her to a private washroom and impressed her enough that she agreed to meet him at the Monroe Arms.'

Captain Miller was thoughtful. 'I'd better call the White House. They asked to be kept up-to-date on this. Don't let up on the kid. I want that name.'

'Right.'

As Detective Reese walked out the door, Captain Miller reached for the telephone and dialed a number. A few minutes later, he was saying, 'Yes, sir. We have a material

witness in custody. He's in a holding cell at the Indiana Avenue police station ... We won't, sir. I think the boy will give us the man's name tomorrow ... Yes, sir. I understand.' The line went dead.

Captain Miller sighed and went back to the pile of papers on his desk.

At eight o'clock the following morning, when Detective Nick Reese went to Paul Yerby's cell, Yerby's body was hanging from one of the top bars.

Eighteen

DEAD 16-YEAR-OLD IDENTIFIED AS DAUGH-
TER OF COLORADO GOVERNOR
 BOYFRIEND IN POLICE CUSTODY HANGS
HIMSELF
 POLICE HUNT MYSTERY WITNESS

He stared at the headlines and felt suddenly faint.
Sixteen years old. She had looked older than that. What
was he guilty of? Murder? Manslaughter, maybe. Plus
statutory rape.

He had watched her come out of the bathroom of
the suite, wearing only a shy smile. *'I've never done
this before.'*

And he had put his arms around her and stroked her.
'I'm glad the first time is with me, honey.' Earlier, he had
shared a glass of liquid Ecstasy with her. *'Drink this. It will
make you feel good.'* They had made love, and afterward
she had complained about not feeling well. She had
gotten out of bed, stumbled, and hit her head against
the table. An accident. Of course, the police would not

see it that way. *But there's nothing to connect me with her. Nothing.*

The whole episode had an air of unreality, a nightmare that had happened to someone else. Somehow, seeing it in print made it real.

Through the walls of the office, he could hear the sound of traffic on Pennsylvania Avenue, outside the White House, and he became aware again of his surroundings. A cabinet meeting was scheduled to begin in a few minutes. He took a deep breath. *Pull yourself together.*

In the Oval Office were gathered Vice President Melvin Wicks, Sime Lombardo, and Peter Tager.

Oliver walked in and sat behind his desk. 'Good morning, gentlemen.'

There were general greetings.

Peter Tager said, 'Have you seen the *Tribune*, Mr President?'

'No.'

'They've identified the girl who died at the Monroe Arms Hotel. I'm afraid it's bad news.'

Oliver unconsciously stiffened in his chair. 'Yes?'

'Her name is Chloe Houston. She's the daughter of Jackie Houston.'

'Oh, my God!' The words barely escaped the president's lips.

They were staring at him, surprised at his reaction. He

recovered quickly. 'I – I knew Jackie Houston . . . a long time ago. This – this is terrible news. Terrible.'

Sime Lombardo said, 'Even though Washington crime is not our responsibility, the *Tribune* is going to hammer us on this.'

Melvin Wicks spoke up. 'Is there any way we can shut Leslie Stewart up?'

Oliver thought of the passionate evening he had spent with her. 'No,' Oliver said. 'Freedom of the press, gentlemen.'

Peter Tager turned to the president. 'About the governor . . . ?'

'I'll handle it.' He flicked down an intercom key. 'Get me Governor Houston in Denver.'

'We've got to start some damage control,' Peter Tager was saying. 'I'll get together statistics on how much crime has gone down in this country, you've asked Congress for more money for our police departments, et cetera.' The words sounded hollow even to his own ears.

'This is terrible timing,' Melvin Wicks said.

The intercom buzzed. Oliver picked up the telephone. 'Yes?' He listened a moment, then replaced the receiver. 'The governor is on her way to Washington.' He looked at Peter Tager. 'Find out what plane she's on, Peter. Meet her and bring her here.'

'Right. There's an editorial in the *Tribune*. It's pretty rough.' Peter Tager handed Oliver the editorial page of the newspaper. PRESIDENT UNABLE TO CONTROL CRIME IN THE CAPITAL. 'It goes on from there.'

'Leslie Stewart is a bitch,' Sime Lombardo said quietly. 'Someone should have a little talk with her.'

In his office at the *Washington Tribune*, Matt Baker was re-reading the editorial attacking the president for being soft on crime when Frank Lonergan walked in. Lonergan was in his early forties, a bright, street-smart journalist who had at one time worked on the police force. He was one of the best investigative journalists in the business.

'You wrote this editorial, Frank?'

'Yes,' he said.

'This paragraph about crime going down twenty-five percent in Minnesota, that's still bothering me. Why did you just talk about Minnesota?'

Lonergan said, 'It was a suggestion from the Ice Princess.'

'That's ridiculous,' Matt Baker snapped. 'I'll talk to her.'

Leslie Stewart was on the telephone when Matt Baker walked into her office.

'I'll leave it to you to arrange the details, but I want us to raise as much money for him as we can. As a matter of fact, Senator Embry of Minnesota is stopping by for lunch today, and I'll get a list of names from him. Thank you.' She replaced the receiver. 'Matt.'

Matt Baker walked over to her desk. 'I want to talk to you about this editorial.'

'It's good, isn't it?'

'It stinks, Leslie. It's propaganda. The president's not responsible for controlling crime in Washington, D.C. We have a mayor who's supposed to do that, and a police force. And what's this crap about crime going down twenty-five percent in Minnesota? Where did you come up with those statistics?'

Leslie Stewart leaned back and said calmly, 'Matt, this is my paper. I'll say anything I want to say. Oliver Russell is a lousy president, and Gregory Embry would make a great one. We're going to help him get into the White House.'

She saw the expression on Matt's face and softened. 'Come on, Matt. The *Tribune* is going to be on the side of the winner. Embry will be good for us. He's on his way here now. Would you like to join us for lunch?'

'No. I don't like people who eat with their hands out.' He turned and left the office.

In the corridor outside, Matt Baker ran into Senator Embry. The senator was in his fifties, a self-important politician.

'Oh, Senator! Congratulations.'

Senator Embry looked at him, puzzled, 'Thank you. Er – for what?'

'For bringing crime down twenty-five percent in your state.' And Matt Baker walked away, leaving the senator looking after him with a blank expression on his face.

*　　*　　*

264

Lunch was in Leslie Stewart's antique-furnished dining room. A chef was working in the kitchen preparing lunch as Leslie and Senator Embry walked in. The captain hurried up to greet them.

'Luncheon is ready whenever you wish, Miss Stewart. Would you care for a drink?'

'Not for me,' Leslie said. 'Senator?'

'Well, I don't usually drink during the day, but I'll have a martini.'

Leslie Stewart was aware that Senator Embry drank a lot during the day. She had a complete file on him. He had a wife and five children and kept a Japanese mistress. His hobby was secretly funding a paramilitary group in his home state. None of this was important to Leslie. What mattered was that Gregory Embry was a man who believed in letting big business alone – and Washington Tribune Enterprises was big business. Leslie intended to make it bigger, and when Embry was president, he was going to help her.

They were seated at the dining table. Senator Embry took a sip of his second martini. 'I want to thank you for the fundraiser, Leslie. That's a nice gesture.'

She smiled warmly. 'It's my pleasure. I'll do everything I can to help you beat Oliver Russell.'

'Well, I think I stand a pretty good chance.'

'I think so, too. The people are getting tired of him and his scandals. My guess is that if there's one more scandal between now and election, they'll throw him out.'

Senator Embry studied her a moment. 'Do you think there will be?'

Leslie nodded and said softly, 'I wouldn't be surprised.'

The lunch was delicious.

The call came from Antonio Valdez, an assistant in the coroner's office. 'Miss Stewart, you said you wanted me to keep you informed about the Chloe Houston case?'

'Yes . . .'

'The cops asked us to keep a lid on it, but since you've been such a good friend, I thought –'

'Don't worry. You'll be taken care of. Tell me about the autopsy.'

'Yes, ma'am. The cause of death was a drug called Ecstasy.'

'What?'

'Ecstasy. She took it in liquid form.'

I have a little surprise for you that I want you to try . . . This is liquid Ecstasy . . . A friend of mine gave me this . . .'

And the woman who had been found in the Kentucky River had died of an overdose of liquid Ecstasy.

Leslie sat there motionless, her heart pounding.

There is a God.

Leslie sent for Frank Lonergan. 'I want you to follow up on the death of Chloe Houston. I think the president is involved.'

Frank Lonergan was staring at her incredulously. 'The president?'

'There's a cover-up going on. I'm convinced of it. That boy they arrested, who conveniently committed suicide ... dig into that. And I want you to check on the president's movements the afternoon and evening of her death. I want this to be a private investigation. Very private. You'll report only to me.'

Frank Lonergan took a deep breath. 'You know what this could mean?'

'Get started. And Frank?'

'Yes?'

'Check the Internet for a drug called Ecstasy. And look for a connection with Oliver Russell.'

In a medical Internet site devoted to the hazards of the drug, Lonergan found the story of Miriam Friedland, the former secretary to Oliver Russell. She was in a hospital in Frankfort, Kentucky. Lonergan telephoned to inquire about her. A doctor said, 'Miss Friedland passed away two days ago. She never recovered from her coma.'

Frank Lonergan put in a telephone call to the office of Governor Houston.

'I'm sorry,' her secretary told him, 'Governor Houston is on her way to Washington.'

Ten minutes later, Frank Lonergan was on his way to National Airport. He was too late.

As the passengers descended from the plane, Lonergan saw Peter Tager approach an attractive blonde in her forties and greet her. The two of them talked for a moment, and then Tager led her to a waiting limousine.

Watching in the distance, Lonergan thought, *I've got to talk to that lady.* He headed back toward town and began making calls on his car phone. On the third call, he learned that Governor Houston was expected at the Four Seasons Hotel.

When Jackie Houston was ushered into the private study next to the Oval Office, Oliver Russell was waiting for her.

He took her hands in his and said, 'I'm so terribly sorry, Jackie. There are no words.'

It had been almost seventeen years since he had last seen her. They had met at a lawyers' convention in Chicago. She had just gotten out of law school. She was young and attractive and eager, and they had had a brief, torrid affair.

Seventeen years ago.

And Chloe was sixteen years old.

He dared not ask Jackie the question in his mind. *I don't want to know.* They looked at each other in silence, and

for a moment Oliver thought she was going to speak of the past. He looked away.

Jackie Houston said, 'The police think Paul Yerby had something to do with Chloe's death.'

'That's right.'

'No.'

'No?'

'Paul was in love with Chloe. He never would have harmed her.' Her voice broke. 'They – they were going to get married one day.'

'According to my information, Jackie, they found the boy's fingerprints in the hotel room where she was killed.'

Jackie Houston said, 'The newspapers said that it . . . that it happened in the Imperial Suite at the Monroe Arms.'

'Yes.'

'Oliver, Chloe was on a small allowance. Paul's father was a retired clerk. Where did Chloe get the money for the Imperial Suite?'

'I – I don't know.'

'Someone has to find out. I won't leave until I know who is responsible for the death of my daughter.' She frowned. 'Chloe had an appointment to see you that afternoon. Did you see her?'

There was a brief hesitation. 'No. I wish I had. Unfortunately, an emergency came up, and I had to cancel our appointment.'

* * *

In an apartment at the other end of town, lying in bed, their naked bodies spooned together, he could feel the tension in her.

'Are you okay, JoAnn?'

'I'm fine, Alex.'

'You seem far away, baby. What are you thinking about?'

'Nothing,' JoAnn McGrath said.

'Nothing?'

'Well, to tell the truth, I was thinking about that poor little girl who was murdered at the hotel.'

'Yeah, I read about it. She was some governor's daughter.'

'Yes.'

'Do the police know who she was with?'

'No. They were all over the hotel questioning everybody.'

'You, too?'

'Yeah. All I could tell them was about the telephone call.'

'What telephone call?'

'The one someone in that suite made to the White House.'

He was suddenly still. He said casually, 'That doesn't mean anything. Everybody gets a kick out of calling the White House. Do that to me again, baby. Got any more maple syrup?'

* * *

Frank Lonergan had just returned to his office from the airport when the phone rang. 'Lonergan.'

'Hello, Mr Lonergan. This is Shallow Throat.' Alex Cooper, a small-time parasite who fancied himself a Watergate-class tipster. It was his idea of a joke. 'Are you still paying for hot tips?'

'Depends on how hot.'

'This one will burn your ass. I want five thousand dollars for it.'

'Goodbye.'

'Wait a minute. Don't hang up. It's about that girl who was murdered at the Monroe Arms.'

Frank Lonergan was suddenly interested. 'What about her?'

'Can you and me meet somewhere?'

'I'll see you at Ricco's in half an hour.'

At two o'clock, Frank Lonergan and Alex Cooper were in a booth at Ricco's. Alex Cooper was a thin weasel of a man, and Lonergan hated doing business with him. Lonergan wasn't sure where Cooper got his information, but he had been very helpful in the past.

'I hope you're not wasting my time,' Lonergan said.

'Oh, I don't think it's a waste of time. How would you feel if I told you there's a White House connection to the girl's murder?' There was a smug smile on his face.

Frank Lonergan managed to conceal his excitement. 'Go on.'

'Five thousand dollars?'

'One thousand.'

'Two.'

'You have a deal. Talk.'

'My girlfriend's a telephone operator at the Monroe Arms.'

'What's her name?'

'JoAnn McGrath.'

Lonergan made a note. 'So?'

'Someone in the Imperial Suite made a telephone call to the White House during the time the girl was there.'

I think the president is involved, Leslie Stewart had said. 'Are you sure about this?'

'Horse's mouth.'

'I'll check it out. If it's true, you'll get your money. Have you mentioned this to anyone else?'

'Nope.'

'Good. Don't.' Lonergan rose. 'We'll keep in touch.'

'There's one more thing,' Cooper said.

Lonergan stopped. 'Yes?'

'You've got to keep me out of this. I don't want JoAnn to know that I talked to anyone about it.'

'No problem.'

And Alex Cooper was alone, thinking about how he was going to spend the two thousand dollars without JoAnn's knowing about it.

The Monroe Arms switchboard was in a cubicle behind

the lobby reception desk. When Lonergan walked in carrying a clipboard, JoAnn McGrath was on duty. She was saying into the mouthpiece, 'I'm ringing for you.'

She connected a call and turned to Lonergan. 'Can I help you?'

'Telephone Company,' Lonergan said. He flashed some identification. 'We have a problem here.'

JoAnn McGrath looked at him, surprised. 'What kind of problem?'

'Someone reported that they're being charged for calls they didn't make.' He pretended to consult the clipboard. 'October fifteenth. They were charged for a call to Germany, and they don't even know anyone in Germany. They're pretty teed off.'

'Well, I don't know anything about that,' JoAnn said indignantly. 'I don't even remember placing any calls to Germany in the last month.'

'Do you have a record of the fifteenth?'

'Of course.'

'I'd like to see it.'

'Very well.' She found a folder under a pile of papers and handed it to him. The switchboard was buzzing. While she attended to the calls, Lonergan quickly went through the folder. October 12th ... 13th ... 14th ... 16th ...

The page for the fifteenth was missing.

Frank Lonergan was waiting in the lobby of the Four

273

Seasons when Jackie Houston returned from the White House.

'Governor Houston?'

She turned. 'Yes?'

'Frank Lonergan. I'm with the *Washington Tribune*. I want to tell you how sorry all of us are, Governor.'

'Thank you.'

'I wonder if I could talk to you for a minute?'

'I'm really not in the –'

'I might be able to be helpful.' He nodded toward the lounge off the main lobby. 'Could we go in there for a moment?'

She took a deep breath. 'All right.'

They walked into the lounge and sat down.

'I understand that your daughter went on a tour of the White House the day she . . .' He couldn't bring himself to finish the sentence.

'Yes. She – she was on a tour with her school friends. She was very excited about meeting the president.'

Lonergan kept his voice casual. 'She was going to see President Russell?'

'Yes. I arranged it. We're old friends.'

'And did she see him, Governor Houston?'

'No. He wasn't able to see her.' Her voice was choked. 'There's one thing I'm sure of.'

'Yes, ma'am.'

'Paul Yerby didn't kill her. They were in love with each other.'

'But the police said –'

'I don't care what they said. They arrested an innocent boy, and he – he was so upset that he hanged himself. It's awful.'

Frank Lonergan studied her for a moment. 'If Paul Yerby didn't kill your daughter, do you have any idea who might have? I mean, did she say anything about meeting anyone in Washington?'

'No. She didn't know a soul here. She was so looking forward to . . . to . . .' Her eyes brimmed with tears. 'I'm sorry. You'll have to excuse me.'

'Of course. Thanks for your time, Governor Houston.'

Lonergan's next stop was at the morgue. Helen Chuan was just coming out of the autopsy room.

'Well, look who's here.'

'Hi, Doc.'

'What brings you down here, Frank?'

'I wanted to talk to you about Paul Yerby.'

Helen Chuan sighed. 'It's a damn shame. Those kids were both so young.'

'Why would a boy like that commit suicide?'

Helen Chuan shrugged. 'Who knows?'

'I mean – are you sure he committed suicide?'

'If he didn't, he gave a great imitation. His belt was wrapped around his neck so tightly that they had to cut it in half to bring him down.'

'There were no other marks or anything on his body that might have suggested foul play?'

She looked at him, curious. 'No.'

Lonergan nodded. 'Okay. Thanks. You don't want to keep your patients waiting.'

'Very funny.'

There was a phone booth in the outside corridor. From the Denver information operator, Lonergan got the number of Paul Yerby's parents. Mrs Yerby answered the phone. Her voice sounded weary. 'Hello.'

'Mrs Yerby?'

'Yes.'

'I'm sorry to bother you. This is Frank Lonergan. I'm with the *Washington Tribune*. I wanted to –'

'I can't . . .'

A moment later, Mr Yerby was on the line. 'I'm sorry. My wife is . . Newspapers have been bothering us all morning. We don't want to –'

'This will only take a minute, Mr Yerby. There are some people in Washington who don't believe your son killed Chloe Houston.'

'Of course he didn't!' His voice suddenly became stronger. 'Paul could never, never have done anything like that.'

'Did Paul have any friends in Washington, Mr Yerby?'

'No. He didn't know anyone there.'

'I see. Well, if there's anything I can do . . .'

'There is something you can do for us, Mr Lonergan. We've arranged to have Paul's body shipped back here,

276

but I'm not sure how to get his possessions. We'd like to have whatever he ... If you could tell me who to talk to ...'

'I can handle that for you.'

'We'd appreciate it. Thank you.'

In the Homicide Branch office, the sergeant on duty was opening a carton containing Paul Yerby's personal effects. 'There's not much in it,' he said. 'Just the kid's clothes and a camera.'

Lonergan reached into the box and picked up a black leather belt.

It was uncut.

When Frank Lonergan walked into the office of President Russell's appointments secretary, Deborah Kanner, she was getting ready to leave for lunch.

'What can I do for you, Frank?'

'I've got a problem, Deborah.'

'What else is new?'

Frank Lonergan pretended to look at some notes. 'I have information that on October fifteenth the president had a secret meeting here with an emissary from China to talk about Tibet.'

'I don't know of any such meeting.'

'Could you just check it out for me?'

'What did you say the date was?'

'October fifteenth.' Lonergan watched as Deborah pulled an appointment book from a drawer and skimmed through it.

'October fifteenth? What time was this meeting supposed to be?'

'Ten P.M., here in the Oval Office.'

She shook her head. 'Nope. At ten o'clock that night the president was in a meeting with General Whitman.'

Lonergan frowned. 'That's not what I heard. Could I have a look at that book?'

'Sorry. It's confidential, Frank.'

'Maybe I got a bum steer. Thanks, Deborah.' He left.

Thirty minutes later, Frank Lonergan was talking to General Steve Whitman.

'General, the *Tribune* would like to do some coverage on the meeting you had with the president on October fifteenth. I understand some important points were discussed.'

The general shook his head. 'I don't know where you get your information, Mr Lonergan. That meeting was called off. The president had another appointment.'

'Are you sure?'

'Yes. We're going to reschedule it.'

'Thank you, General.'

* * *

Frank Lonergan returned to the White House. He walked into Deborah Kanner's office again.

'What is it this time, Frank?'

'Same thing,' Lonergan said ruefully. 'My informant swears that at ten o'clock on the night of October fifteenth the president was here in a meeting with a Chinese emissary to discuss Tibet.'

She looked at him, exasperated. 'How many times do I have to tell you that there was no such meeting?'

Lonergan sighed. 'Frankly, I don't know what to do. My boss really wants to run that story. It's big news. I guess we'll just have to go with it.' He started toward the door.

'Wait a minute!'

He turned. 'Yes?'

'You can't run that story. It's not true. The president will be furious.'

'It's not my decision.'

Deborah hesitated. 'If I can prove to you that he was meeting with General Whitman, will you forget about it?'

'Sure. I don't want to cause any problems.' Lonergan watched Deborah pull the appointment book out again and flip the pages. 'Here's a list of the president's appointments for that date. Look. October fifteenth.' There were two pages of listings. Deborah pointed to a 10:00 P.M. entry. 'There it is, in black and white.'

'You're right,' Lonergan said. He was busy scanning the page. There was an entry at three o'clock.

Chloe Houston.

Nineteen

The hastily called meeting in the Oval Office had been going on for only a few minutes and the air was already crackling with dissension.

The secretary of defense was saying, 'If we delay any longer, the situation is going to get completely out of control. It will be too late to stop it.'

'We can't rush into this.' General Stephen Gossard turned to the head of the CIA. 'How hard is your information?'

'It's difficult to say. We're fairly certain that Libya is buying a variety of weapons from Iran and China.'

Oliver turned to the secretary of state. 'Libya denies it?'

'Of course. So do China and Iran.'

Oliver asked, 'What about the other Arab states?'

The CIA chief responded. 'From the information I have, Mr President, if a serious attack is launched on Israel, I think it's going to be the excuse that all the other Arab states have been waiting for. They'll join in to wipe Israel out.'

They were all looking at Oliver expectantly. 'Do you have reliable assets in Libya?' he asked.

'Yes, sir.'

'I want an update. Keep me informed. If there are signs of an attack, we have no choice but to move.'

The meeting was adjourned.

Oliver's secretary's voice came over the intercom. 'Mr Tager would like to see you, Mr President.'

'Have him come in.'

'How did the meeting go?' Peter Tager asked.

'Oh, it was just your average meeting,' Oliver said bitterly, 'about whether I want to start a war now or later.'

Tager said sympathetically, 'It goes with the territory.'

'Right.'

'Something of interest has come up.'

'Sit down.'

Peter Tager took a seat. 'What do you know about the United Arab Emirates?'

'Not a lot,' Oliver said. 'Five or six Arab states got together twenty years ago or so and formed a coalition.'

'Seven of them. They joined together in 1971. Abu Dhabi, Fujaira, Dubai, Sharjah, Ras al-Khaimah, Umm al-Qaiwan, and Ajman. When they started out, they weren't very strong, but the Emirates have been incredibly well run. Today they have one of the world's highest standards of living. Their gross domestic product last year was over thirty-nine billion dollars.'

Oliver said impatiently, 'I assume there's a point to this, Peter?'

'Yes, sir. The head of the council of the United Arab Emirates wants to meet with you.'

'All right. I'll have the secretary of defense –'

'Today. In private.'

'Are you serious? I couldn't possibly –'

'Oliver, the Majlis – their council – is one of the most important Arab influences in the world. It has the respect of every other Arab nation. This could be an important breakthrough. I know this is unorthodox, but I think you should meet with them.'

'State would have a fit if I –'

'I'll make the arrangements.'

There was a long silence. 'Where do they want to meet?'

'They have a yacht anchored in Chesapeake Bay, near Annapolis. I can get you there quietly.'

Oliver sat there, studying the ceiling. Finally, he leaned forward and pressed down the intercom switch. 'Cancel my appointments for this afternoon.'

The yacht, a 212-foot Feadship, was moored at the dock. They were waiting for him. All the crew members were Arabs.

'Welcome, Mr President.' It was Ali al-Fulani, the secretary at one of the United Arab Emirates. 'Please come aboard.'

Oliver stepped aboard and Ali al-Fulani signaled to one of the men. A few moments later, the yacht was underway.

'Shall we go below?'

Right. Where I can be killed or kidnapped. This is the stupidest thing I have ever done, Oliver decided. *Maybe they brought me here so they can begin their attack on Israel, and I won't be able to give orders to retaliate. Why the hell did I let Tager talk me into this?*

Oliver followed Ali al-Fulani downstairs into the sumptuous main saloon, which was decorated in Middle Eastern style. There were four muscular Arabs standing on guard in the saloon. An imposing-looking man seated on the couch rose as Oliver came in.

Ali al-Fulani said, 'Mr President, His Majesty King Hamad of Ajman.'

The two men shook hands. 'Your Majesty.'

'Thank you for coming, Mr President. Would you care for some tea?'

'No, thank you.'

'I believe you will find this visit well worth your while.' King Hamad began to pace. 'Mr President, over the centuries, it has been difficult, if not impossible, to bridge the problems that divide us – philosophical, linguistic, religious, cultural. Those are the reasons there have been so many wars in our part of the world. If Jews confiscate the land of Palestinians, no one in Omaha or Kansas is affected. Their lives go on the same. If a synagogue in Jerusalem is bombed, the Italians in Rome and Venice pay no attention.'

Oliver wondered where this was heading. Was it a warning of a coming war?

'There is only one part of the world that suffers from all the wars and bloodshed in the Middle East. And that is the Middle East.'

He sat down across from Oliver. 'It is time for us to put a stop to this madness.'

Here it comes, Oliver thought.

'The heads of the Arab states and the Majlis have authorized me to make you an offer.'

'What kind of an offer?'

'An offer of peace.'

Oliver blinked. 'Peace?'

'We want to make peace with your ally, Israel. Your embargoes against Iran and other Arab countries have cost us untold billions of dollars. We want to put an end to that. If the United States will act as a sponsor, the Arab countries – including Iran, Libya, and Syria – have agreed to sit down and negotiate a permanent peace treaty with Israel.'

Oliver was stunned. When he found his voice, he said, 'You're doing this because –'

'I assure you it is not out of love for the Israelis or for the Americans. It is in our own interests. Too many of our sons have been killed in this madness. We want it to end. It is enough. We want to be free to sell all our oil to the world again. We are prepared to go to war if necessary, but we would prefer peace.'

Oliver took a deep breath. 'I think I would like some tea.'

* * *

'I wish you had been there,' Oliver said to Peter Tager. 'It was incredible. They're ready to go to war, but they don't want to. They're pragmatists. They want to sell their oil to the world, so they want peace.'

'That's fantastic,' Tager said enthusiastically. 'When this gets out, you're going to be a hero.'

'And I can do this on my own,' Oliver told him. 'It doesn't have to go through Congress. I'll have a talk with the Prime Minister of Israel. We'll help him make a deal with the Arab countries.' He looked at Tager and said ruefully, 'For a few minutes there, I thought I was going to be kidnapped.'

'No chance,' Peter Tager assured him. 'I had a boat and a helicopter following you.'

'Senator Davis is here to see you, Mr President. He has no appointment, but he says it's urgent.'

'Hold up my next appointment and send the senator in.'

The door opened and Todd Davis walked into the Oval Office.

'This is a nice surprise, Todd. Is everything all right?'

Senator Davis took a seat. 'Fine, Oliver. I just thought you and I should have a little chat.'

Oliver smiled. 'I have a pretty full schedule today, but for you –'

'This will take only a few minutes. I ran into Peter Tager. He told me about your meeting with the Arabs.'

Oliver grinned. 'Isn't that wonderful? It looks like we're finally going to have peace in the Middle East.' He slammed a fist on the desk. 'After all these decades! That's what my administration is going to be remembered for, Todd.'

Senator Davis asked quietly, 'Have you thought this through, Oliver?'

Oliver frowned. 'What? What do you mean?'

'Peace is a simple word, but it has a lot of ramifications. Peace doesn't have any financial benefits. When there's a war, countries buy billions of dollars' worth of armaments that are made here in the United States. In peacetime, they don't need any. Because Iran can't sell its oil, oil prices are up, and the United States gets the benefit of that.'

Oliver was listening to him unbelievingly. 'Todd – this is the opportunity of a lifetime!'

'Don't be naive, Oliver. If we had really wanted to make peace between Israel and the Arab countries, we could have done it long ago. Israel is a tiny country. Any one of the last half-dozen presidents could have forced them to make a deal with the Arabs, but they preferred to keep things as they were. Don't misunderstand me. Jews are fine people. I work with some of them in the Senate.'

'I don't believe that you can –'

'Believe what you like, Oliver. A peace treaty now

would not be in the best interest of this country. I don't want you to go ahead with it.'

'I have to go ahead with it.'

'Don't tell me what you have to do, Oliver.' Senator Davis leaned forward. 'I'll tell you. Don't forget who put you in that chair.'

Oliver said quietly, 'Todd, you may not respect me, but you must respect this office. Regardless of who put me here, I'm the president.'

Senator Davis got to his feet. 'The president? You're a fucking blow-up toy! You're my dummy, Oliver. You take orders, you don't give them.'

Oliver looked at him for a long moment. 'How many oil fields do you and your friends own, Todd?'

'That's none of your goddam business. If you go through with this, you're finished. Do you hear me? I'm giving you twenty-four hours to come to your senses.'

At dinner that evening, Jan said, 'Father asked me to talk to you, Oliver. He's very upset.'

He looked across the table at his wife and thought, *I'm going to have to fight you, too.*

'He told me what was happening.'

'Did he?'

'Yes.' She leaned across the table. 'And I think what you're going to do is wonderful.'

It took a moment for Oliver to understand. 'But your father's against it.'

'I know. And he's wrong. If they're willing to make peace – you have to help.'

Oliver sat there listening to Jan's words, studying her. He thought about how well she had handled herself as the First Lady. She had become involved in important charities and had been an advocate for a half-dozen major causes. She was lovely and intelligent and caring and – it was as though Oliver were seeing her for the first time. *Why have I been running around?* Oliver thought. *I have everything I need right here.*

'Will it be a long meeting tonight?'

'No,' Oliver said slowly. 'I'm going to cancel it. I'm staying home.'

That evening, Oliver made love to Jan for the first time in weeks, and it was wonderful. And in the morning, he thought, *I'm going to have Peter get rid of the apartment.*

The note was on his desk the next morning.

> *I want you to know that I am a real fan of yours, and I would not do anything to harm you. I was in the garage of the Monroe Arms on the 15th, and I was very surprised to see you there. The next day when I read about the murder of that young girl, I knew why you went back to wipe your fingerprints off the elevator buttons. I'm sure that all the newspapers would be interested in my*

story and would pay me a lot of money. But like I said, I'm a fan of yours. I certainly would not want to do anything to hurt you. I could use some financial help, and if you are interested, this will be just between us. I will get in touch with you in a few days while you think about it.

<div style="text-align: right">

Sincerely,
A friend

</div>

'Jesus,' Sime Lombardo said softly. 'This is incredible. How was it delivered?'

'It was mailed,' Peter Tager told him. 'Addressed to the president, "Personal."'

Sime Lombardo said, 'It could be some nut who's just trying to —'

'We can't take a chance, Sime. I don't believe for a minute that it's true, but if even a whisper of this gets out, it would destroy the president. We must protect him.'

'How do we do that?'

'First, we have to find out who sent this.'

Peter Tager was at the Federal Bureau of Investigation headquarters at 10th Street and Pennsylvania Avenue, talking to Special Agent Clay Jacobs.

'You said it was urgent, Peter?'

'Yes.' Peter Tager opened a briefcase and took out a

single sheet of paper. He slid it across the desk. Clay Jacobs picked it up and read it aloud:

'"I want you to know that I'm a real fan of yours . . . I will get in touch with you in a few days while you think about it."'

Everything in between had been whited out.

Jacobs looked up. 'What is this?'

'It involves the highest security,' Peter Tager said. 'The president asked me to try to find out who sent it. He would like you to check it for fingerprints.'

Clay Jacobs studied the paper again, frowning. 'This is highly unusual, Peter.'

'Why?'

'It just smells wrong.'

'All the president wants is for you to give him the name of the individual who wrote it.'

'Assuming his fingerprints are on it.'

Peter Tager nodded. 'Assuming his fingerprints are on it.'

'Wait here.' Jacobs rose and left the office.

Peter Tager sat there looking out the window, thinking about the letter and its possible terrible consequences.

Exactly seven minutes later, Clay Jacobs returned.

'You're in luck,' he said.

Peter Tager's heart began to race. 'You found something?'

'Yes.' Jacobs handed Tager a slip of paper. 'The man you're looking for was involved in a traffic accident about a year ago. His name is Carl Gorman. He works as a

clerk at the Monroe Arms.' He stood there a moment, studying Tager. 'Is there anything else you'd like to tell me about this?'

'No,' Peter Tager said sincerely. 'There isn't.'

'Frank Lonergan is on line three, Miss Stewart. He says it's urgent.'

'I'll take it.' Leslie picked up the telephone and pressed a button. 'Frank?'

'Are you alone?'

'Yes.'

She heard him take a deep breath. 'Okay. Here we go.' He spoke for the next ten minutes without interruption.

Leslie Stewart hurried into Matt Baker's office. 'We have to talk, Matt.' She sat down across from his desk. 'What if I told you that Oliver Russell is involved in the murder of Chloe Houston?'

'For openers, I'd say you are paranoid and that you've gone over the edge.'

'Frank Lonergan just phoned in. He talked to Governor Houston, who doesn't believe that Paul Yerby killed her daughter. He talked to Paul Yerby's parents. They don't believe it either.'

'I wouldn't expect them to,' Matt Baker said. 'If that's the only –'

'That's just the beginning. Frank went down to the

morgue and spoke to the coroner. She told him that the kid's belt was so tight that they had to cut it away from his throat.'

He was listening more intently now. 'And –?'

'Frank went down to pick up Yerby's belongings. His belt was there. Intact.'

Matt Baker drew a deep breath. 'You're telling me that he was murdered in prison and that there was a cover-up?'

'I'm not telling you anything. I'm just reporting the facts. Oliver Russell tried to get me to use Ecstasy once. When he was running for governor, a woman who was a legal secretary died from Ecstasy. While he was governor, his secretary was found in a park in an Ecstasy-induced coma. Lonergan learned that Oliver called the hospital and suggested they take her off life-support systems.' Leslie leaned forward. 'There was a telephone call from the Imperial Suite to the White House the night Chloe Houston was murdered. Frank checked the hotel telephone records. The page for the fifteenth was missing. The president's appointments secretary told Lonergan that the president had a meeting with General Whitman that night. There was no meeting. Frank spoke to Governor Houston, and she said that Chloe was on a tour of the White House and that she had arranged for her daughter to meet the president.'

There was a long silence. 'Where's Frank Lonergan now?' Matt Baker asked.

'He's tracking down Carl Gorman, the hotel clerk who booked the Imperial Suite.'

* * *

Jeremy Robinson was saying, 'I'm sorry. We don't give out personal information about our employees.'

Frank Lonergan said, 'All I'm asking for is his home address so I can –'

'It wouldn't do you any good. Mr Gorman is on vacation.'

Lonergan sighed. 'That's too bad. I was hoping he could fill in a few blank spots.'

'Blank spots?'

'Yes. We're doing a big story on the death of Governor Houston's daughter in your hotel. Well, I'll just have to piece it together without Gorman.' He took out a pad and a pen. 'How long has this hotel been here? I want to know all about its background, its clientele, its –'

Jeremy Robinson frowned. 'Wait a minute! Surely that's not necessary. I mean – she could have died anywhere.'

Frank Lonergan said sympathetically, 'I know, but it happened here. Your hotel is going to become as famous as Watergate.'

'Mr –?'

'Lonergan.'

'Mr Lonergan, I would appreciate it if you could – I mean this kind of publicity is very bad. Isn't there some way –?'

Lonergan was thoughtful for a moment. 'Well, if I

293

spoke to Mr Gorman, I suppose I could find a different angle.'

'I would really appreciate that. Let me get you his address.'

Frank Lonergan was becoming nervous. As the outline of events began to take shape, it became clear that there was a murder conspiracy and a cover-up at the highest level. Before he went to see the hotel clerk, he decided to stop at his apartment house. His wife, Rita, was in the kitchen preparing dinner. She was a petite redhead with sparkling green eyes and a fair complexion. She turned in surprise as her husband walked in.

'Frank, what are you doing home in the middle of the day?'

'Just thought I'd drop in and say hello.'

She looked at his face. 'No. There's something going on. What is it?'

He hesitated. 'How long has it been since you've seen your mother?'

'I saw her last week. Why?'

'Why don't you go visit her again, honey?'

'Is anything wrong?'

He grinned. 'Wrong?' He walked over to the mantel. 'You'd better start dusting this off. We're going to put a Pulitzer Prize here and a Peabody Award here.'

'What are you talking about?'

'I'm on to something that's going to blow everybody

away – and I mean people in high places. It's the most exciting story I've ever been involved in.'

'Why do you want me to go see my mother?'

He shrugged. 'There's just an outside chance that this could get to be a little dangerous. There are some people who don't want this story to get out. I'd feel better if you were away for a few days, just until this breaks.'

'But if you're in danger –'

'I'm not in any danger.'

'You're sure nothing's going to happen to you?'

'Positive. Pack a few things, and I'll call you tonight.'

'All right,' Rita said reluctantly.

Lonergan looked at his watch. 'I'll drive you to the train station.'

One hour later, Lonergan stopped in front of a modest brick house in the Wheaton area. He got out of the car, walked to the front door, and rang the bell. There was no answer. He rang again and waited. The door suddenly swung open and a heavyset middle-aged woman stood in the doorway, regarding him suspiciously.

'Yes?'

'I'm with the Internal Revenue Service,' Lonergan said. He flashed a piece of identification. 'I want to see Carl Gorman.'

'My brother's not here.'

'Do you know where he is?'

'No.' Too fast.

Lonergan nodded. 'That's a shame. Well, you might as well start packing up his things. I'll have the department send over the vans.' Lonergan started back down the driveway toward his car.

'Wait a minute! What vans? What are you talking about?'

Lonergan stopped and turned. 'Didn't your brother tell you?'

'Tell me what?'

Lonergan took a few steps back toward the house, 'He's in trouble.'

She looked at him anxiously. 'What kind of trouble?'

'I'm afraid I'm not at liberty to discuss it.' He shook his head. 'He seems like a nice guy, too.'

'He is,' she said fervently. 'Carl is a wonderful person.'

Lonergan nodded. 'That was my feeling when we were questioning him down at the bureau.'

She was panicky. 'Questioning him about what?'

'Cheating on his income tax. It's too bad. I wanted to tell him about a loophole that could have helped him out, but –' He shrugged. 'If he's not here . . .' He turned to go again.

'Wait! He's – he's at a fishing lodge. I – I'm not supposed to tell anybody.'

He shrugged. 'That's okay with me.'

'No . . . but this is different. It's the Sunshine Fishing Lodge on the lake in Richmond, Virginia.'

'Fine. I'll contact him there.'

'That would be wonderful. You're sure he'll be all right?'

'Absolutely,' Lonergan said. 'I'll see that he's taken care of.'

Lonergan took I-95, heading south. Richmond was a little over a hundred miles away. On a vacation, years ago, Lonergan had fished the lake, and he had been lucky.

He hoped he would be as lucky this time.

It was drizzling, but Carl Gorman did not mind. That's when the fish were supposed to bite. He was fishing for striped bass, using large minnows on slip bobbers, far out behind the rowboat. The waves lapped against the small boat in the middle of the lake, and the bait drifted behind the boat, untouched. The fish were in no hurry. It did not matter. Neither was he. He had never been happier. He was going to be rich beyond his wildest dreams. It had been sheer luck. *You have to be at the right place at the right time.* He had returned to the Monroe Arms to pick up a jacket he had forgotten and was about to leave the garage when the private elevator door opened. When he saw who got out, he had sat in his car, stunned. He had watched the man return, wipe off his fingerprints, then drive away.

It was not until he read about the murder the following day that he had put it all together. In a way, he felt sorry for the man. *I really am a fan of his. The trouble is, when*

you're that famous, you can never hide. Wherever you go, the world knows you. He'll pay me to be quiet. He has no choice. I'll start with a hundred thousand. Once he pays that, he'll have to keep paying. Maybe I'll buy a chateau in France or a chalet in Switzerland.

He felt a tug at the end of his line and snapped the rod toward him. He could feel the fish trying to get away. *You're not going anywhere. I've got you hooked.*

In the distance, he heard a large speedboat approaching. *They shouldn't allow power boats on the lake. They'll scare all the fish away.* The speedboat was bearing down on him.

'Don't get too close,' Carl shouted.

The speedboat seemed to be heading right toward him.

'Hey! Be careful. Watch where you're going. For God's sake –'

The speedboat plowed into the rowboat, cutting it in half, the water sucking Gorman under.

Damn drunken fool! He was gasping for air. He managed to get his head above water. The speedboat had circled and was heading straight for him again. And the last thing Carl Gorman felt before the boat smashed into his skull was the tug of the fish on his line.

When Frank Lonergan arrived, the area was crowded with police cars, a fire engine, and an ambulance. The ambulance was just pulling away.

Frank Lonergan got out of his car and said to a bystander, 'What's all the excitement?'

'Some poor guy was in an accident on the lake. There's not much left of him.'

And Lonergan knew.

At midnight, Frank Lonergan was working at his computer, alone in his apartment, writing the story that was going to destroy the President of the United States. It was a story that would earn him a Pulitzer Prize. There was no doubt about it in his mind. This was going to make him more famous than Woodward and Bernstein. It was the story of the century.

He was interrupted by the sound of the doorbell. He got up and walked over to the front door.

'Who is it?'

'A package from Leslie Stewart.'

She's found some new information. He opened the door. There was a glint of metal, and an unbearable pain tore his chest apart.

Then nothing.

Twenty

Frank Lonergan's living room looked as if it had been struck by a miniature hurricane. All the drawers and cabinets had been pulled open and their contents had been scattered over the floor.

Nick Reese watched Frank Lonergan's body being removed. He turned to Detective Steve Brown. 'Any sign of the murder weapon?'

'No.'

'Have you talked to the neighbors?'

'Yeah. The apartment building is a zoo, full of monkeys. See no evil, hear no evil, speak no evil. *Nada.* Mrs Lonergan is on her way back here. She heard the news on the radio. There have been a couple other robberies here in the last six months, and –'

'I'm not so sure this was a robbery.'

'What do you mean?'

'Lonergan was down at headquarters the other day to check on Paul Yerby's things. I'd like to know what story Lonergan was working on. No papers in the drawers?'

'Nope.'

'No notes?'

'Nothing.'

'So either he was very neat, or someone took the trouble to clean everything out.' Reese walked over to the work table. There was a cable dangling off the table, connected to nothing. Reese held it up. 'What's this?'

Detective Brown walked over. 'It's a power cable for a computer. There must have been one here. That means there could be backups somewhere.'

'They may have taken the computer, but Lonergan might have saved copies of his files. Let's check it out.'

They found the backup disk in a briefcase in Lonergan's automobile. Reese handed it to Brown.

'I want you to take this down to headquarters. There's probably a password to get into it. Have Chris Colby look at it. He's an expert.'

The front door of the apartment opened and Rita Lonergan walked in. She looked pale and distraught. She stopped when she saw the men.

'Mrs Lonergan?'

'Who are –?'

'Detective Nick Reese, Homicide. This is Detective Brown.'

Rita Lonergan looked around. 'Where is –?'

'We had your husband's body taken away, Mrs Lonergan.

I'm terribly sorry. I know it's a bad time, but I'd like to ask you a few questions.'

She looked at him, and her eyes suddenly filled with fear. The last reaction Reese had expected. What was she afraid of?

'Your husband was working on a story, wasn't he?'

His voice echoed in her mind. *I'm on to something that's going to blow everybody away – and I mean people in high places. It's the most exciting story I've ever been involved in.*

'Mrs Lonergan?'

'I – I don't know anything.'

'You don't know what assignment he was working on?'

'No. Frank never discussed his work with me.'

She was obviously lying.

'You have no idea who might have killed him?'

She looked around at the open drawers and cabinets. 'It – it must have been a burglar.'

Detective Reese and Detective Brown looked at each other.

'If you don't mind, I'd – I'd like to be alone. This has been a terrible shock.'

'Of course. Is there anything we can do for you?'

'No. Just . . . just leave.'

'We'll be back,' Nick Reese promised.

When Detective Reese returned to police headquarters,

he telephoned Matt Baker. 'I'm investigating the Frank Lonergan murder,' Reese said. 'Can you tell me what he was working on?'

'Yes. Frank was investigating the Chloe Houston killing.'

'I see. Did he file a story?'

'No. We were waiting for it, when –' He stopped.

'Right. Thank you, Mr Baker.'

'If you get any information, will you let me know?'

'You'll be the first,' Reese assured him.

The following morning, Dana Evans went into Tom Hawkins's office. 'I want to do a story on Frank's death. I'd like to go see his widow.'

'Good idea. I'll arrange for a camera crew.'

Late that afternoon, Dana and her camera crew pulled up in front of Frank Lonergan's apartment building. With the crew following her, Dana approached Lonergan's apartment door and rang the bell. This was the kind of interview Dana dreaded. It was bad enough to show on television the victims of horrible crimes, but to intrude on the grief of the stricken families seemed even worse to her.

The door opened and Rita Lonergan stood there. 'What do you –?'

'I'm sorry to bother you, Mrs Lonergan. I'm Dana

Evans, with WTE. We'd like to get your reaction to –'

Rita Lonergan froze for a moment, and then screamed, 'You murderers!' She turned and ran inside the apartment.

Dana looked at the cameraman, shocked. 'Wait here.' She went inside and found Rita Lonergan in the bedroom. 'Mrs Lonergan –'

'Get out! You killed my husband!'

Dana was puzzled. 'What are you talking about?'

'Your people gave him an assignment so dangerous that he made me leave town because he . . . he was afraid for my life.'

Dana looked at her, appalled. 'What – what story was he working on?'

'Frank wouldn't tell me.' She was fighting hysteria. 'He said it was too – too dangerous. It was something big. He talked about the Pulitzer Prize and the –' She started to cry.

Dana went over to her and put her arms around her. 'I'm so sorry. Did he say anything else?'

'No. He said I should get out, and he drove me to the train station. He was on his way to see some – some hotel clerk.'

'Where?'

'At the Monroe Arms.'

'I don't know why you're here, Miss Evans,' Jeremy Robinson protested. 'Lonergan promised me that if I

cooperated, there would be no bad publicity about the hotel.'

'Mr Robinson, Mr Lonergan is dead. All I want is some information.'

Jeremy Robinson shook his head. 'I don't know anything.'

'What did you tell Mr Lonergan?'

Robinson sighed. 'He asked for the address of Carl Gorman, my hotel clerk. I gave it to him.'

'Did Mr Lonergan go to see him?'

'I have no idea.'

'I'd like to have that address.'

Jeremy looked at her a moment and sighed again. 'Very well. He lives with his sister.'

A few minutes later, Dana had the address in her hands. Robinson watched her leave the hotel, and then he picked up the phone and dialed the White House.

He wondered why they were so interested in the case.

Chris Colby, the department's computer expert, walked into Detective Reese's office holding a floppy disk. He was almost trembling with excitement.

'What did you get?' Detective Reese asked.

Chris Colby took a deep breath. 'This is going to blow your mind. Here's a printout of what's on this disk.'

Detective Reese started to read it and an incredulous

expression came over his face. 'Mother of God,' he said. 'I've got to show this to Captain Miller.'

When Captain Otto Miller finished reading the printout, he looked up at Detective Reese. 'I – I've never seen anything like this.'

'There's never been anything like this,' Detective Reese said. 'What the hell do we do with it?'

Captain Miller said slowly, 'I think we have to turn it over to the U.S. attorney general.'

They were gathered in the office of Attorney General Barbara Gatlin. With her in the room were Scott Brandon, director of the FBI; Dean Bergstrom, the Washington chief of police; James Frisch, director of Central Intelligence, and Edgar Graves, Chief Justice of the Supreme Court.

Barbara Gatlin said, 'I asked you gentlemen here because I need your advice. Frankly, I don't know how to proceed. We have a situation that's unique. Frank Lonergan was a reporter for the *Washington Tribune*. When he was killed, he was in the middle of an investigation into the murder of Chloe Houston. I'm going to read you a transcript of what the police found on a disk in Lonergan's car.' She looked at the printout in her hand and started to read aloud:

'"I have reason to believe that the President of the

United States has committed at least one murder and is involved in four more –"'

'What?' Scott Brandon exclaimed.

'Let me go on.' She started to read again.

'"I obtained the following information from various sources. Leslie Stewart, the owner and publisher of the *Washington Tribune*, is willing to swear that at one time, Oliver Russell tried to persuade her to take an illegal drug called liquid Ecstasy.

'"When Oliver Russell was running for governor of Kentucky, Lisa Burnette, a legal secretary who worked in the state capitol building, threatened to sue him for sexual harassment. Russell told a colleague that he would have a talk with her. The next day, Lisa Burnette's body was found in the Kentucky River. She had died of an overdose of liquid Ecstasy.

'"Then-Governor Oliver Russell's secretary Miriam Friedland, was found unconscious on a park bench late at night. She was in a coma induced by liquid Ecstasy. The police were waiting for her to come out of it so that they could find out who had given it to her. Oliver Russell telephoned the hospital and suggested they take her off life support. Miriam Friedland passed away without coming out of the coma.

'"Chloe Houston was killed by an overdose of liquid Ecstasy. I learned that on the night of her death, there was a phone call from the hotel suite to the White House. When I looked at the hotel telephone records to check it, the page for that day was missing.

'"I was told that the president was at a meeting that night, but I discovered that the meeting had been canceled. No one knows the president's whereabouts that night.

'"Paul Yerby was detained as a suspect in Chloe Houston's murder. Captain Otto Miller told the White House where Yerby was being held. The following morning Yerby was found hanging in his cell. He was supposed to have hanged himself with his belt, but when I looked through his effects at the police station, his belt was there, intact.

'"Through a friend at the FBI, I learned that a blackmail letter had been sent to the White House. President Russell asked the FBI to check it for fingerprints. Most of the letter had been whited out, but with the aid of an infrascope, the FBI was able to decipher it.

'"The fingerprints on the letter were identified as belonging to Carl Gorman, a clerk at the Monroe Arms Hotel, probably the only one who might have known the identity of the person who booked the suite where the girl was killed. He was away at a fishing camp, but his name had been revealed to the White House. When I arrived at the camp, Gorman had been killed in what appeared to be an accident.

'"There are too many connections for these killings to be a coincidence. I am going ahead with the investigation, but frankly, I'm frightened. At least I have this on the record, in case anything should happen to me. More later."'

'My God,' James Frisch exclaimed. 'This is . . . horrible.'

'I can't believe it.'

Attorney General Gatlin said, 'Lonergan believed it, and he was probably killed to stop this information from getting out.'

'What do we do now?' Chief Justice Graves asked. 'How do you ask the President of the United States if he's killed half a dozen people?'

'That's a good question. Impeach him? Arrest him? Throw him in jail?'

'Before we do anything,' Attorney General Gatlin said, 'I think we have to present this transcript to the president himself and give him an opportunity to comment.'

There were murmurs of agreement.

'In the meantime, I'll have a warrant for his arrest drawn up. Just in case it's necessary.'

One of the men in the room was thinking, *I've got to inform Peter Tager.*

Peter Tager put the telephone down and sat there for a long time, thinking about what he had just been told. He rose and walked down the corridor to Deborah Kanner's office.

'I have to see the president.'

'He's in a meeting. If you can –'

'I have to see him now, Deborah. It's urgent.'

She saw the look on his face. 'Just a moment.' She

picked up the telephone and pressed a button. 'I'm sorry to interrupt you, Mr President. Mr Tager is here, and he said he must see you.' She listened a moment. 'Thank you.' She replaced the receiver and turned to Tager. 'Five minutes.'

Five minutes later, Peter Tager was alone in the Oval Office with President Russell.

'What's so important, Peter?'

Tager took a deep breath. 'The Attorney General and the FBI think you're involved in six murders.'

Oliver smiled. 'This is some kind of joke . . .'

'Is it? They're on their way here now. They believe you killed Chloe Houston and –'

Oliver had gone pale. 'What?'

'I know – it's crazy. From what I was told, all the evidence is circumstantial. I'm sure you can explain where you were the night the girl died.'

Oliver was silent.

Peter Tager was waiting. 'Oliver, you can explain, can't you?'

Oliver swallowed. 'No. I can't.'

'You have to!'

Oliver said heavily, 'Peter, I need to be alone.'

Peter Tager went to see Senator Davis in the Capitol.

'What is it that's so urgent, Peter?'

'It's – it's about the president.'

'Yes?'

'The attorney general and the FBI think that Oliver is a murderer.'

Senator Davis sat there staring at Tager. 'What the hell are you talking about?'

'They're convinced Oliver's committed several murders. I got a tip from a friend at the FBI.'

Tager told Senator Davis about the evidence.

When Tager was through, Senator Davis said slowly, 'That dumb son of a bitch! Do you know what this means?'

'Yes, sir. It means that Oliver –'

'Fuck Oliver. I've spent years putting him where I want him. I don't care what happens to him. I'm in control now, Peter. I have the power. I'm not going to let Oliver's stupidity take it away from me. I'm not going to let anyone take it away from me!'

'I don't see what you can –'

'You said the evidence was all circumstantial?'

'That's right. I was told they have no hard proof. But he has no alibi.'

'Where is the president now?'

'In the Oval Office.'

'I've got some good news for him,' Senator Todd Davis said.

Senator Davis was facing Oliver in the Oval Office. 'I've

311

been hearing some very disturbing things, Oliver. It's insane, of course. I don't know how anyone could possibly think you –'

'I don't, either. I haven't done anything wrong, Todd.'

'I'm sure you haven't. But if word got out that you were even suspected of horrible crimes like these – well, you can see how this would affect the office, can't you?'

'Of course, but –'

'You're too important to let anything like this happen to you. This office controls the world, Oliver. You don't want to give this up.'

'Todd – I'm not guilty of anything.'

'But they think you are. I'm told you have no alibi for the evening of Chloe Houston's murder?'

There was a momentary silence. 'No.'

Senator Davis smiled. 'What happened to your memory, son? You were with me that evening. We spent the whole evening together.'

Oliver was looking at him, confused. 'What?'

'That's right. I'm your alibi. No one's going to question my word. No one. I'm going to save you, Oliver.'

There was a long silence. Oliver said, 'What do you want in return, Todd?'

Senator Davis nodded. 'We'll start with the Middle Eastern peace conference. You'll call that off. After that, we'll talk. I have great plans for us. We're not going to let anything spoil them.'

Oliver said, 'I'm going ahead with the peace conference.'

Senator Davis's eyes narrowed. 'What did you say?'

'I've decided to go ahead with it. You see, what's important is not how long a president stays in this office, Todd, but what he does when he's in it.'

Senator Davis's face was turning red. 'Do you know what you're doing?'

'Yes.'

The senator leaned across the desk. 'I don't think you do. They're on their way here to accuse you of murder, Oliver. Where are you going to make your goddam deals from – the penitentiary? You've just thrown your whole life away, you stupid –'

A voice came over the intercom. 'Mr President, there are some people here to see you. Attorney General Gatlin, Mr Brandon from the FBI, Chief Justice Graves, and –'

'Send them in.'

Senator Davis said savagely, 'It looks like I should stick to judging horseflesh. I made a big mistake with you, Oliver. But you just made the biggest mistake of your life. I'm going to destroy you.'

The door opened and Attorney General Gatlin entered, followed by Brandon, Justice Graves, and Bergstrom.

Justice Graves said, 'Senator Davis . . .'

Todd Davis nodded curtly and strode out of the room. Barbara Gatlin closed the door behind him. She walked up to the desk.

'Mr President, this is highly embarrassing, but I hope you will understand. We have to ask you some questions.'

313

Oliver faced them. 'I've been told why you're here. Of course, I had nothing to do with any of those deaths.'

'I'm sure we're all relieved to hear that, Mr President,' Scott Brandon said, 'and I assure you that none of us really believes that you could be involved. But an accusation has been made, and we have no choice but to pursue it.'

'I understand.'

'Mr President, have you ever taken the drug Ecstasy?'

'No.'

The group looked at one another.

'Mr President, if you could tell us where you were on October fifteenth, the evening of Chloe Houston's death . . .'

There was a silence.

'Mr President?'

'I'm sorry. I can't.'

'But surely you can remember where you were, or what you were doing on that evening?'

Silence.

'Mr President?'

'I – I can't think right now. I'd like you to come back later.'

'How much later?' Bergstrom asked.

'Eight o'clock.'

Oliver watched them leave. He got up and slowly walked into the small sitting room where Jan was working at a desk. She looked up as Oliver entered.

He took a deep breath and said, 'Jan, I – I have a confession to make.'

Senator Davis was in an icy rage. *How could I have been so stupid? I picked the wrong man. He's trying to destroy everything I've worked for. I'll teach him what happens to people who try to double-cross me.* The Senator sat at his desk for a long time, deciding what he was going to do. Then he picked up a telephone and dialed.

'Miss Stewart, you told me to call you when I had something more for you.'

'Yes, Senator?'

'Let me tell you what I want. From now on, I'll expect the full support of the *Tribune* – campaign contributions, glowing editorials, the works.'

'And what do I get in exchange for all this?' Leslie asked.

'The President of the United States. The attorney general has just sworn out a warrant for his arrest for a series of murders.'

There was a sharp intake of breath. 'Keep talking.'

Leslie Stewart was speaking so fast that Matt Baker could not understand a word. 'For God's sake, calm down,' he said. 'What are you trying to say?'

'The president! We've got him, Matt! I just talked to Senator Todd Davis. The chief justice of the Supreme

Court, the chief of police, the director of the FBI, and the U.S. attorney general are in the president's office now with a warrant for his arrest on charges of murder. There's a pile of evidence against him, Matt, and he has no alibi. It's the story of the goddam century!'

'You can't print it.'

She looked at him in surprise. 'What do you mean?'

'Leslie, a story like this is too big to just – I mean the facts have to be checked and rechecked –'

'And rechecked again until it becomes a headline in *The Washington Post*? No, thank you. I'm not going to lose this one.'

'You can't accuse the President of the United States of murder without –'

Leslie smiled. 'I'm not going to, Matt. All we have to do is print the fact that there is a warrant for his arrest. That's enough to destroy him.'

'Senator Davis –'

'– is turning in his own son-in-law. He believes the president is guilty. He told me so.'

'That's not enough. We'll verify it first, and –'

'With whom – Katharine Graham? Are you out of your mind? We run this right now, or we lose it.'

'I can't let you do this, not without verifying everything that –'

'Who do you think you're talking to? This is my paper, and I'll do anything I like with it.'

Matt Baker rose. 'This is irresponsible. I won't let any of my people write this story.'

'They don't have to. I'll write it myself.'

'Leslie, if you do this, I'm leaving. For good.'

'No, you're not, Matt. You and I are going to share a Pulitzer Prize.' She watched him turn and walk out of the office. 'You'll be back.'

Leslie pressed down the intercom button. 'Have Zoltaire come in here.'

She looked at him and said; 'I want to know my horoscope for the next twenty-four hours.'

'Yes, Miss Stewart. I'll be happy to do that.' From his pocket, Zoltaire took a small ephemeris, the astrological bible, and opened it. He studied the positions of the stars and the planets for a moment, and his eyes widened.

'What is it?'

Zoltaire looked up. 'I – something very important seems to be happening.' He pointed to the ephemeris. 'Look. Transiting Mars is going over your ninth house Pluto for three days, setting off a square to your –'

'Never mind that,' Leslie said impatiently. 'Cut to the chase.'

He blinked. 'The chase? Ah, yes.' He looked at the book again. 'There is some kind of major event happening. You are in the middle of it. You're going to be even more famous than you are now, Miss Stewart. The whole world is going to know your name.'

Leslie was filled with a feeling of intense euphoria. The whole world was going to know her name. She was at the awards ceremonies and the speaker was saying, 'And now, the recipient of this year's Pulitzer Prize for the most important story in newspaper history. I give you Miss Leslie Stewart.' There was a standing ovation, and the roar was deafening.

'Miss Stewart . . .'

Leslie shook away the dream.

'Will there be anything else?'

'No,' Leslie said. 'Thank you, Zoltaire. That's enough.'

At seven o'clock that evening, Leslie was looking at a proof of the story she had written. The headline read: MURDER WARRANT SERVED ON PRESIDENT RUSSELL. PRESIDENT ALSO TO BE QUESTIONED IN INVESTIGATION OF SIX DEATHS.

Leslie skimmed her story under it and turned to Lyle Bannister, her managing editor. 'Run it,' she said. 'Put it out as an extra. I want it to hit the streets in an hour, and WTE can broadcast the story at the same time.'

Lyle Bannister hesitated. 'You don't think Matt Baker should take a look at –?'

'This isn't his paper, it's mine. Run it. Now.'

'Yes, ma'am.' He reached for the telephone on Leslie's desk and dialed a number. 'We're going with it.'

*　　*　　*

At seven-thirty that evening, Barbara Gatlin and the others in the group were preparing to return to the White House. Barbara Gatlin said heavily, 'I hope to God it isn't going to be necessary to use it, but just to be prepared, I'm bringing the warrant for the president's arrest.'

Thirty minutes later, Oliver's secretary said, 'Attorney General Gatlin and the others are here.'

'Send them in.'

Oliver watched, pale-faced, as they walked into the Oval Office. Jan was at his side, holding his hand tightly.

Barbara Gatlin said, 'Are you prepared to answer our questions now, Mr President?'

Oliver nodded. 'I am.'

'Mr President, did Chloe Houston have an appointment to see you on October fifteenth?'

'She did.'

'And did you see her?'

'No. I had to cancel.'

The call had come in just before three o'clock. *'Darling, it's me. I'm lonely for you. I'm at the lodge in Maryland. I'm sitting by the pool, naked.'*

'We'll have to do something about that.'

'When can you get away?'

'I'll be there in an hour.'

Oliver turned to face the group. 'If what I'm about to tell you should ever leave this office, it would do irreparable damage to the presidency and to our relations

with another country. I'm doing this with the greatest reluctance, but you leave me no choice.'

As the group watched in wonder, Oliver walked over to a side door leading to a den and opened it. Sylva Picone stepped into the room.

'This is Sylva Picone, the wife of the Italian ambassador. On the fifteenth, Mrs Picone and I were together at her lodge in Maryland from four o'clock in the afternoon until two o'clock in the morning. I know absolutely nothing about the murder of Chloe Houston, or any of the other deaths.'

Twenty-One

Dana walked into Tom Hawkins's office. 'Tom, I'm on to something interesting. Before Frank Lonergan was murdered, he went to the home of Carl Gorman, a clerk who worked at the Monroe Arms. Gorman was killed in a supposed boating accident. He lived with his sister. I'd like to take a crew over there to do a taped segment for the ten o'clock news tonight.'

'You don't think it was a boating accident?'

'No. Too many coincidences.'

Tom Hawkins was thoughtful for a moment. 'Okay. I'll set it up.'

'Thanks. Here's the address. I'll meet the camera crew there. I'm going home to change.'

When Dana walked into her apartment, she had a sudden feeling that something was wrong. It was a sense she had developed in Sarajevo, a warning of danger. Somebody had been here. She walked through the apartment slowly, warily checking the closets. Nothing was amiss.

It's my imagination, Dana told herself. But she did not believe it.

When Dana arrived at the house that Carl Gorman's sister lived in, the electronic news-gathering vehicle had arrived and was parked down the street. The ENG was an enormous van with a large antenna on the roof and sophisticated electronic equipment inside. Waiting for Dana were Andrew Wright, the soundman, and Vernon Mills, the cameraman.

'Where are we doing the interview?' Mills asked.

'I want to do it inside the house. I'll call you when we're ready.'

'Right.'

Dana went up to the front door and knocked. Marianne Gorman opened the door. 'Yes?'

'I'm –'

'Oh! I know who you are. I've seen you on television.'

'Right,' Dana said. 'Could we talk for a minute?'

Marianne Gorman hesitated. 'Yes. Come in.' Dana followed her into the living room.

Marianne Gorman offered Dana a chair. 'It's about my brother, isn't it? He was murdered. I know it.'

'Who killed him?'

Marianne Gorman looked away. 'I don't know.'

'Did Frank Lonergan come here to see you?'

The woman's eyes narrowed. 'He tricked me. I told

him where he could find my brother and –' Her eyes filled with tears. 'Now Carl is dead.'

'What did Lonergan want to talk to your brother about?'

'He said he was from the IRS.'

Dana sat there watching her. 'Would you mind if I did a brief television interview with you? You can just say a few words about your brother's murder and how you feel about the crime in this city.'

Marianne Gorman nodded. 'I guess that will be all right.'

'Thank you.' Dana went to the front door, opened it, and waved to Vernon Mills. He picked up his camera equipment and started toward the house, followed by Andrew Wright.

'I've never done this kind of thing before,' Marianne said.

'There's nothing to be nervous about. It will only take a few minutes.'

Vernon entered the living room with the camera. 'Where do you want to shoot this?'

'We'll do it here, in the living room.' She nodded toward a corner. 'You can put the camera there.'

Vernon placed the camera, then walked back to Dana. He pinned a lavaliere microphone on each woman's jacket. 'You can turn it on whenever you're ready.' He set it down on a table.

Marianne Gorman said, 'No! Wait a minute! I'm sorry. I – I can't do this.'

'Why?' Dana asked.

'It's ... it's dangerous. Could – could I talk to you alone?'

'Yes.' Dana looked at Vernon and Wright. 'Leave the camera where it is. I'll call you.'

Vernon nodded, 'We'll be in the van.'

Dana turned to Marianne Gorman. 'Why is it dangerous for you to be on television?'

Marianne said reluctantly, 'I don't want them to see me.'

'You don't want who to see you?'

Marianne swallowed. 'Carl did something he ... he shouldn't have done. He was killed because of it. And the men who killed him will try to kill me.' She was trembling.

'What did Carl do?'

'Oh, my God,' Marianne moaned. 'I begged him not to.'

'Not to what?' Dana persisted.

'He – he wrote a blackmail letter.'

Dana looked at her in surprise. 'A blackmail letter?'

'Yes. Believe me, Carl was a good man. It's just that he liked – he had expensive tastes, and on his salary, he couldn't afford to live the way he wanted to. I couldn't stop him. He was murdered because of that letter. I know it. They found him, and now they know where I am. I'm going to be killed.' She was sobbing. 'I – I don't know what to do.'

'Tell me about the letter.'

Marianne Gorman took a deep breath. 'My brother was going away on a vacation. He had forgotten a jacket that he wanted to take with him, and he went back to the hotel. He got his jacket and was back in his car in the garage when the private elevator door to the Imperial Suite opened. Carl told me he saw a man get out. He was surprised to see him there. He was even more surprised when the man walked back to the elevator and wiped off his fingerprints. Carl couldn't figure out what was going on. Then the – the next day, he read about that poor girl's murder, and he knew that this man had killed her.' She hesitated. 'That's when he sent the letter to the White House.'

Dana said slowly, 'The White House?'

'Yes.'

'Who did he send the letter to?'

'The man he saw in the garage. You know – the one with the eye patch. Peter Tager.'

Twenty-Two

Through the walls of the office, he could hear the sound of traffic on Pennsylvania Avenue, outside the White House, and he became aware again of his surroundings. He reviewed everything that was happening, and he was satisfied that he was safe. Oliver Russell was going to be arrested for murders he hadn't committed, and Melvin Wicks, the vice president, would become president. Senator Davis would have no problem controlling Vice President Wicks. *And there's nothing to link me to any of the deaths*, Tager thought.

There was a prayer meeting that evening, and Peter Tager was looking forward to it. The group enjoyed hearing him talk about religion and power. Peter Tager had become interested in girls when he was fourteen. God had given him an extraordinarily strong libido, and Peter had thought that the loss of his eye would make him unattractive to the opposite sex. Instead, girls found his eye patch intriguing. In addition, God had given Peter the gift of persuasion, and he was able to charm diffident young girls into the backseats of cars, into barns, and into

beds. Unfortunately, he had gotten one of them pregnant and had been forced to marry her. She bore him two children. His family could have become an onerous burden, tying him down. But it turned out to be a marvelous cover for his extracurricular activities. He had seriously thought of going into the ministry, but then he had met Senator Todd Davis, and his life had changed. He had found a new and bigger forum. Politics.

In the beginning, there had been no problems with his secret relationships. Then a friend had given him a drug called Ecstasy, and Peter had shared it with Lisa Burnette, a fellow church member in Frankfort. Something had gone wrong, and she had died. They found her body in the Kentucky River.

The next unfortunate incident had occurred when Miriam Friedland, Oliver Russell's secretary, had had a bad reaction and lapsed into a coma. *Not my fault*, Peter Tager thought. It had not harmed him. Miriam had obviously been on too many other drugs.

Then, of course, there was poor Chloe Houston. He had run into her in a corridor of the White House where she was looking for a rest room.

She had recognized him instantly and was impressed. 'You're Peter Tager! I see you on television all the time.'

'Well, I'm delighted. Can I help you with something?'

'I was looking for a ladies' room.' She was young and very pretty.

'There are no public rest rooms in the White House, miss.'

'Oh, dear.'

He said conspiratorially, 'I think I can help you out. Come with me.' He had led her upstairs to a private bathroom and waited outside for her. When she came out, he asked, 'Are you just visiting Washington?'

'Yes.'

'Why don't you let me show you the real Washington? Would you like that?' He could feel that she was attracted to him.

'I – I certainly would – if it isn't too much trouble.'

'For someone as pretty as you? No trouble at all. We'll start with dinner tonight.'

She smiled. 'That sounds exciting.'

'I promise you it will be. Now, you mustn't tell anyone we're meeting. It's our secret.'

'I won't. I promise.'

'I have a high-level meeting with the Russian government at the Monroe Arms Hotel tonight.' He could see that she was impressed. 'We can have dinner at the Imperial Suite there, afterward. Why don't you meet me there about seven o'clock?'

She looked at him and nodded excitedly. 'All right.'

He had explained to her what she had to do to get inside the suite. 'There won't be any problem. Just call me to let me know you're there.'

And she had.

* * *

In the beginning, Chloe Houston had been reluctant. When Peter took her in his arms, she said, 'Don't. I – I'm a virgin.'

That made him all the more excited. 'I don't want you to do anything you don't want to do,' he assured her. 'We'll just sit and talk.'

'Are you disappointed?'

He squeezed her hand. 'Not at all, my dear.'

He took out a bottle of liquid Ecstasy and poured some into two glasses.

'What is that?' Chloe asked.

'It's an energy booster. Cheers.' He raised his glass in a toast and watched as she finished the liquid in her glass.

'It's good,' Chloe said.

They had spent the next half hour talking, and Peter had waited as the drug began to work. Finally, he moved next to Chloe and put his arms around her, and this time there was no resistance.

'Get undressed,' he said.

'Yes.'

Peter's eyes followed her into the bathroom, and he began to undress. Chloe came out a few minutes later, naked, and he became excited at the sight of her young, nubile body. She was beautiful. Chloe got into bed beside him, and they made love. She was inexperienced, but the fact that she was a virgin gave Peter the extra excitement that he needed.

In the middle of a sentence, Chloe had sat up in bed, suddenly dizzy.

'Are you all right, my dear?'

'I – I'm fine. I just feel a little –' She held on to the side of the bed for a moment. 'I'll be right back.'

She got up. And as Peter watched, Chloe stumbled, fell, and smashed her head against the sharp corner of the iron table.

'Chloe!' He leaped out of bed and hurried to her side. 'Chloe!'

He could feel no pulse. *Oh, God*, he thought. *How could you do this to me? It wasn't my fault. She slipped.*

He looked around. *They mustn't trace me to this suite.* He had quickly gotten dressed, gone into the bathroom, moistened a towel, and begun polishing the surfaces of every place he might have touched. He picked up Chloe's purse, looked around to make sure there were no signs that he had been there, and took the elevator down to the garage. The last thing he had done was to wipe his fingerprints off the elevator buttons. When Paul Yerby had surfaced as a threat, Tager had used his connections to dispose of him. There was no way anyone could connect Tager to Chloe's death.

And then the blackmail letter had come. Carl Gorman, the hotel clerk, had seen him. Peter had sent Sime to get rid of Gorman, telling him that it was to protect the president.

That should have been the end of the problem.

But Frank Lonergan had started asking questions, and

it had been necessary to dispose of him, too. Now there was another nosy reporter to deal with.

So there were only two threats left: Marianne Gorman and Dana Evans.

And Sime was on his way to kill them both.

Twenty-Three

Marianne Gorman repeated, 'You know – the one with the eye patch. Peter Tager.'

Dana was stunned. 'Are you sure?'

'Well, it's hard not to recognize someone who looks like that, isn't it?'

'I need to use your phone.' Dana hurried over to the telephone and dialed Matt Baker's number. His secretary answered.

'Mr Baker's office.'

'It's Dana. I have to talk to him. It's urgent.'

'Hold on, please.'

A moment later, Matt Baker was on the line. 'Dana – is anything wrong?'

She took a deep breath. 'Matt, I just found out who was with Chloe Houston when she died.'

'We know who it was. It was –'

'Peter Tager.'

'What?' It was a shout.

'I'm with the sister of Carl Gorman, the hotel clerk who was murdered. Carl Gorman saw Tager wiping his

fingerprints off the elevator in the hotel garage the night Chloe Houston died. Gorman sent Tager a blackmail letter, and I think Tager had him murdered. I have a camera crew here. Do you want me to go on the air with this?'

'Don't do anything right now!' Matt ordered. 'I'll handle it. Call me back in ten minutes.'

He slammed down the receiver and headed for the White Tower. Leslie was in her office.

'Leslie, you can't print −'

She turned and held up the mock-up of the headline: MURDER WARRANT SERVED ON PRESIDENT RUSSELL.

'Look at this, Matt.' Her voice was filled with exaltation.

'Leslie − I have news for you. There's −'

'This is all the news I need.' She nodded smugly. 'I told you you'd come back. You couldn't stay away, could you? This was just too big to walk away from, wasn't it, Matt? You need me. You'll always need me.'

He stood there, looking at her, wondering: *What happened to turn her into this kind of woman? It's still not too late to save her.* 'Leslie −'

'Don't be embarrassed because you made a mistake,' Leslie said complacently. 'What did you want to say?'

Matt Baker looked at her for a long time. 'I wanted to say goodbye, Leslie.'

She watched him turn and walk out the door.

Twenty-Four

'What's going to happen to me?' Marianne Gorman asked.

'Don't worry,' Dana told her. 'You'll be protected.' She made a quick decision. 'Marianne, we're going to do a live interview, and I'll turn the tape of it over to the FBI. As soon as we finish the interview, I'll get you away from here.'

Outside, there was the sound of a car screaming to a stop.

Marianne hurried over to the window. 'Oh, my God!'

Dana moved to her side. 'What is it?'

Sime Lombardo was getting out of the car. He looked at the house, then headed toward the door.

Marianne stammered, 'That's the – the – other man who was here asking about Carl, the day Carl was killed. I'm sure he had something to do with his murder.'

Dana picked up the phone and hastily dialed a number.

'Mr Hawkins's office.'

'Nadine, I have to talk to him right away.'

'He's not in. He should be back in about –'

'Let me talk to Nate Erickson.'

Nate Erickson, Hawkins's assistant, came on the phone. 'Dana?'

'Nate – I need help fast. I have a breaking news story. I want you to put me on live, immediately.'

'I can't do that,' Erickson protested. 'Tom would have to authorize it.'

'There's no time for that,' Dana exploded.

Outside the window, Dana saw Sime Lombardo moving toward the front door.

In the news van, Vernon Mills looked at his watch. 'Are we going to do this interview or not? I have a date.'

Inside the house, Dana was saying, 'It's a matter of life and death, Nate. You've got to put me on live. For God's sake, do it now!' She slammed the receiver down, stepped over to the television set, and turned it on Channel Six.

A soap opera was in progress. An older man was talking to a young woman.

'You never really understood me, did you, Kristen?'

'The truth is that I understand you too well. That's why I want a divorce, George.'

'Is there someone else?'

Dana hurried into the bedroom and turned on the set there.

Sime Lombardo was at the front door. He knocked.

'Don't open it,' Dana warned Marianne. Dana checked to make sure that her microphone was live. The knocking at the door became louder.

'Let's get out of here,' Marianne whispered. 'The back –'

At that moment, the front door splintered open and Sime charged into the room. He closed the door behind him and looked at the two women. 'Ladies. I see that I have both of you.'

Desperately, Dana glanced toward the television set. 'If there is someone else, it's your fault, George.'

'Perhaps I am at fault, Kristen.'

Sime Lombardo took a .22 caliber semiautomatic pistol out of his pocket and started screwing a silencer onto the barrel.

'No!' Dana said. 'You can't –'

Sime raised the gun. 'Shut up. Into the bedroom – go on.'

Marianne mumbled, 'Oh, my God!'

'Listen . . .' Dana said. 'We can –'

'I told you to shut up. Now move.'

Dana looked at the television set.

'I've always believed in second chances, Kristen. I don't want to lose what we had – what we could have again.'

The same voices echoed from the television set in the bedroom.

Sime commanded, 'I told you two to move! Let's get this over with.'

As the two panicky women took a tentative step toward the bedroom, the red light on the camera in the corner suddenly turned on. The images of Kristen and George faded from the screen and an announcer's voice said, 'We interrupt this program to take you now live to a breaking story in the Wheaton area.'

As the soap opera faded, the Gorman living room suddenly appeared on the screen. Dana and Marianne were in the foreground, Sime in the background. Sime stopped, confused, as he saw himself on the television set.

'What – what the hell is this?'

In the van, the technicians watched the new image flash on the screen. 'My God,' Vernon Mills said. 'We're live!'

Dana glanced at the screen and breathed a silent prayer. She turned to face the camera. 'This is Dana Evans coming to you live from the home of Carl Gorman, who was murdered a few days ago. We're interviewing a man who has some information about his murder.' She turned to face him. 'So – would you like to tell us exactly what happened?'

Lombardo stood there, paralyzed, watching himself on the screen, licking his lips. 'Hey!'

From the television set, he heard himself say, 'Hey!' and he saw his image move, as he swung toward Dana. 'What – what the hell are you doing? What kind of trick is this?'

'It's not a trick. We're on the air, live. There are two million people watching us.'

337

Lombardo saw his image on the screen and hastily put the gun back into his pocket.

Dana glanced at Marianne Gorman, then looked Sime Lombardo square in the eye. 'Peter Tager is behind the murder of Carl Gorman, isn't he?'

In the Daly Building, Nick Reese was in his office when an assistant rushed in. 'Quick! Take a look at this! They're at Gorman's house.' He turned the television set to Channel Six, and the picture flashed on the screen.

'Did Peter Tager tell you to kill Carl Gorman?'

'I don't know what you're talking about. Turn that damned television set off before I –'

'Before you what? Are you going to kill us in front of two million people?'

'Jesus!' Nick Reese shouted. 'Get some patrol cars out there, fast!'

In the Blue Room in the White House, Oliver and Jan were watching station WTE, stunned.

'*Peter?*' Oliver said slowly. 'I can't believe it!'

Peter Tager's secretary hurried into his office. 'Mr Tager, I think you had better turn on Channel Six.' She gave him a nervous look and hurried out again. Peter Tager looked after her, puzzled. He picked up the remote and

pressed a button, and the television set came to life.

Dana was saying, '. . . and was Peter Tager also responsible for the death of Chloe Houston?'

'I don't know anything about that. You'll have to ask Tager.'

Peter Tager looked at the television set unbelievingly. *This can't be happening! God wouldn't do this to me!* He sprang to his feet and hurried toward the door. *I'm not going to let them get me. I'll hide!* And then he stopped. *Where? Where can I hide?* He walked slowly back to his desk and sank into a chair. Waiting.

In her office, Leslie Stewart was watching the interview, in shock.

Peter Tager? No! No! No! Leslie snatched up the phone and pressed a number. 'Lyle, stop that story! It must not go out! Do you hear me? It –'

Over the phone she heard him say, 'Miss Stewart, the papers hit the streets half an hour ago. You said . . .'

Slowly, Leslie replaced the receiver. She looked at the headline of the *Washington Tribune*: MURDER WARRANT SERVED ON PRESIDENT RUSSELL.

Then she looked up at the framed front page on the wall: DEWEY DEFEATS TRUMAN.

'You're going to be even more famous than you are now, Miss Stewart. The whole world is going to know your name.'

Tomorrow she would be the laughingstock of the world.

At the Gorman home, Sime Lombardo took one last, frantic look at himself on the television screen and said, 'I'm getting out of here.'

He hurried to the front door and opened it. Half a dozen squad cars were screaming to a stop outside.

Twenty-Five

Jeff Connors was at Dulles International Airport with Dana, waiting for Kemal's plane to arrive.

'He's been through hell,' Dana explained nervously. 'He – he's not like other little boys. I mean – don't be surprised if he doesn't show any emotion.' She desperately wanted Jeff to like Kemal.

Jeff sensed her anxiety. 'Don't worry, darling. I'm sure he's a wonderful boy.'

'Here it comes!'

They looked up and watched the small speck in the sky grow larger and larger until it became a shining 747.

Dana squeezed Jeff's hand tightly. 'He's here.'

The passengers were deplaning. Dana watched anxiously as they exited one by one. 'Where's –?'

And there he was. He was dressed in the outfit that Dana had bought him in Sarajevo, and his face was freshly washed. He came down the ramp slowly, and when he saw Dana, he stopped. The two of them stood

there, motionless, staring at each other. And then they were running toward each other, and Dana was holding him, and his good arm was squeezing her tightly, and they were both crying.

When Dana found her voice, she said, 'Welcome to America, Kemal.'

He nodded. He could not speak.

'Kemal, I want you to meet my friend. This is Jeff Connors.'

Jeff leaned down. 'Hello, Kemal. I've been hearing a lot about you.'

Kemal clung to Dana fiercely.

'You'll be coming to live with me,' Dana said. 'Would you like that?'

Kemal nodded. He would not let go of her.

Dana looked at her watch. 'We have to leave. I'm covering a speech at the White House.'

It was a perfect day. The sky was a deep, clear blue, and a cooling breeze was blowing in from the Potomac River.

They stood in the Rose Garden, with three dozen other television and newspaper reporters. Dana's camera was focused on the president, who stood on a podium with Jan at his side.

President Oliver Russell was saying, 'I have an important announcement to make. At this moment, there is a meeting of the heads of state of the United Arab Emirates, Libya, Iran, and Syria, to discuss a lasting

peace treaty with Israel. I received word this morning that the meeting is going extremely well and that the treaty should be signed within the next day or two. It is of the utmost importance that the Congress of the United States solidly support us in helping this vital effort.' Oliver turned to the man standing next to him. 'Senator Todd Davis.'

Senator Davis stepped up to the microphone, wearing his trademark white suit and white, broad-brimmed leghorn hat, beaming at the crowd. 'This is truly a historic moment in the history of our great country. For many years, as you know, I have been striving to bring about peace between Israel and the Arab countries. It has been a long and difficult task, but now, at last, with the help and guidance of our wonderful president, I am happy to say that our efforts are finally coming to fruition.' He turned to Oliver. 'We should all congratulate our great president on the magnificent part he has played in helping us to bring this about ...'

Dana was thinking, *One war is coming to an end. Perhaps this is a beginning. Maybe one day we'll have a world where adults learn to settle their problems with love instead of hate, a world where children can grow up without ever hearing the obscene sounds of bombs and machine-gun fire, without fear of their limbs being torn apart by faceless strangers.* She turned to look at Kemal, who was excitedly whispering to Jeff. Dana smiled. Jeff had proposed to her. Kemal would have a father. They

were going to be a family. *How did I get so lucky?* Dana wondered. The speeches were winding down.

The cameraman swung the camera away from the podium and moved into a close-up of Dana. She looked into the lens.

'This is Dana Evans, reporting for WTE, Washington, D.C.'